# Gisèle Freund

## PHOTOGRAPHER

# Gisèle Freund
# PHOTOGRAPHER

TEXT BY GISÈLE FREUND

FOREWORD BY CHRISTIAN CAUJOLLE

TRANSLATED FROM THE FRENCH BY JOHN SHEPLEY

HARRY N. ABRAMS, INC., PUBLISHERS, NEW YORK

Designed by Massin, Paris

A Schirmer/Mosel Production

Library of Congress Cataloging in Publication Data

Freund, Gisèle.
  Gisèle Freund, photographer.

  Translation of: Gisèle Freund, itinéraires.
  Bibliography: p.
  Includes index.
  1. Photography—Portraits.   2. Photography,
Documentary.   3. Freund, Gisèle.   I. Title.
TR680.F7313   1985      770′.92′4     85–7447
ISBN 0–8109–0939–1

Printed and bound in West Germany

# Contents

# Foreword

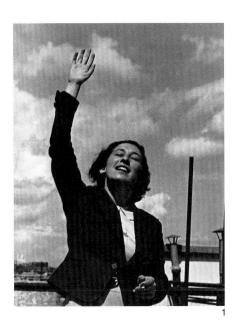

It was at the Maison des Amis des Livres, 7 Rue de l'Odéon, one Sunday afternoon in March, 1939. The owner, Adrienne Monnier, had invited writers and friends to a grand premiere: a projection of color photographs by her friend Gisèle Freund. A white sheet served as a screen, and the shelves had been covered with wrapping paper so that no one would succumb to the temptation to steal a book.

Paul Valéry had sent his wife and his son François; André Gide was represented by his daughter and "la petite Dame." Jean Paulhan, Jules Romains, Léon-Paul Fargue, Jules Supervielle, and twenty others attended, accompanied by their families. The Surrealists were represented by André Breton. Louis Aragon, Elsa Triolet, and Paul Nizan, author of *La Conspiration*, formed a group of writers of the extreme left. Jean-Paul Sartre had come, accompanied by his mother and Simone de Beauvoir. There were also some well-known art critics and society figures like the Duchesse de la Rochefoucauld and Julien Cain, director of the Bibliothèque Nationale, and finally Jean Genet and Maurice Sachs.

The showing began and silence fell, soon broken by whispers and muffled remarks. Seeing themselves this way, enlarged and in color, in close-up on the improvised screen, most of the writers present did not like themselves. Like any ordinary person looking at his picture, they did not recognize in the features and poses captured by the camera what they thought—and wished— their image to be. For the truth is that each of us strives to display the permanence of a countenance, while the photograph, and especially the portrait, is the result of a struggle between the subject and the photographer's interpretation.

This showing, which so disappointed each of the writers—who moreover found the photos of their colleagues to be "successful" or a "good likeness"— this bringing together of mirror and image in a place as symbolic as the most

1. *Vive la vie!* Gisèle Freund on the terrace of her studio, Rue Lakanal, Paris, 1933

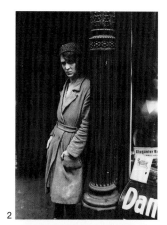

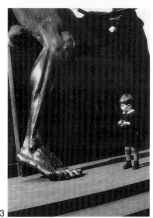

2. In the old quarter of Frankfurt am Main, 1932

3. Siegesallee, Berlin, 1933

4. Self-portrait of Gisèle Freund, Paris, 1939

5. Beggar, London, 1933

6. Peddler, Paris, 1960

truly literary bookstore in Paris, was historical in nature. In addition to exhibiting the first portraits in color of those who created the history of thought in the last half century, it marked, with its close-ups, its sometimes unbearable details, its permanent wrinkles and small conspicuous imperfections, the end of the period when the writer, photographed in the studio in a halo of soft light, took flattering poses, with an "artistic look," an arrogantly flowing necktie, his eyes gazing somewhat into the distance and his image often retouched on the final proofs.

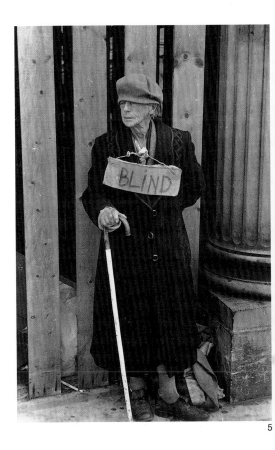

Half a century has passed since this memorable occasion, which brief notices in the press of the time greeted as a small literary event. But these portraits still exist. They exist perhaps even more than they did at the time. First of all, because they are truly unique and because without them we would know nothing, or at least not in this way, of that translucent skin, pierced by two astonishingly clear eyes, that Romain Rolland, his calm and attentive face resting on his hand, displays above a stand-up collar.

They are thus documentary portraits, which we look at with the same amazement, the same wish to decipher evidence of reality, as in the case of any other photo. But they derive from the will to choose and the characteristic gaze of the photographer, who selects a tiny portion of time and fixes a fleeting expression for eternity. Half a century after these portraits left their outlines in color on film, what do we look for in them, we who did not know these people and that period? Probably the reflection of an appearance, voyeurs that we are, facing "great" figures, those who constitute our culture and whom we have the impression of approaching through the photograph.

How can it be, you will say, that certain portraits attract us more than others, that the reflection of a certain face seems to us more of a "likeness" than some other, since most of the time we have not met any of those whose image we are contemplating? It is perfectly obvious, when this feeling of familiarity, this quality of meeting a portrait, is repeated, that all such "resemblance to persons living or dead" has to do not with photography itself but with the photographer.

It is not so much with the subjects as with the gaze of the photographer that we find ourselves in accord and share, in the physical sense of the word, a point of view. And this is the way recognizable styles are established: in the profound need for a photographer to repeat the approach of his or her eye, until what is created for us is a family and an album whose unity is due solely to that kinship which has brought them together in a viewfinder.

Gisèle Freund is an almost perfect example. It would be quite correct to say that her Matisse does not resemble Brassaï's or Cartier-Bresson's—to cite the names of those who were treating the same subjects in the same period. Here it is not a question of comparing their styles but simply of noting the difference and upholding it.

Each person looks in his own way, more or less sensitively to details or the whole. The photographer adds to this a strange awareness of the moment, a capacity to transmit, by the simple pressure of his finger on the release, his decision and the selection that he decides to record. And this at a speed whereby each photograph, at perhaps a hundredth of a second, chooses a portion of an event that, in reality, we never see in the way the photograph will show it. Here we have the whole problem of the portrait—whether of a face or of a period—now fixed for eternity. When we look at it, however, it is always essential—since we are dealing with photography—to distinguish those elements that pertain to the taking of the picture and those that have to do with its interpretation. It is not at all this feeling of the ephemeral, of chance controlled by the photographer's will, that counts the most. More significant is that we project into these wavering expressions, these faces posing before the

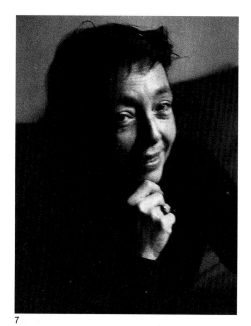

7

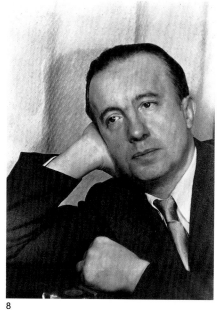

8

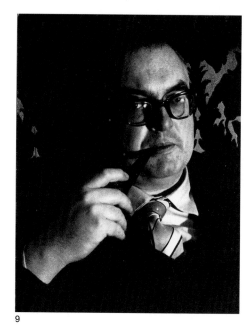

9

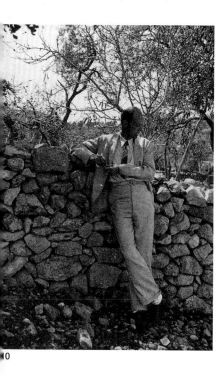

0

7. Marguerite Duras, 1955

8. Paul Eluard, Paris, 1939

9. Friedrich Dürrenmatt, Paris

10. Drieu La Rochelle, Ibiza, 1932

11. Léon-Paul Fargue, Paris

12. Max Ernst, at the Fonderie Suss, Paris

13. Carlos Fuentes, Paris

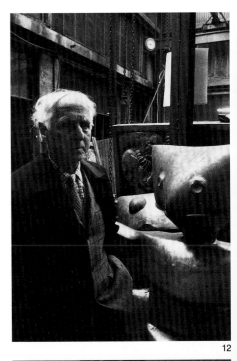

12

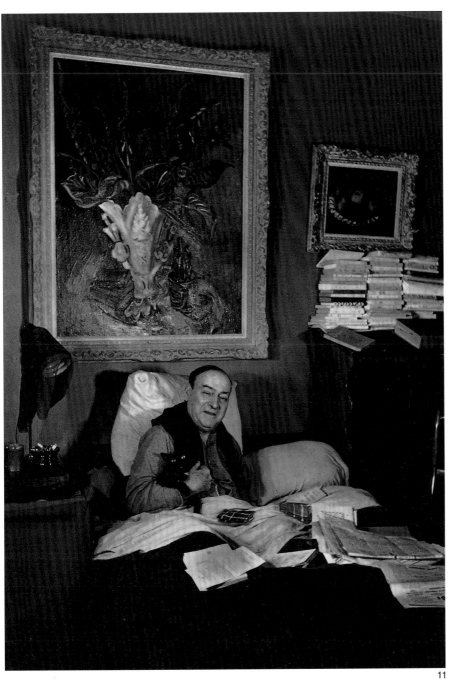

11

13

camera, what we know or would like to grasp about the person. Particularly striking in the case of writers, painters, or intellectuals, this phenomenon drives us to set up symbolic correspondences between the apparent sweetness of a poet and his style, between the fragility and silhouette of a painter and the vibration of his touch. We conceive the photograph in a certain way, on the basis of elements transmitted to us by the photographer.

The caption accompanying the picture will, in this case as always, be essential. The well-known name attached to the image of a face will act to orient one's interpretation: if the six pictures that sum up with rare perfection the life of André Malraux were not accompanied by his name, what would they have to express, beyond the formal beauty of a romantic young man, or of an aged man dreaming in his garden in the company of his cat? Certainly not a legend of our century, as the text immediately makes clear, relating the images to the stature of one of the most remarkable figures of the French intelligentsia. The text, the words, make these photographs speak. The words give speech to the images. But the caption, indispensable as it is, can also make the image lie, and impose an interpretation that, contrary to truth, threatens to divert it from its documentary meaning. Likewise the passage of time will require some modifications in the caption, so that the photograph, having been a document of current reality, will still be comprehensible when it becomes a piece of historical evidence.

From these years of friendly association with writers and painters, there remains today an album that testifies above all to a quality of literary choice. Gisèle Freund did not photograph all writers, only the ones she liked, something that strikes us as much by its formal aspect as by that calm air of eternity in which these different faces shine. It was a literary choice marked also by the total absence of the spectacular, since in photographing these writers, who often became her friends, for her own pleasure and her own memory, she was not constrained by any of the commercial necessities that often make the image more important than the purpose behind the photograph. The reporter has traveled through what she likes to call her "country of faces."

Just as one might say that all photography is the portrait of a period, a place, or an object, as well as a self-portrait of the person who executes it, so it is correct to think of the faces assembled here as constituting a reportage in time and of each of them as reportage. This is not surprising, since that girl whom nothing had destined for photography, and who did not profess any particular aesthetic goal, embarked on photographic images by chance. She was curious and she had the good luck to own a Leica, one of those small, handy cameras that by their technology revolutionized the aesthetics of photojournalism. She began by recording the things around her that surprised her. That the pictures that seem so striking to us today—of fascist and antifascist demonstrations in Frankfurt in 1932, or of writers gathered in the name of the defense of culture—bear a family resemblance to the later portraits is due to the specificity of her gaze and to that desire to discover and understand which has constantly inspired her photography. Thus there emerged a series of moments so calm and so stretched between light and shadow that they allow us equally to grasp, in the same tonality, Joyce in conversation after taking his taxi and the still life on the kitchen table in the bookstore. Whether it is a question of poverty in England, the discovery of Paris, Virginia Woolf, or her own Latin American friends, Gisèle Freund always attaches herself to what constitutes the very essence of photography: light. She thereby affirms one of the essential realities of a photograph, one that is often overlooked in the name of objectivity: the fact that each photographer, in order to convey his personal vision and inner world, must, like all artists, work through a reality that

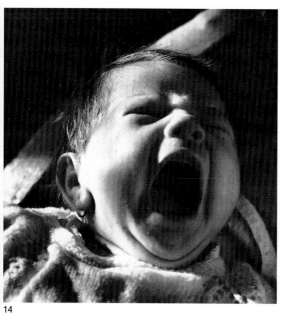

14

14. Baby, Mexico, 1950

remains within himself. What he offers can necessarily only be his vision of reality, and in no case reality itself. This simple principle, too often forgotten, suggests that photographers are the faithful storytellers of reality, for the photograph—and it was then called heliographic design—assigns itself the task of reproducing the subjects that it wants to show.

Gisèle Freund has been successful perhaps precisely because she has approached her models with infinite modesty, while trying simply to photograph well, shunning framing effects that cut the composition in too symbolist a way, like distortions of vision, and relying merely on the choice of brief moments when the look on a face offers something more than its appearance. She tries to capture, in the personality of the subject about to be photographed, a dimension that photography can gain when it remains a privileged instrument of the ephemeral.

Thus she has brought together good luck and intuition. It is as though her finger, divining that some moment is about to arrive and let itself be caught—an imperceptible crinkle of the eyes, an invisible smile, a glimmer of slyness, a tiny look of dejection—has been able to anticipate the fleeting movement so as to trap it with an astonishing combination of optics and chemistry.

There still remains a magical dimension in photography. This is what makes it possible to explain the production of those rare moments that say more than the image itself. If there is an art of portrait photography—and this collection proves that there is—there undoubtedly resides in these successful portraits a supplementary proof of Gisèle Freund as sociologist and historian of photography. She studies her models almost scientifically and is able to pin them down without malice when the moment is revealed to her.

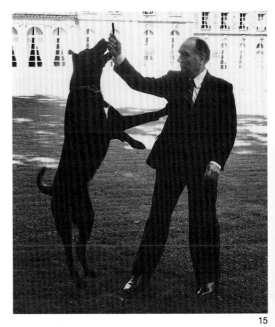

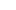
15

One ought accordingly to mention what, in both the portraits and the reportage pictures, belongs to one of the essential provinces of photography: time. She rejects the anecdote and strives to seek out deeper elements. Instead of the restlessness and uninterrupted movement of the machine, she awaits the minor event that will be significant. She does not steal the image but helps it to come, seduces it the better to capture it, and then declares that everything is simple. Apparently simple, since there is nothing more difficult than to gain the subject's confidence, nothing more risky than to entrust to photography, which can also betray them, those miraculous moments that often require long preparations by the mind.

What is touching and moving in these photographs is the humility of the photographer, which has allowed her to record her family album. These are not statements of an aesthetic, not definitions of an art of seeing. Rather, they are the necessities of an art of living, an art that loiters, out of taste and passion, alongside practitioners of the pen and book, and assigns itself the simple goal, at the moment of snapping the shutter, of putting into form the encounters dreamed of by so many others. The photographer thereby becomes the practitioner of a sort of collective will.

Later—and here time still plays a role—the photographer, and everyone along with her, takes account of the fact that this series amassed like a history makes sense, that no one else has encountered with such intimacy so many figures who have become famous by the sole fact of their writing.

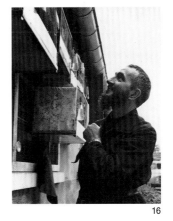
16

Gisèle Freund's portraits, the most important itinerary in her work as a photographer, are documents for her, and that is the reason they are so moving. These photographs overwhelm us by their simplicity. For the reader of today, as for the subject of yesterday, they express the esteem and sincerity with which they were conceived. She offers us this album only if we want to look at it, because before us she truly knew how to see.

CHRISTIAN CAUJOLLE

15. François Mitterrand, in the garden of the Elysée, Paris, 1981

16. The Abbé Pierre, Fondation Emmaus, near Paris

17

16

# Introduction

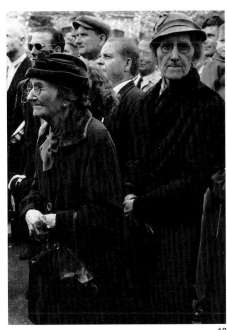

Photography was invented in France by Niepce and improved by Daguerre. In 1839, the scientist Arago proposed to the Chamber of Deputies that the State buy this invention and make the process public. He prophesied that photography would render enormous services to the arts and sciences. The bill was passed unanimously. Since that time, photography has made incredible advances. In 1985 it is possible, thanks to electronics, to send pictures across thousands of miles of distance without passing through film. By satellite or telephone, any image can be transmitted to television and the illustrated press. One of the most startling images of our century was that of man walking on the moon, and billions of people, seated before their television screens, saw it. Niepce died in poverty. In his wildest dreams he could not have imagined the extraordinary importance that photography would assume in our century and civilization, one that has been called an "image civilization."

One must never forget that film and television would not exist without the invention of photography.

The camera is a mechanical instrument. It can exactly reproduce the appearance of the world that surrounds us. But the manner of recording an occurrence depends on the taste and talent of the photographer. An almost imperceptible shift in one's gaze makes it possible to see simultaneously a whole collection of things. In one glance we embrace the street, the sky, the people passing by, and the gestures they make. While the human eye absorbs a myriad of details, the eye of the camera selects; therein resides its power if one knows how to use it. The camera catches isolated reality in a fraction of a second. The immediate present accordingly takes on a symbolic value that awakens in the observer—if the photo has a meaning—an endless series of associations and emotions.

17. Fans of the Beatles, London, 1963

18. Old women, Paris

From the moment the professional photographer sells the reproduction rights to his photos to the press, television, or advertising, he is no longer in control of their presentation.

The meaning of a photograph can be changed in all sorts of ways. An image can come to represent the opposite of what the photographer intended to show, thanks to retouching, the accompanying caption, and a host of other means. Thus photography, in the hands of those who make use of it, can become an all-powerful method of propaganda.

Hundreds of millions of amateur photographers have no inkling of this. They go on believing that photographs are exact copies of nature and of human beings. Don't they have the proof of it from their own experience? The pictures of Johnny on the dresser—as a baby, taking his First Communion, as a soldier, a bridegroom, the father of children—were they not taken by his intimates? They show Johnny to perfection at the various stages of his life. From this people deduce that the photos they see every day in magazines and on the television screen express the truth. They do not realize that they often present a falsified, manipulated reality.

Our period is called an "image civilization" because photography is everywhere. It literally stares us in the face. Our optic nerve is ceaselessly assailed by the endlessly repeated sight of advertising spots. In the streets of no matter what city in the world, images are plastered on the walls, the hoardings of building sites, trains, roads, buses, the subway; they have even made their way into taxis. They fill thousands of magazines and family albums, and they parade every day on the television screen past the tired eyes of billions of spectators, like a drug the viewers cannot do without. By dint of being seen everywhere, images have become so incorporated into our lives that we no longer see the reality.

How many of us have ever seen a President of the Republic? We know only his image, the one we see in the press and on television. How many people have seen a real war, or witnessed a real catastrophe, assassination, or famine? They show us these images with the comment that they involve millions of people who are suffering, struggling, and dying, but the numbers and facts do not touch the spectators, for these images are only images.

The irony of our image civilization is that it consists in concealing reality from us by superimposing itself on reality.

One day at Roissy airport I saw a middle-aged couple getting off a plane.

"Wonderful!" they exclaimed. "In Frankfurt at last!"

"But you're in Paris, you're coming *from* Frankfurt," said the tourist agent who had been waiting for them. The husband made a fatalistic gesture.

"Never mind, I have my camera. When we get home, I'll see all the countries where we've been."

They went away, tired. In their case, as in that of thousands of other tourists, the photo becomes an ersatz that replaces the real world with a pseudo-truth.

Look at visitors to the Eiffel Tower. Their eyes are glued to their cameras. They don't see Paris, their camera sees it for them. They carry away images of a city they haven't seen.

Taking pictures today is child's play. Anyone can do it, and the results are technically perfect. But photos that go beyond simple reality, ones that we would call the best and that resist time, are rare. One day, Cartier-Bresson said to me, "As far as I'm concerned, I've taken three hundred pictures that are worth saving." By that time he already had more than a million negatives. I've seen his exhibitions and I know his portfolios. I think he was being modest.

When I was invited by Sidney Janis, owner of a leading New York art gallery, to hold an exhibition with him, he told me, "I need three hundred pictures."

19. Mount Scopus, Jerusalem, 1981

20. Floating logs, Canada, 1975

21. Oil stains, San Francisco, 1982

"But I don't have three hundred pictures that are worth showing."

"What? You, who've been a photographic reporter for fifty years, you don't have three hundred pictures among all the thousands you've taken? So how many do you have?"

"I'd say eighty," I replied, to my own great astonishment. And yet many of them had only become well known because of the celebrities I had had the good fortune to photograph. In the end we agreed that I would show about a hundred pictures.

I have selected for this book those photographs which are important to me for their documentary value. There is no denying, however, that there are exceptional moments in which photographers succeed in communicating, through such documentary images, some small part of their thought and experience. These are the images that fix themselves in the collective memory.

# Frankfurt

In 1932 I was a sociology student, but my hobby was photography. My father, in 1928, had given me a Leica camera, a make that had been on the market for only six years. I was impressed by the ease with which this little camera could be handled and the possibility of taking almost forty pictures without changing the reel (film in those days was not yet numbered).

Sunday, May 1, Frankfurt am Main. The weather is splendid, not a cloud in the transparent sky, and the spring air is surprisingly mild.

In the dawn, lines of trucks transporting men and women approach the city. All of the passengers get off as soon as they arrive and line up in columns, led by people carrying placards covered with political slogans. The streets swarm with a crowd that moves toward the Roemerplatz, the large medieval square in the old city, alongside the cathedral. Soon the square is filled by a veritable human sea and the arriving columns must station themselves in the adjoining streets (*Frankfurter Zeitung*, May 2, 1932).

May Day is the holiday celebrating labor, but most of the faces are grim and anxious. At least a third of those assembled on this day are unemployed. In 1932 Germany had more than six million unemployed, and this, when one includes their families, represents a total of twenty million people living in poverty. It is the greatest economic and social disaster ever experienced by the Weimar Republic, which had been established only thirteen years before. The crisis had begun with the crash of the New York stock exchange in 1929. Considerable American capital was invested in Germany. Banks collapsed, thousands of businesses were ruined, and the climate became one of catastrophe. Political behavior accordingly became radicalized. Parapolitical squads of the Communist party and of the National Socialist party met face to face during bloody battles on the streets of large cities. Chancellor Brüning, heading a government composed of the Catholic party of the center and of parties on the right, could govern only by emergency measures.

On this May Day, the Social Democratic party, the Communist party, the trade unions, and other workers' organizations have summoned all their members and sympathizers to demonstrate against the government. The left is anxious: the Communists and Social Democrats are still strong, but in the last Landtag elections they have lost a considerable number of seats to the National Socialists, whose rise seems to be overwhelming.

Speakers address the crowd and denounce the fascists. They also blame the Social Democrats, whom they hold responsible for the situation and for the rise of the forces of the right, since their leaders have not opposed Hilter vigorously enough. They also condemn big business for financing him out of fear of the Communists.

The students, too, are politicized, and battles take place in front of the University between those of the right and those of the left.

Members of rightist groups organize a demonstration protected by the police, in which students of the "Korps" participate in uniform. When the leftist students see them march, they hastily organize a counterdemonstra-

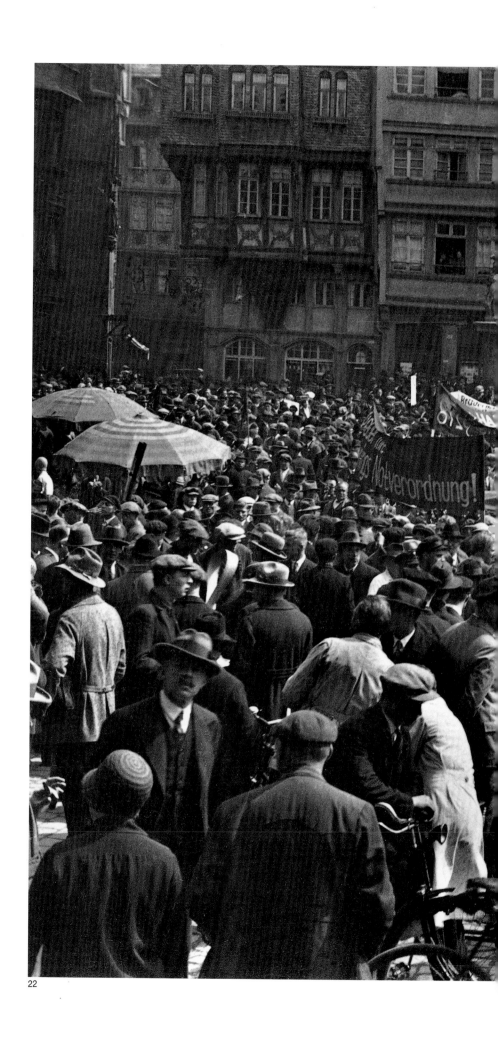

22. May Day, Frankfurt am Main, 1932

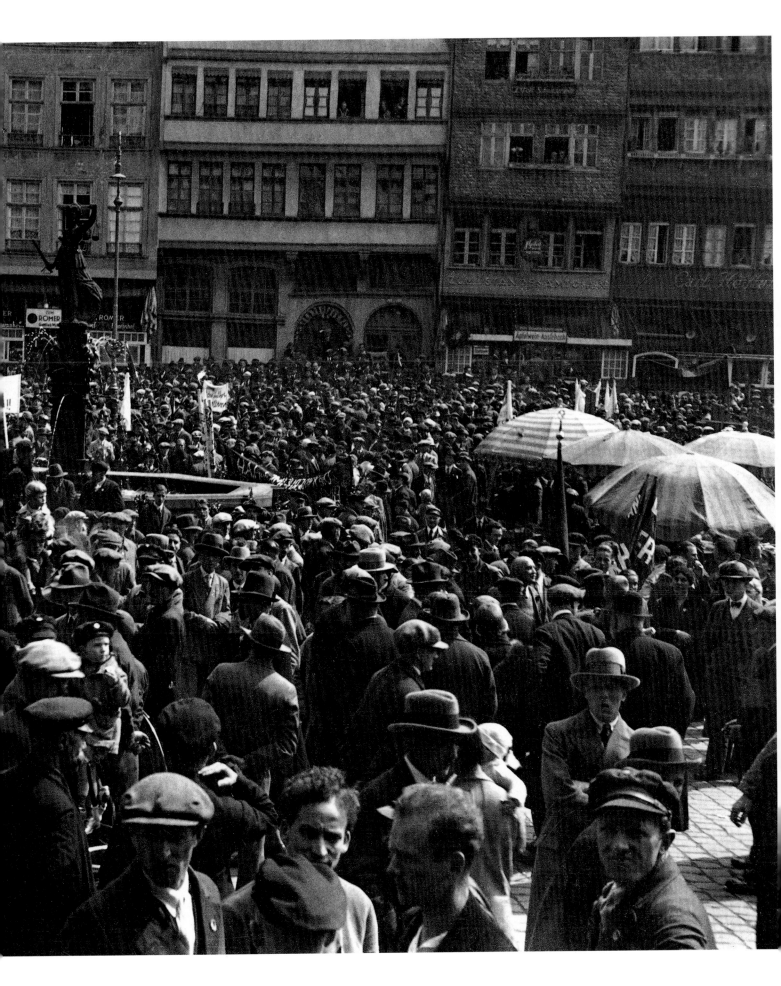

23. May Day, Frankfurt, 1932

24. May Day speaker, Frankfurt, 1932

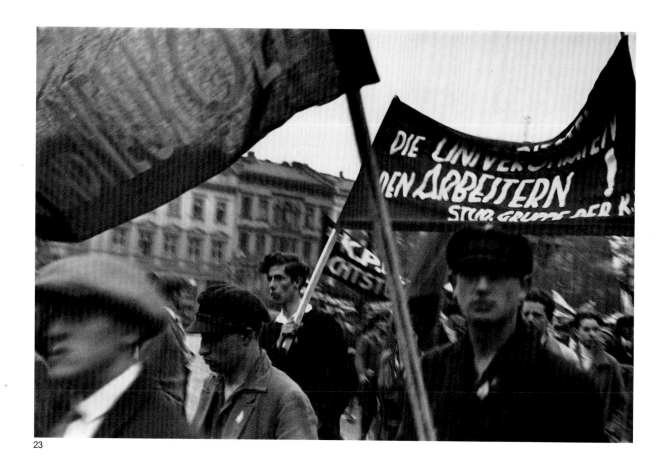

23

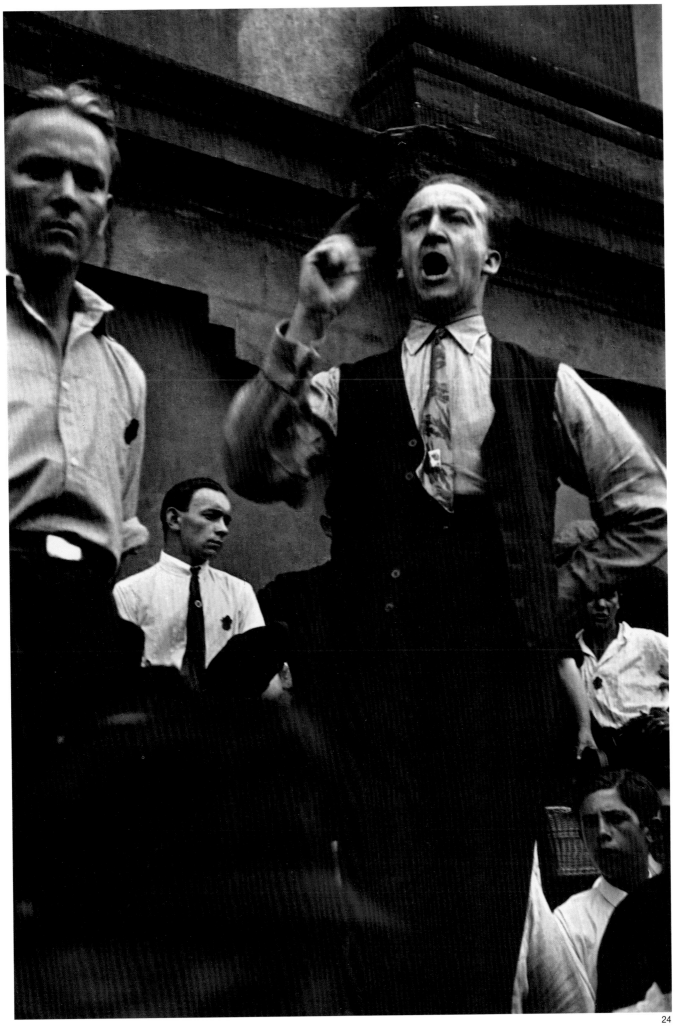

25. Crowd listening to a speaker, May Day,
Frankfurt, 1932

26. *Schupo* (policemen), May Day, Frankfurt,
1932

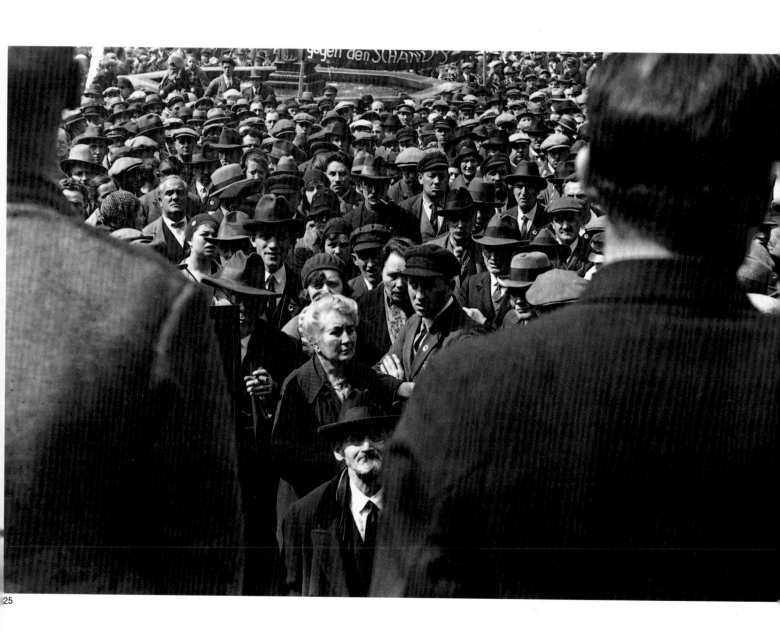

25

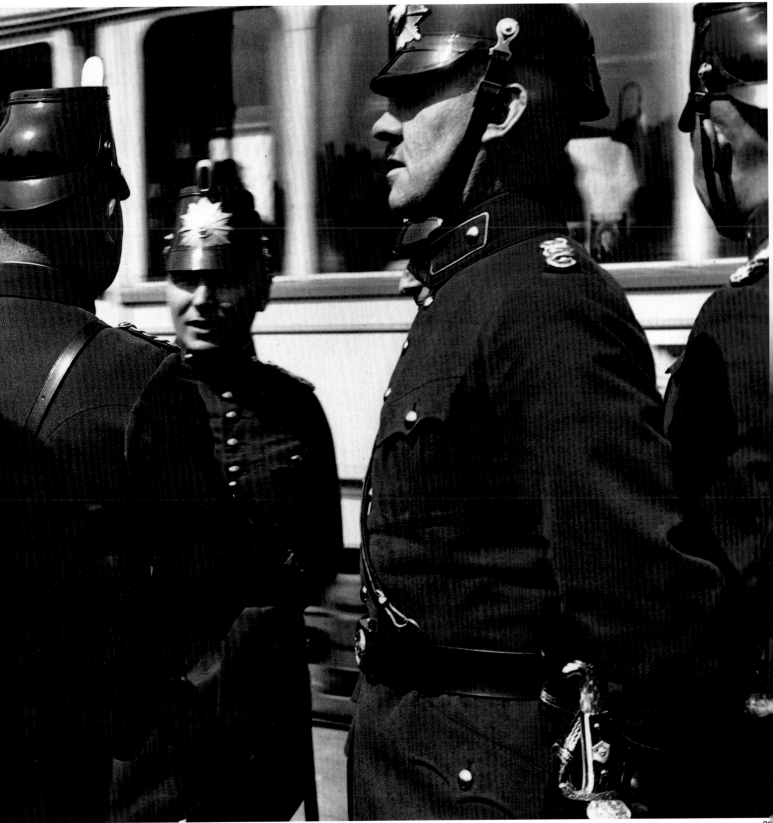

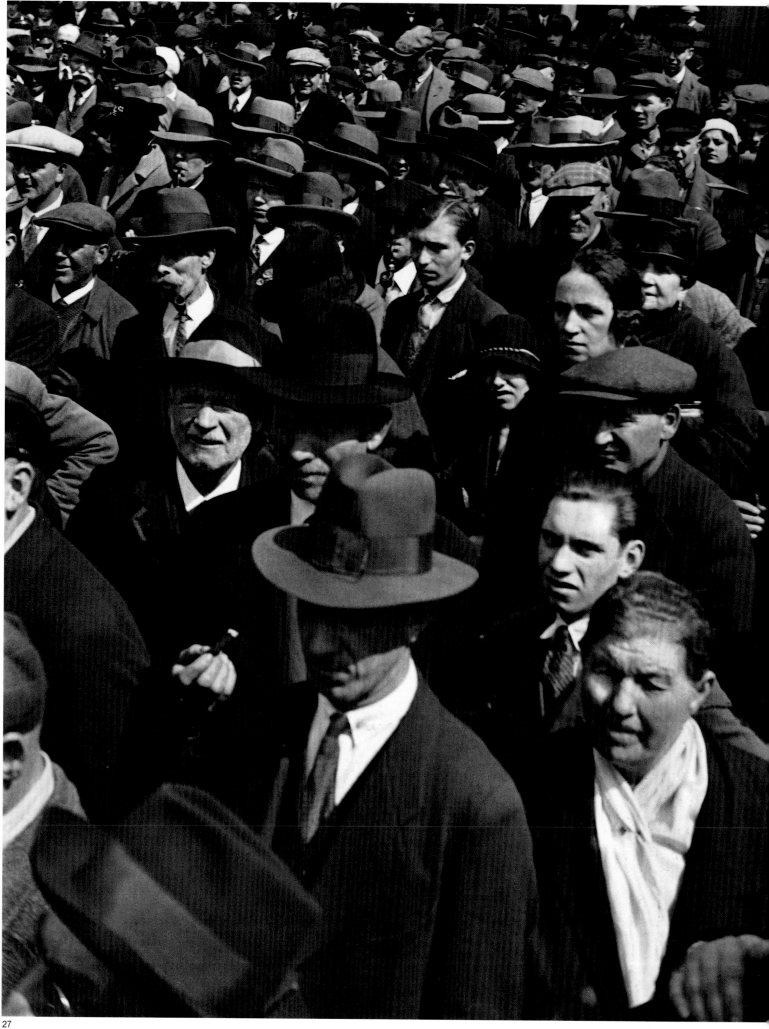

27. Crowd, May Day, Frankfurt, 1932

28. Demonstration by rightist students in front of the University, under the protection of the police, May Day, Frankfurt, 1932

28

29. Students of the *Korps* (military guild of
    rightist students) in the procession, May
    Day, Frankfurt, 1932

30. Arrival of leftist students, May Day,
    Frankfurt, 1932

31. Demonstration by leftist students in front
    of the University

32. The police approach to confiscate the
    placards

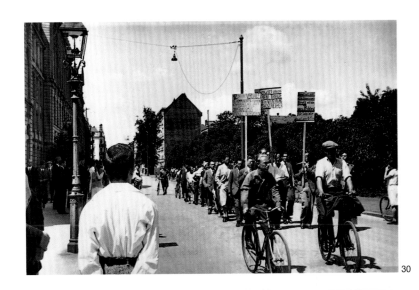

30

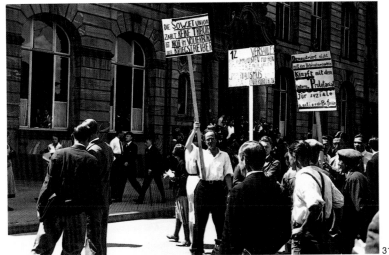

31

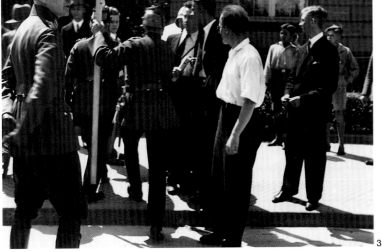

32

tion, improvise handwritten placards, and go in formation to the University. The police immediately intervene, confiscate the placards, and arrest those carrying them, taking them away in police vans while the other demonstrators flee.

Actually the Government's emergency decrees oblige the organizers of street rallies, whatever their orientation, to obtain a permit first from the police, something that the leftist students, caught by surprise by their opponents' demonstration, have not had time to do.

I do not recall seeing a single professional photographer during this impressive demonstration, which was to be the last before the end of the Weimar Republic. In January, 1933, Hitler became chancellor of the Reich and established his dictatorship in Germany. Many of those I photographed on that May Day in 1932 became members of the Nazi party; others ended up in concentration camps.

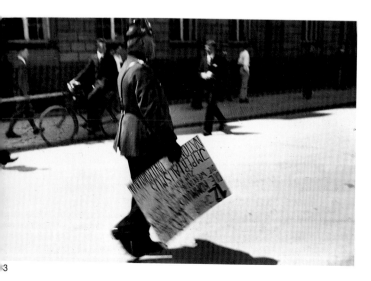

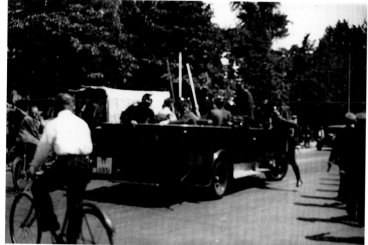

34

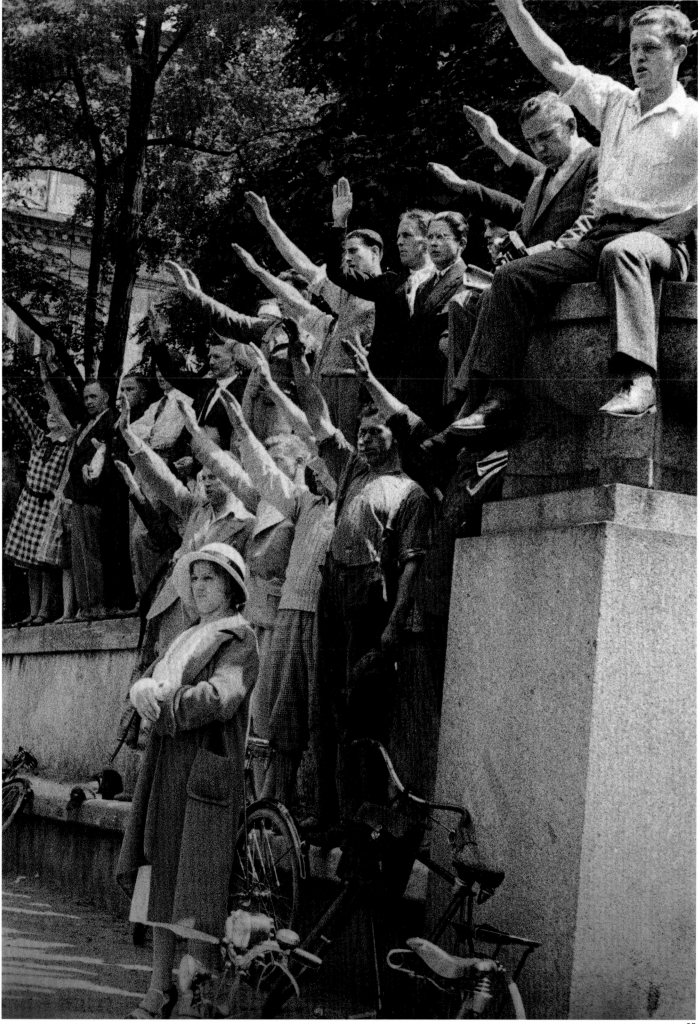

# International Congress for the Defense of Culture

On the evening of June 21, 1935, thousands of people converge on the Maison de la Mutualité in Paris, where the Congress for the Defense of Culture is opening. The large hall, containing three thousand seats, is full, and outside a crowd gathers around loudspeakers that have been set up so that those unable to enter can at least follow the speeches. Tickets must be bought, and the audience is largely composed of writers and intellectuals from the most diverse horizons and political parties. Close to two hundred and fifty writers, from thirty-eight countries, have been invited, constituting the most brilliant audience ever assembled. For five days they meet at 3 P.M. and 9 P.M.

On the platform, André Gide, E. M. Forster, Julien Benda, Robert Musil, Jean Cassou, E. E. Kisch, Jean Guéhenno, Edouard Dujardin, and André Malraux. With their differing political, literary, and philosophical opinions, they are a good representation of the stakes at this historic gathering; to defend freedom of the mind against the threat of war and fascism. The organization of the Congress, in which the French delegation is naturally the most numerous, is chiefly owing to the speaker who most fascinates the audience by his eloquence and fire: André Malraux.

"The humanism we want to create, and which finds its former expression in the line of thought running from Voltaire to Marx, lays claim above all to man's true awareness. To be a man is to reduce one's pretense to a minimum," he declares, at a time when he believes that "communism restores to the individual his fertility."

The most famous Frenchman present is undoubtedly André Gide, with his clean-shaven, ascetic face. He too has recently been won over to the cause of the working classes. "It is my claim that one can be profoundly internationalist while remaining profoundly French. Just as I claim to remain profoundly individualist in full communist assent and with the help of communism. For my thesis has always been the following: it is by being the most private that each person best serves the community. Today I would add another thesis, counterpart or corollary of the first: it is in a communist society that each individual, the privacy of each individual, can most perfectly expand." (After his trip to the USSR, André Gide was to change his opinion radically, as did André Malraux a few years later.)

I also remember Henri Barbusse, his features already wasted with illness; Aldous Huxley, half-blind behind his thick glasses; Bertolt Brecht, with his timid smile and his head shaved like a prisoner; Ilya Ehrenburg and his lion's mane; Heinrich Mann, looking like a peaceful bourgeois; Anna Seghers, with her dreamy eyes. And Boris Pasternak, whom no one yet knew, since his poems had not been translated, and who at the Congress had this to say about poetry: "It will always be in the grass, it will always be necessary to bend over to see it, it will always be too simple to be discussed in assemblies. It will always remain the organic function of a happy being, overflowing with all the felicity of language, lying contracted in the native heart ever heavy with its load, and the more happy men there are, the easier it will be to be an artist." The photograph I took of Pasternak on that occasion shows him young and smiling, like his

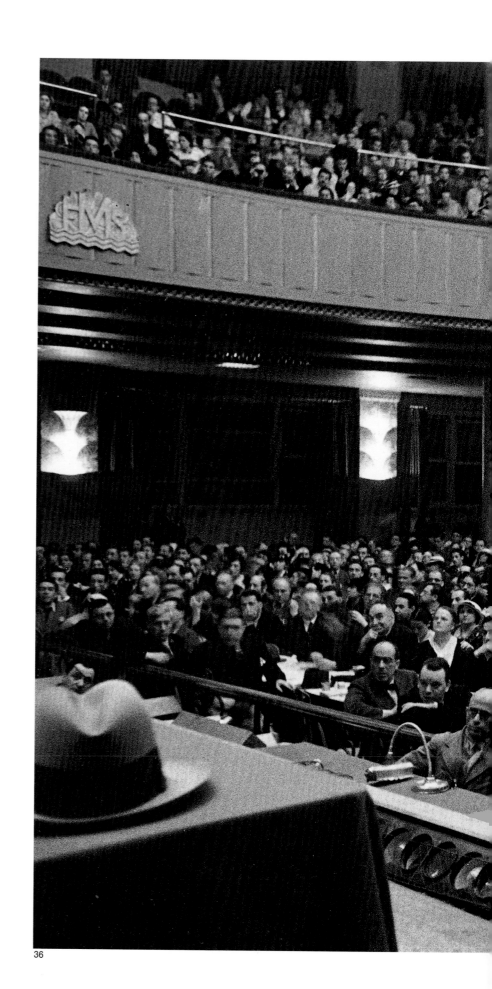

36. Congress for the Defense of Culture, hall
of the Mutualité, Paris, 1935

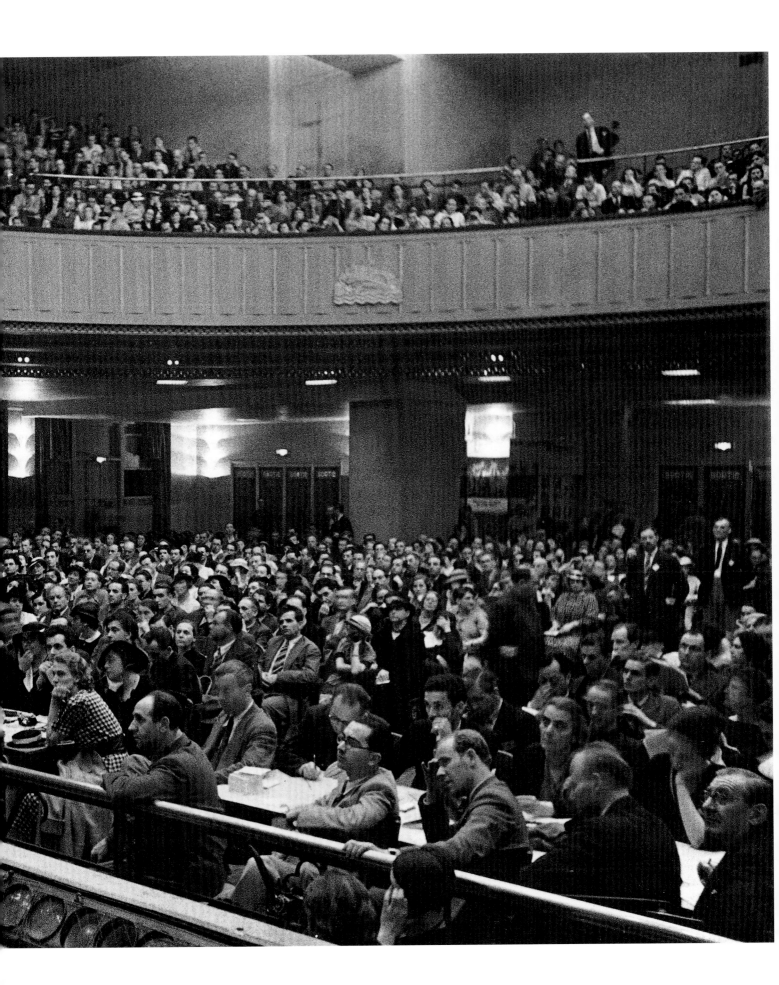

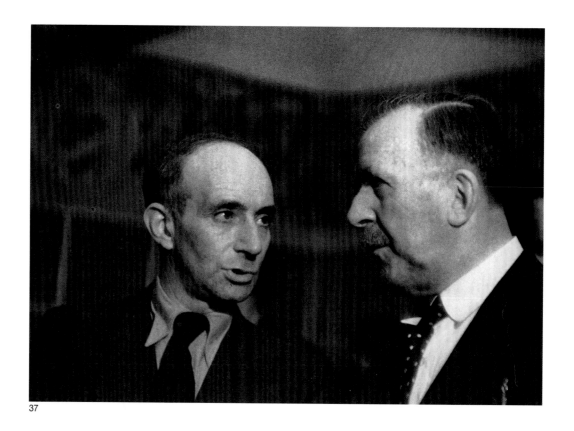

37

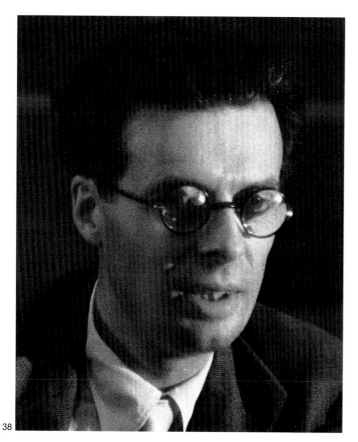

38

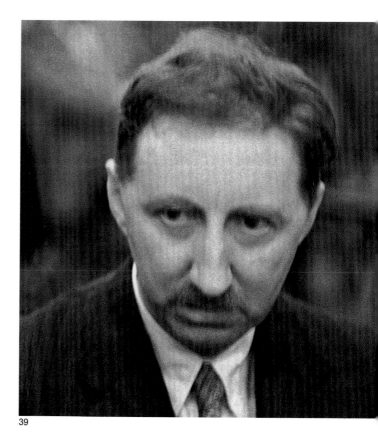

39

37. Jean-Richard Bloch and Heinrich Mann,
    1935

38. Aldous Huxley, Paris, 1935

39. E. M. Forster, Paris, 1935

words. Unlike Gide, he did not bother to find a justification for his individualism. His expansiveness was not owing to a communist society, and was certainly not against it; rather, it was a pure and natural movement. Poetry was his only world.

If a Congress of such importance were to be held today, a hundred photographers would be there to take pictures. In 1935, there were only myself and Chim, who a few years later was to become David Seymour. The hall was dark, but I did not want to work with those magnesium flashes that photographers then used. Film, however, was much less sensitive than today, which explains why a number of negatives were underexposed. They resembled "solarizations," with that surprising effect that makes the photograph look like a drawing.

I thought back on this memorable Congress when I attended the Rencontres Internationales de la Sorbonne on February 12 and 13, 1983. At the instigation of François Mitterrand, close to six hundred artists and intellectuals had been invited from all over the world. Writers, philosophers, painters, composers, scientists, economists, journalists, and others discussed the gravity of the crisis that was beginning to be perceived by public opinion. They tried to shed light on the present relations between culture and economic development, between creation and technological innovation; they analyzed the necessary diversity of cultures and their cross-fertilization. Intellectuals of different races and religions sat side by side in the study halls where the opening discussions took place: between North and South, Arabs and Israelis, blacks and whites. Even for the most skeptical of those present, this dialogue between adversaries conveyed an emotion that was perceptible not only in the tone of the debates, but in informal meetings and in the often lyrical flights of the speeches as well. And on the second day, when two thousand people crowded into the great hall, the calm and cordial atmosphere was truly extraordinary. Was culture perhaps capable of resolving the most difficult problems of our period, as Keynes had wondered decades before.

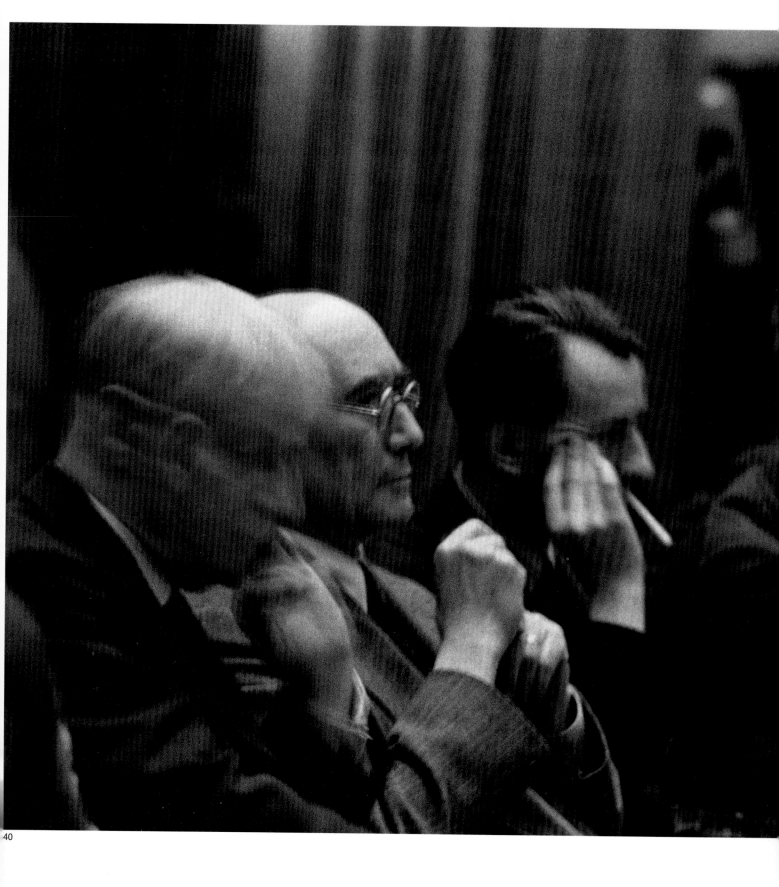

40. (Left to right) Julien Benda, André Gide, André Malraux, Paris, 1935

41. Anna Seghers, Paris, 1935

42. Ilya Ehrenburg, Paris, 1935

43. (Left to right) Henri Barbusse, Alexey Tolstoy, unidentified, Boris Pasternak, Paris, 1935

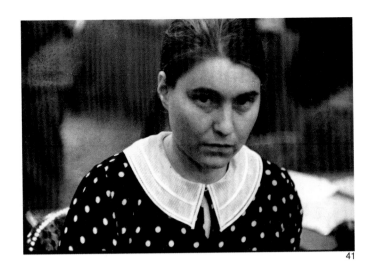

41

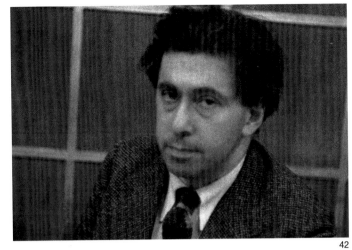

42

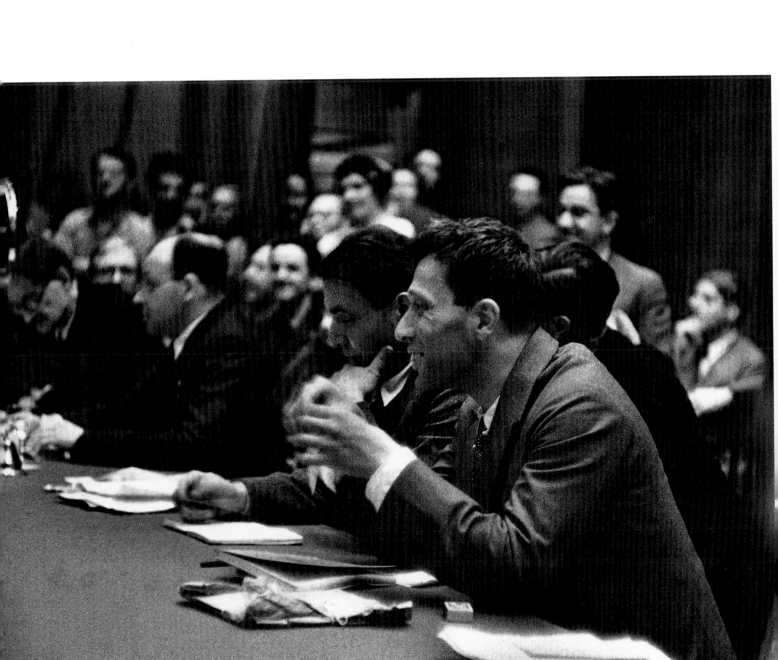

43

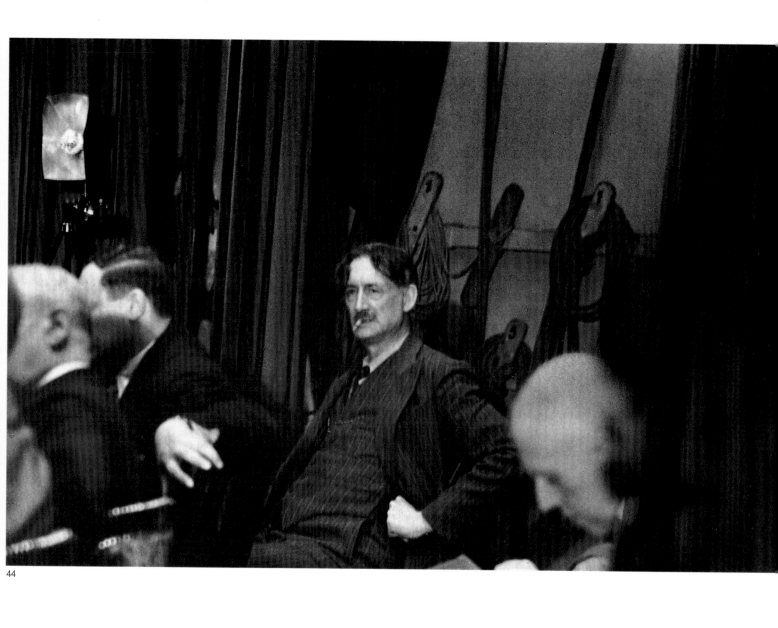

44

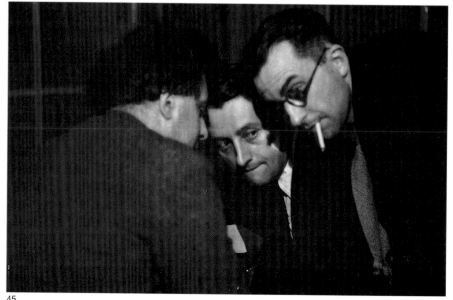

44. Henri Barbusse, Paris, 1935

45. Ilya Ehrenburg, André Malraux, Paul
    Nizan, Paris, 1935

45

46. (Left to right, at table) Paul Nizan, Henri Barbusse, Alexey Tolstoy, Paris, 1935

47. Bertolt Brecht, Paris, 1935

48. Julien Benda, André Gide, André Malraux, Paris, 1935

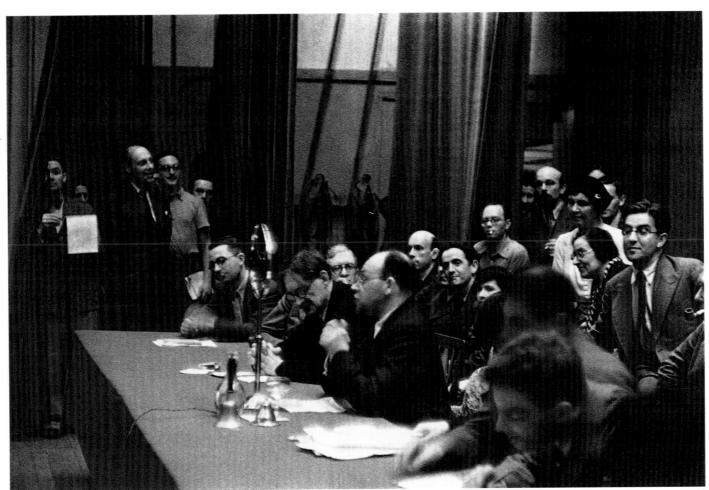

46

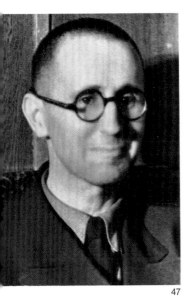

47

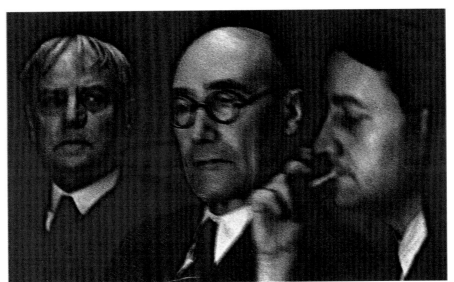

48

# England

"Distressed areas" is what the English called the northern regions of their country in the 1930s. The huge naval shipyards of Newcastle-upon-Tyne and Jarrow, and the coal mines of the Bishop Auckland and Cumberland districts, cradle of capitalism in the nineteenth century, were abandoned because these enterprises were obsolete and could no longer compete with more modern facilities. The owners decided to shut them down, leaving a whole population without work. The unemployed, numbering two million, lived with their families in the greatest poverty. *Life* magazine asked me to do a photoreportage on these areas.

It was at this time that the Wallis Simpson scandal broke out. King Edward had fallen in love with Mrs. Simpson, an American divorcée, and wanted to marry her. Still steeped in Victorian morality, the British press published violent articles against this American woman. The scandal was such that the king decided to abdicate. *Life* published a long article on Mrs. Simpson, along with pictures showing the wealth and elegance of the British aristocracy. In the middle of this article they inserted my photographs showing the misery of that population in the north. It was liberal America's way of revenging itself on British hypocrisy. I had not been told how my pictures were going to be used.

49. Abandoned factory, northern England, 1936

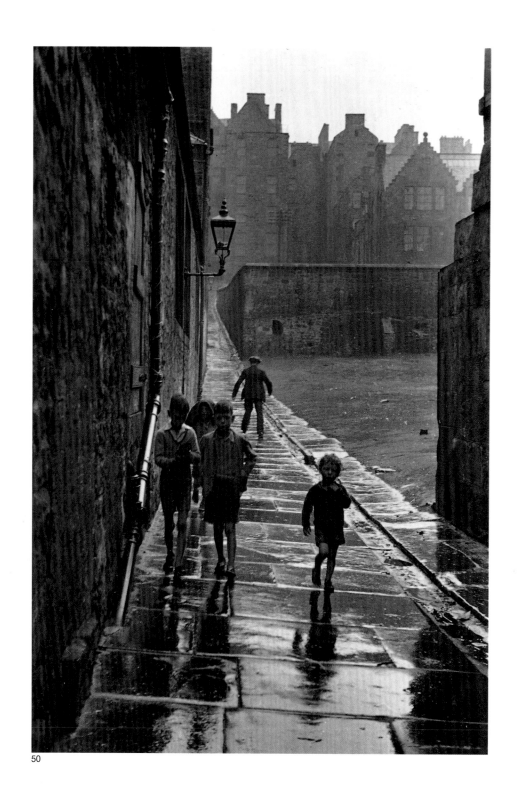

50

50. Street in Newcastle-upon-Tyne, England,
    1936

51. Unemployed worker with his family,
    England, 1936

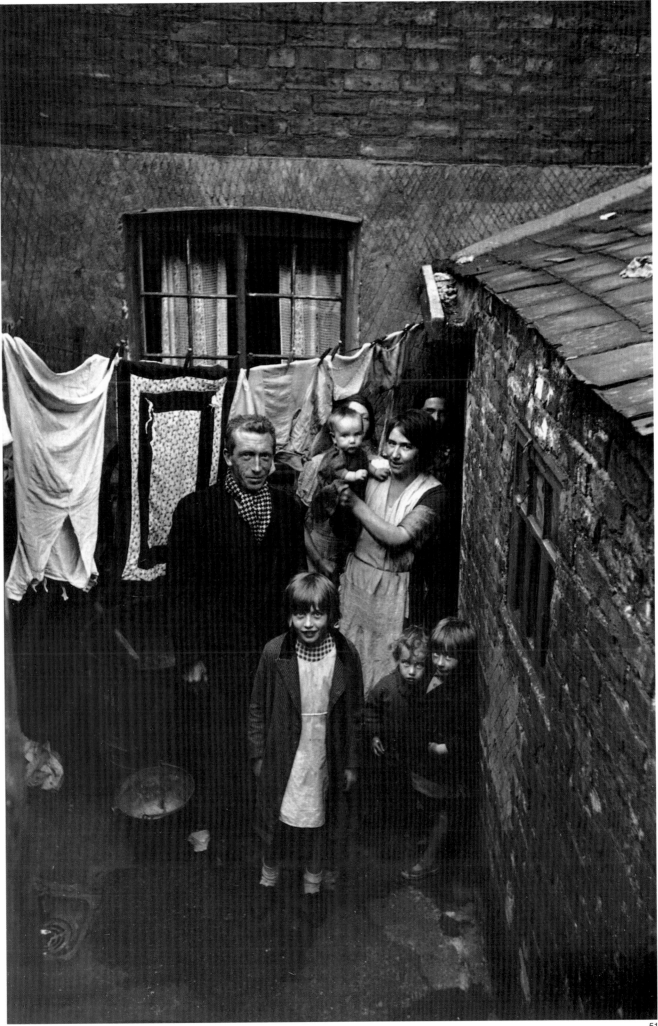

52. Street in England, 1936

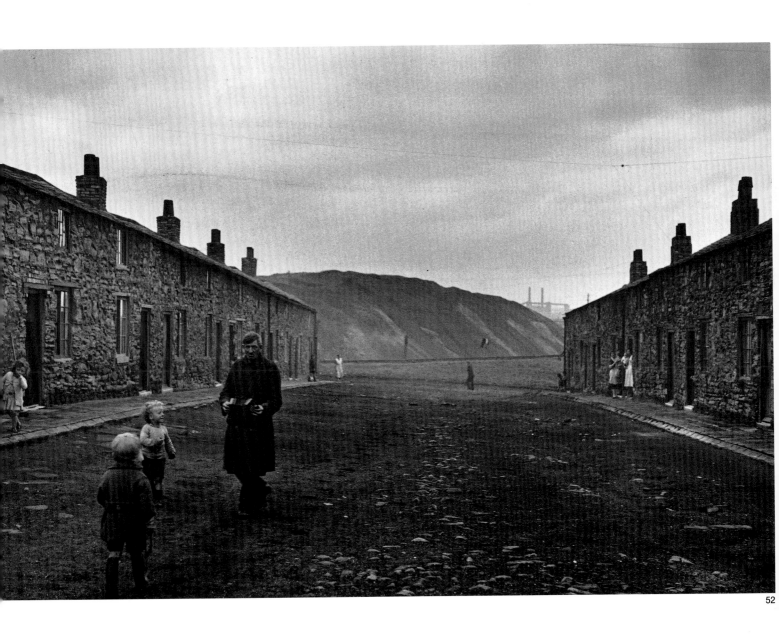

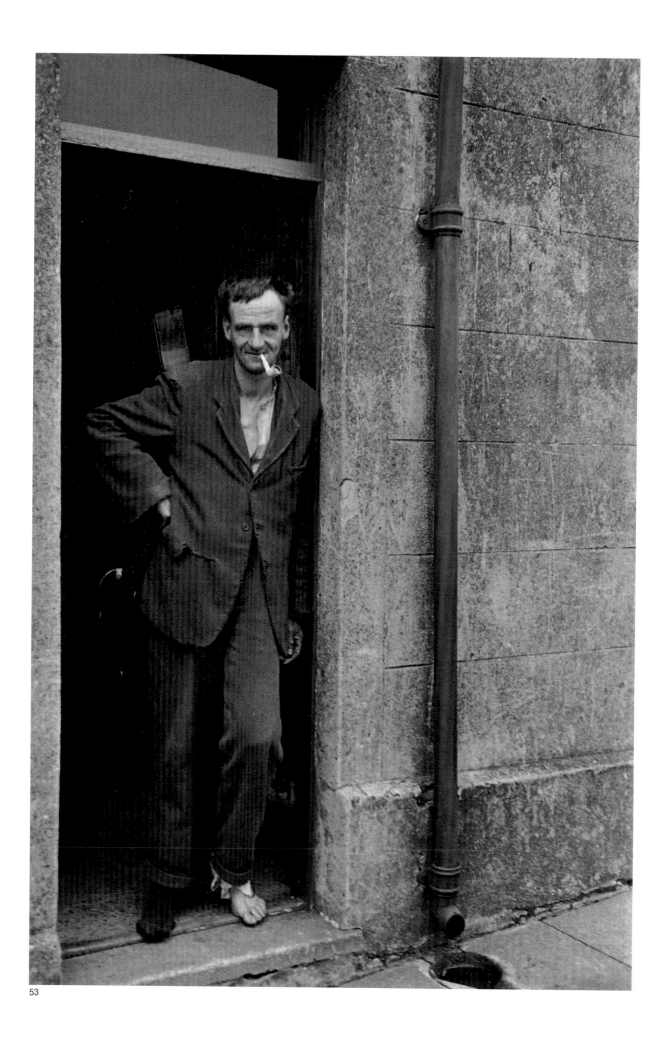

53

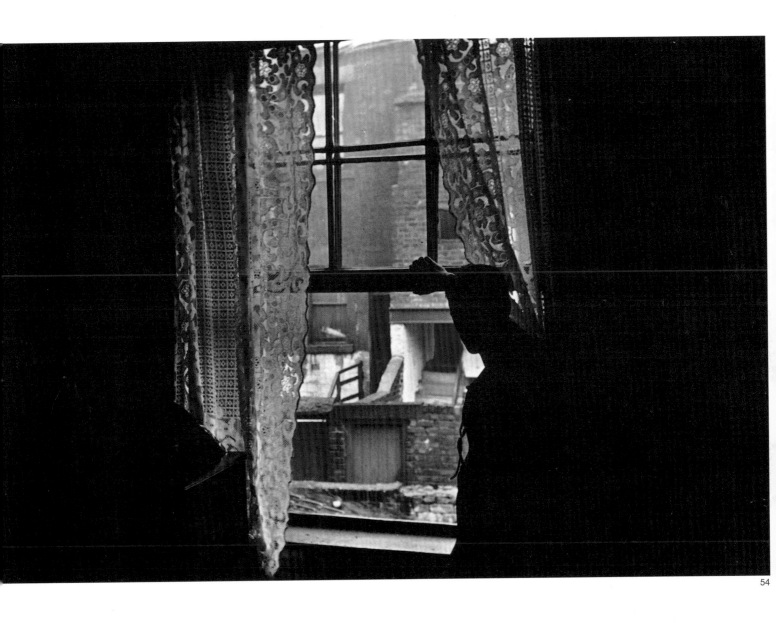

53. Unemployed worker, England, 1936

54. View from window, England, 1936

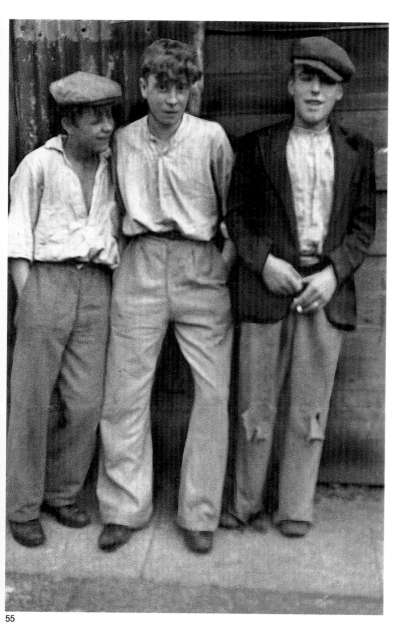

55

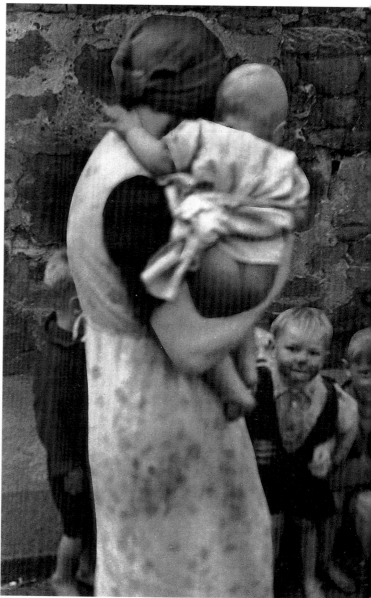

56

54

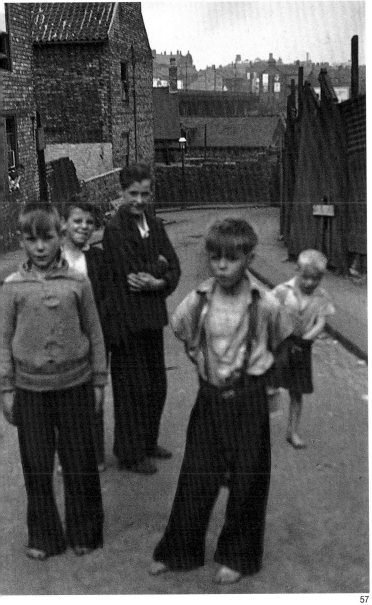

57

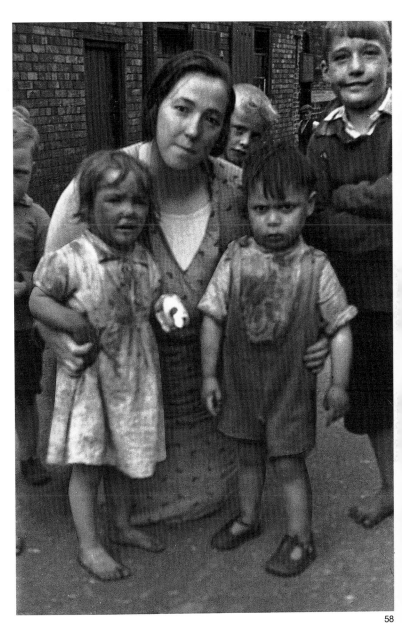

58

55. Unemployed youths, England, 1936

56. Unemployed worker's wife and baby,
England, 1936

57/58. Unemployed worker's children, England,
1936

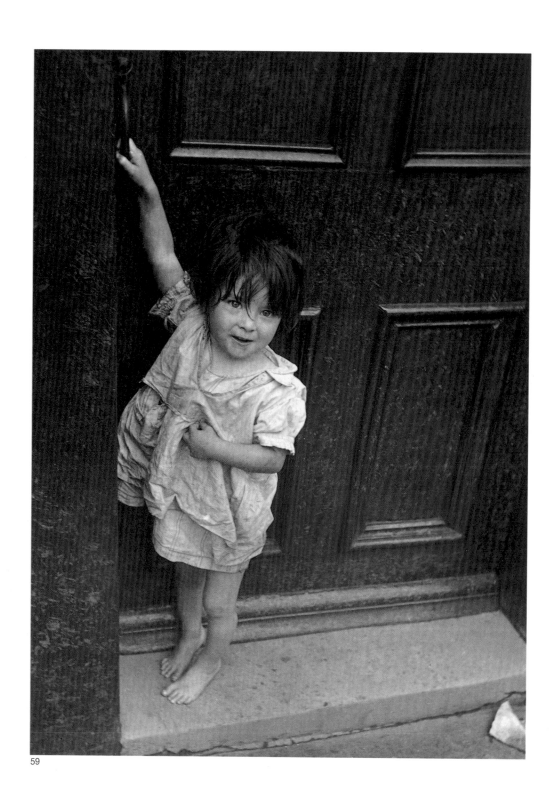

59

59. Unemployed worker's young child,
England, 1936

60. No future for the miners, England, 1936

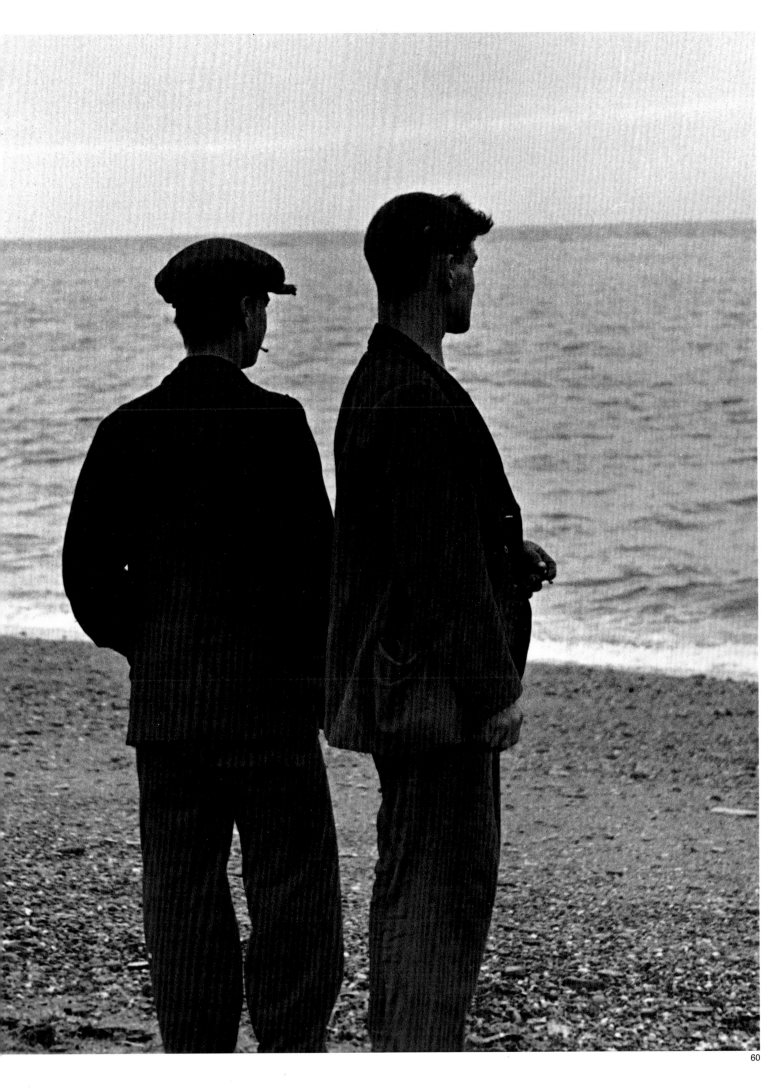

# Portraits

Since the beginning of my career as a photographer, I have been enthusiastic about taking portraits. The enormous series of faces which paraded before me, and which I will never see again, has shown me that no two physiognomies are exactly alike. I would have liked to devote myself to this inexhaustible panorama of the human face, but I would never have been able to earn my living at it without accepting the conventions of the period (which, incidentally, still apply today)—I mean the need for retouching, to beautify the model. If you were able to make your clients resemble movie stars, the type of beauty that was in vogue, success was assured. Photographers who were reluctant to comply had no other choice but to photograph either their friends or else artists and writers, who are always open to new experiences. But since these portraits didn't pay anything, one had to turn to some other branch of the profession, such as photoreportage, to earn one's living. That is what I did, while taking portraits for my own enjoyment.

For a writer, his portrait is the only link he can establish with his readers. When we read a book whose content moves us, we are interested to look at the author's face, which is generally printed on the jacket since the publisher is aware of our wish to see if these features correspond to the idea we have formed of the author. This image is thus very important to the man of letters. He prefers a photographer in whom he can have confidence.

As a child, I grew up surrounded by artists, because my father was a great collector and invited many talented painters to our home. But as an adult, it was literature that attracted me most, and naturally I gravitated toward writers. Many of them had confidence in me, becoming my friends and the favorite subject for my lens.

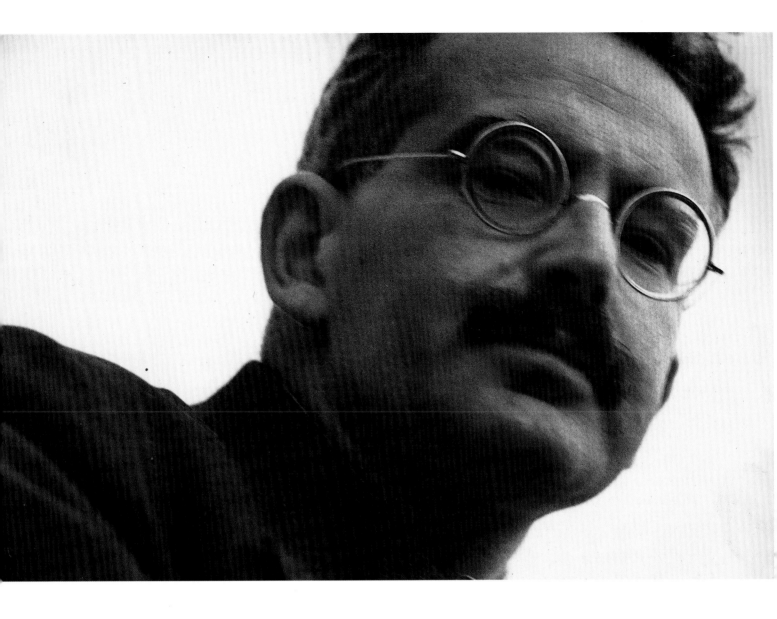

# WALTER BENJAMIN

I met Walter Benjamin for the first time in 1932, in the Balearic Islands. Most likely he did not pay much attention to this twenty-year-old girl who was too timid to speak to him.

In 1934, after the Hitler regime came to power, Benjamin moved to Paris. I was working every day at the Bibliothèque Nationale in order to finish my doctoral thesis, and he was doing research on Baudelaire. We soon became good friends.

Benjamin was of medium height and plump. He had little, pudgy hands. His forehead was high and bulging, his nose slightly aquiline, and his lips very red and full. He wore a small mustache. His hair, brown and naturally wavy, was already getting gray at the temples. He was nearsighted, and his gaze, half hidden behind thick glasses, was extremely lively. When he walked, he moved slowly. Sometimes he complained about his heart; he had trouble climbing stairs.

61. Walter Benjamin, Paris, 1937

62. Walter Benjamin at the Bibliothèque
Nationale, Paris, 1937

63. Walter Benjamin in Pontigny, France,
1938

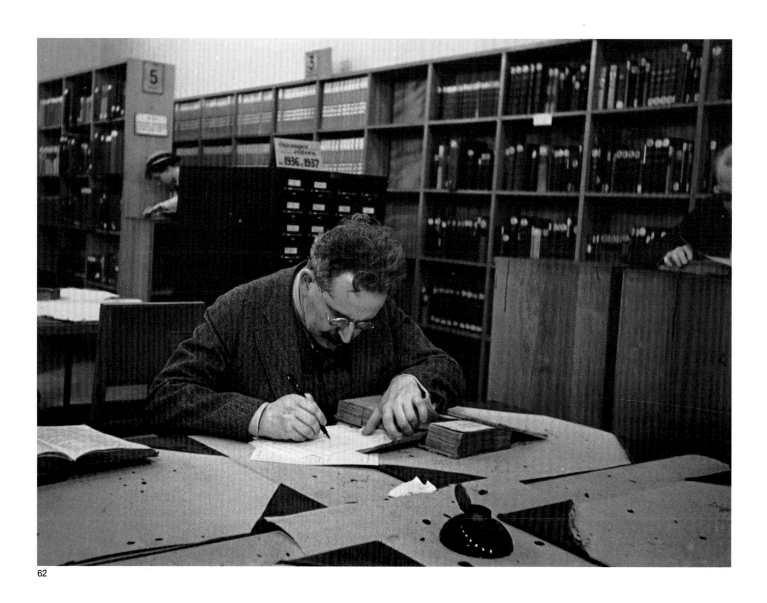

62

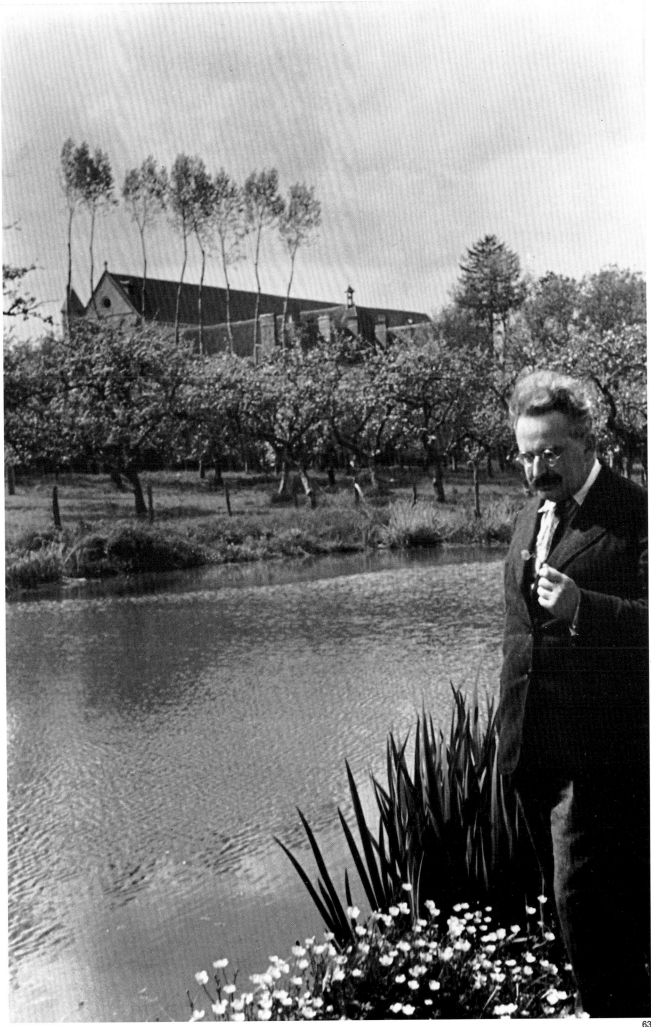

Over the years, I saw him wearing the same dark suit, whose sleeves had become too short from too much wear and tear. He spoke very slowly and always after much thought, and he had a very ceremonious, very German, manner of comporting himself with people. Only once did I see him beside himself, his face red with anger: when he told Hélène Hessel (wife of the writer) and me that his writings for the magazine of the Institute for Social Research (which had moved from Frankfurt to New York via Paris) had been criticized by Adorno, who with Horkheimer ran the Institute. The Institute paid him a small monthly stipend, just barely enough for him to survive in Paris, which was essential for his researches. Thus he could not openly oppose Adorno. It took him weeks of hiding his bitterness before he could answer his critics.

For years we met every day in that huge, silent reading room. Sometimes we went out together and took a walk in the corridor of the Bibliothèque, or crossed the Rue Richelieu and sat on a bench in the Square Louvois. Benjamin lit his pipe and we would converse on a variety of subjects: the political situation, Marxism, contemporary writers…

When the Bibliothèque closed, we often left the reading room together. We would cross the Tuileries and walk along the quays of the Seine. Benjamin always stopped in front of the bookstalls and sometimes bought a book.

He occupied a single room in the apartment of a psychiatrist friend, who sublet it to him. Koestler lived in the same house, but Benjamin had no contact with him. During one of my visits to his place, he showed me several printed kerchiefs from the period of the French Revolution. He had the soul of a collector and was especially interested in children's books. After I had shown him a very rare original edition of Brentano's *Gockel, Hinkel und Gakeleia*, illustrated with a large number of magnificent engravings, he insisted for weeks on having it—it was the only book I had been able to save from my father's library—and I finally made him a present of it. Twice a week we used to meet on the upper floor of a café on the Boulevard Saint-Germain to play chess. For the price of a small black coffee you could sit there for hours. Benjamin always got angry when he lost a game.

Between the two wars, Benjamin had paid frequent visits to Paris. He had interviewed Gide, Valéry, and many other writers and was the first to spread their fame in Germany. Now here he was a poor refugee who would have liked to contribute to French literary periodicals. He was very disappointed by the hesitant attitude of certain writers—Gide, for example—but was too proud to ask for help and explain his almost desperate financial situation.

When I told Adrienne Monnier that Benjamin was living in Paris, she immediately invited him to dinner. She had known and admired him during the twenties. He became a regular visitor to the Rue de l'Odéon and had long conversations with Adrienne. When I asked her, shortly before her death in 1955, what writer she would consider closest to her spiritually, Adrienne—who had counted among her friends the most illustrious minds of the period—replied, "Walter Benjamin."

64. Walter Benjamin, Paris, 1938

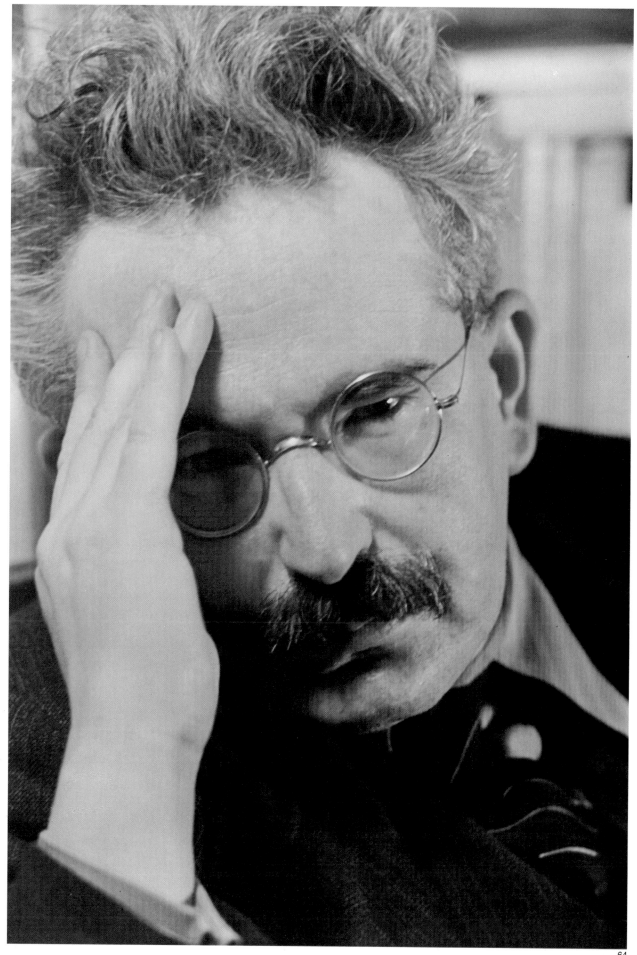

# ADRIENNE MONNIER

In the 1930s, the Rue de l'Odéon still had a provincial look. Not many automobiles passed along that Parisian street between the Théâtre de France and the Boulevard Saint-Germain, a stone's throw from the Luxembourg Gardens. Its shops included two bookstores, one at number 7 and the other, almost directly across the street, at number 12. The first was called La Maison des Amis des Livres and belonged to a plump little woman who was always dressed in gray; when she went out on an errand, her neighbors recognized her by her full-length cape of the same color: she was Adrienne Monnier. The other bookstore, called Shakespeare and Company, belonged to Sylvia Beach, who was tall, slender, and sportive-looking and always wore tailored suits. Both bookstores were also lending libraries.

These two booksellers were great friends. Adrienne specialized in contemporary French literature, Sylvia in English-language literature. Both of them made literary history.

Sylvia Beach became well known for being the first to publish James Joyce's novel *Ulysses*, at a time when the book was still banned for obscenity in England and the United States. No regular publisher had dared to bring it out. Today Joyce is considered the most important writer of the twentieth century; his stream-of-consciousness technique has influenced generations of writers.

Adrienne Monnier had published a literary magazine, *Le Navire d'Argent*, in which she presented the works of young and totally unknown writers, some of whom count today among the most important of the time. Having an avant-garde magazine printed is a costly enterprise, since it does not sell very well. Adrienne did not have the means to go on with it for long. After the twelfth issue she had to suspend publication and sell her valuable personal library of signed first editions in order to pay the printer. Her great distinction lay in never having been mistaken about the literary quality of anyone she had published or recommended.

One of her friends was the poet Léon-Paul Fargue. Every day he took a walk to the Rue de l'Odéon, where he would meet young writers who had entrusted their manuscripts to Adrienne, and he would listen to her judgment. Then he would rush off to the publisher Gaston Gallimard to tell him about these meetings, and Gallimard hastened to publish those manuscripts that had been praised by Adrienne Monnier. One day Adrienne, becoming aware of these circumstances and also of the gossip that Fargue was spreading about her and her friends, forbade him ever to set foot in her bookstore again. It was only in 1938, when I asked the poet to pose for me, an idea he accepted with alacrity, that he came back to the Rue de l'Odéon.

The day in 1935 when I first met Adrienne Monnier and Sylvia Beach I could hardly have known that my visits to their two bookstores would have a great influence on my destiny. It was thanks to them that a few years later I was able to photograph most of their friends, little known at that time but famous today.

Adrienne, who came from a modest background, confessed to me one day that she had become a bookseller in order to read the books she had been unable to buy for herself. She would have liked to write, but the bookstore took up her whole day and brought her just enough money to live on. She contributed to magazines and newspapers by writing book reviews and essays—for example, for the column "L'Air du mois" in the *Nouvelle Revue Française*. In 1923 she had even published a short book under the imprint of her bookstore. The author, Sollier, was unknown. The stories were much talked about in literary circles and people wondered who was hiding under this name. When it was

65. Adrienne Monnier, Paris, 1938

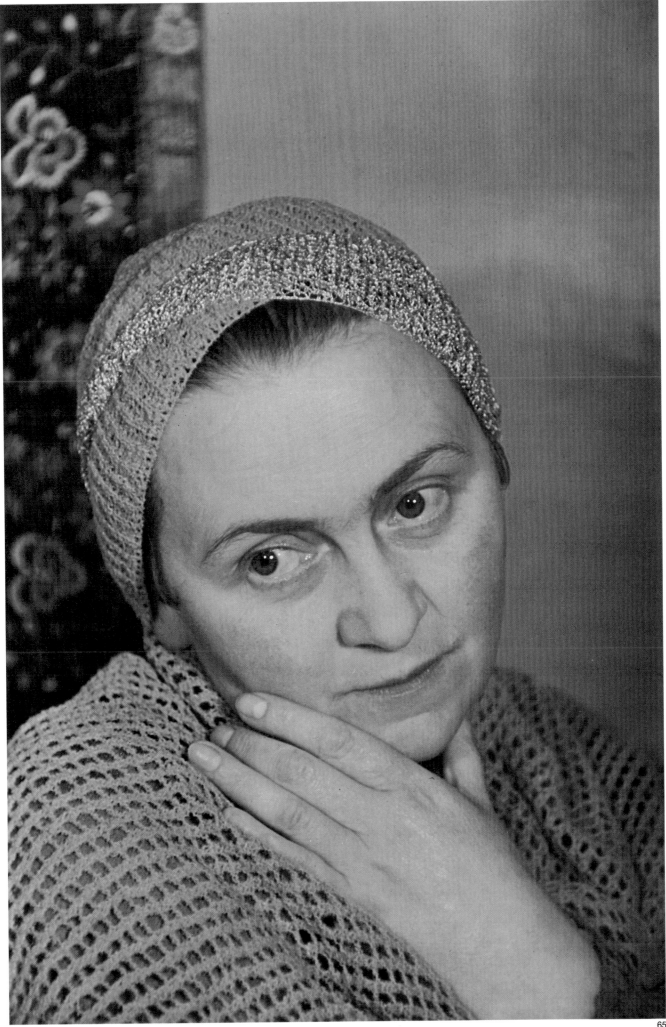

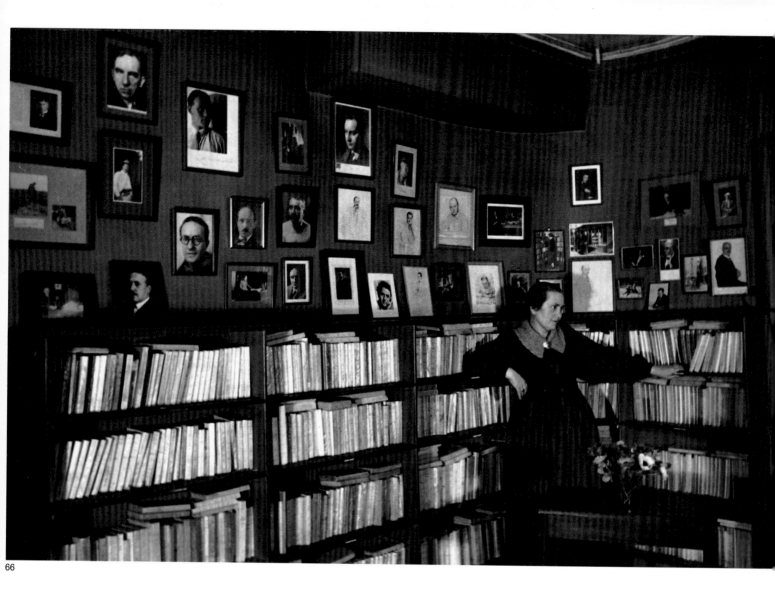

66

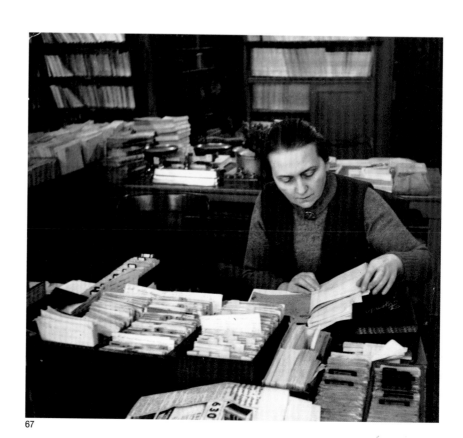

68

67

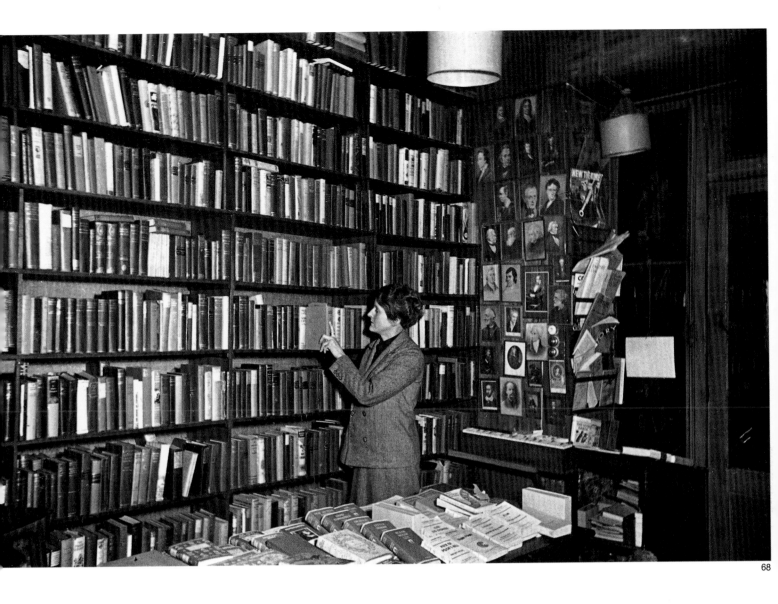

learned that the author was Adrienne Monnier herself, all voices fell silent and people stopped talking about it. As far as publishers and writers were concerned, she was much more useful as a bookseller than as a rival.

Adrienne felt some bitterness on this score, but a woman's role in the thirties was still to serve men. To be a woman and a bookseller in her time was already an exceptional adventure. Some of her women friends, who had been students toward the end of the twenties, told me that they had gone in great secret to Adrienne's bookstore because their families would never have openly accepted it.

Two volumes of her writings have been published: *Les Gazettes d'Adrienne Monnier, 1925–1945*, edited by René Julliard, and *Rue de l'Odéon*, published in 1960 by Albin Michel. This latter volume has been republished this year. These articles, tales, and essays reflect her profoundly intelligent mind and are an extraordinary living testimony on the writers and artists of her time.

I hope that someone someday will write her biography, for Adrienne Monnier was one of the most engaging figures on the literary scene in the first half of the twentieth century.

66. Adrienne Monnier in her bookstore, La Maison des Amis des Livres, Paris, c. 1936

67. Adrienne Monnier at her work table, Paris, c. 1936

68. Sylvia Beach in her bookstore, Shakespeare and Company, Paris, 1936

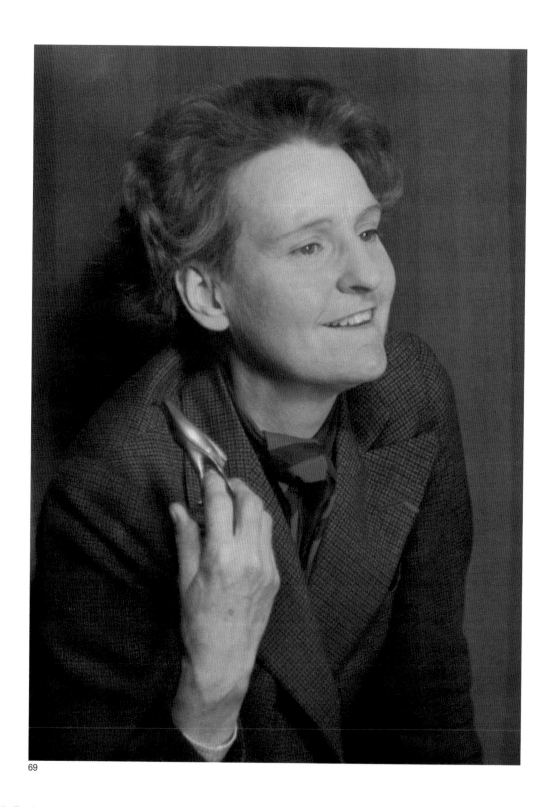

69

69. Sylvia Beach, Paris, 1939

70. Sylvia Beach, Adrienne Monnier, and a
    customer in front of Shakespeare and
    Company, 12 Rue de l'Odéon, Paris, 1938

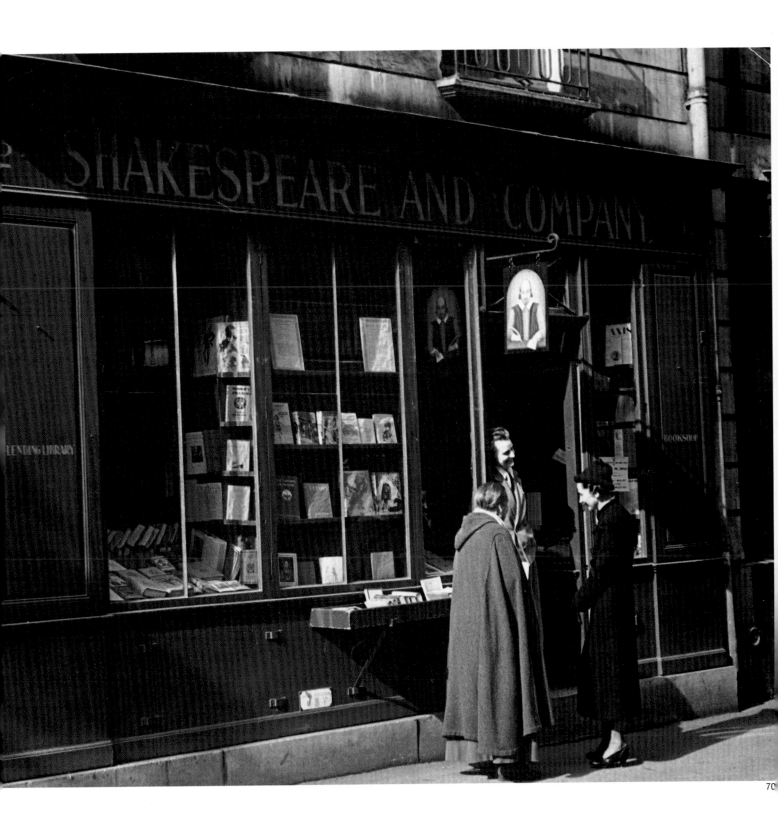

# *MESURES*

*Mesures* was a literary magazine founded in 1935 by Henry Church, an American writer who wrote in French. He was the literary editor of this highbrow review, along with Jean Paulhan, Bernard Groethuysen, Henri Michaux, and Giuseppe Ungaretti. Adrienne Monnier was the business manager. She was to remain so until 1937, when she gave up the job in order to devote herself to her own little magazine, *La Gazette des Amis des Livres*.

This photograph was taken during a meeting of the editorial staff in 1937, in the garden of Henry Church's house, built by Le Corbusier, in Ville d'Avray, a suburb of Paris. *Mesures* disappeared, like so many other reviews, at the beginning of the war in 1939.

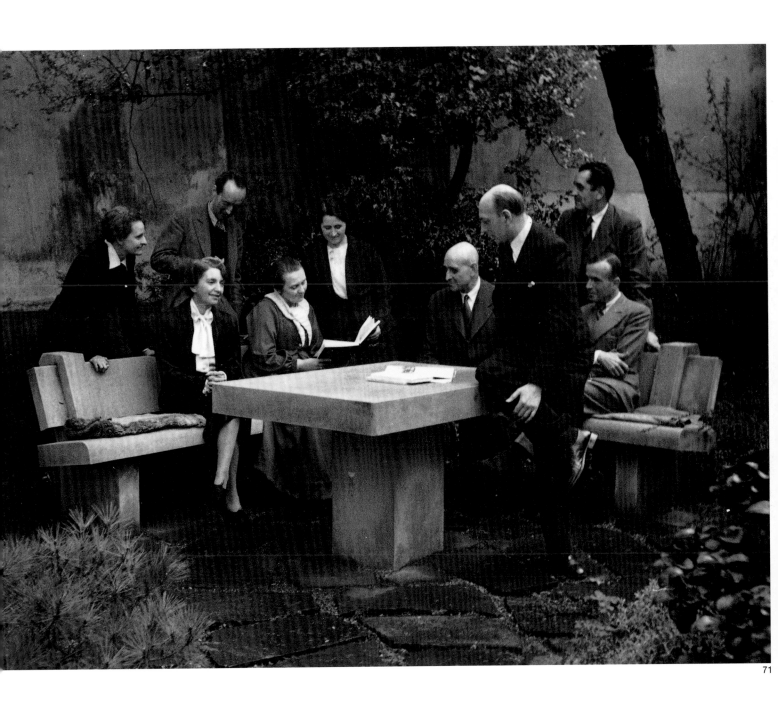

71. The editorial staff of the magazine
*Mesures* in Ville d'Avray, 1937

# PAUL VALÉRY

He was sixty-seven when I photographed him, at home in his study. He was considered at the time the most important French poet and thinker of his generation, and also the most official. He was said to have brought the poetry of Mallarmé to its perfection.

In 1919, the first reading organized by Adrienne Monnier in her bookstore was devoted to him. Portions of *La jeune Parque* and *La Soirée avec M. Teste*, two of his most famous works, were read for the first time in public.

He died in 1945 and was given a State funeral.

He was also the first writer to use a typewriter, because he could no longer decipher his own handwriting.

"Between the lamp and the sun, a pure and profound hour, I write what creates itself."

72

72. Paul Valéry, Georges Duhamel, and Marcel Bouteron in the lobby of the Institut de France, Paris, 1940

73. Paul Valéry in his study, Paris, 1938

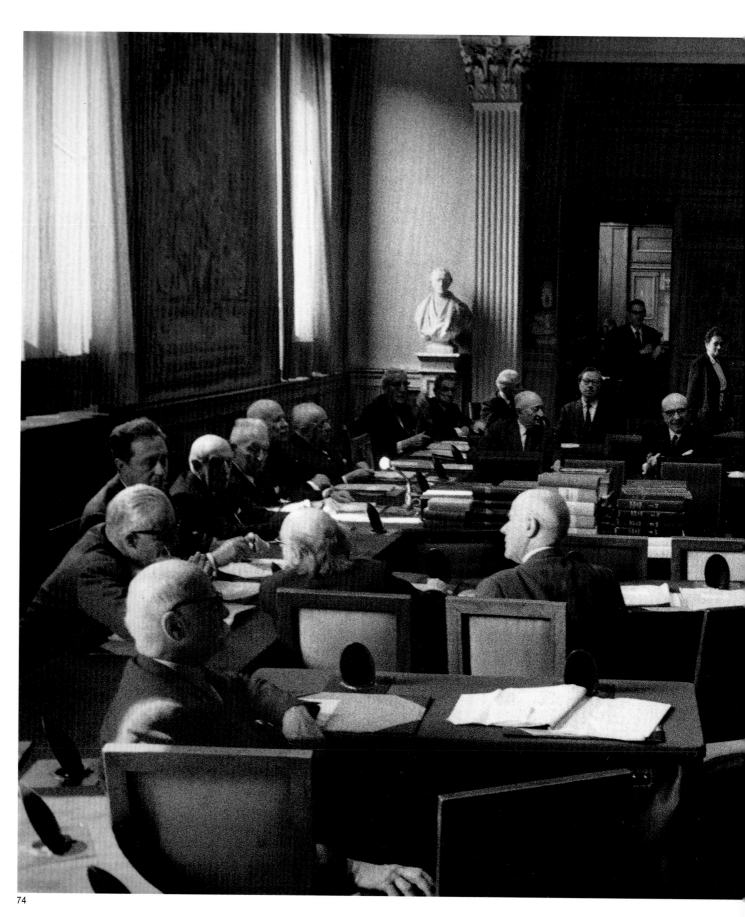

74

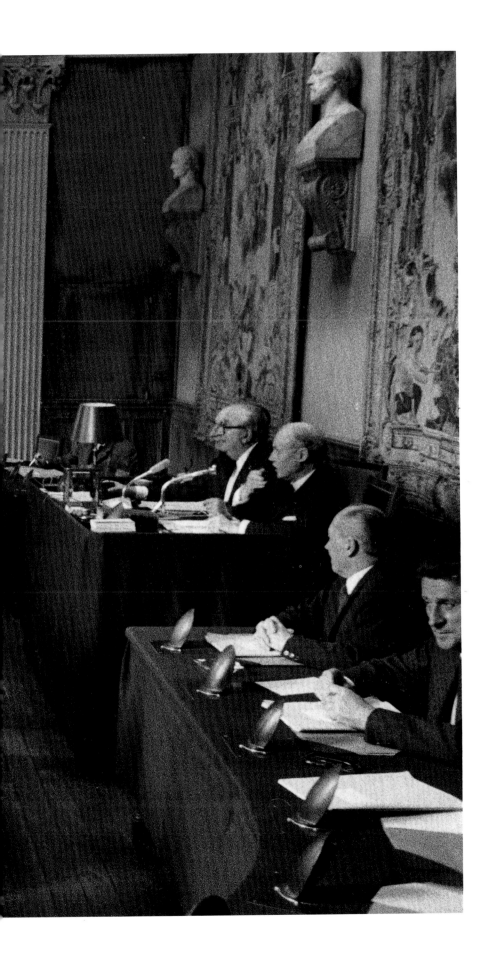

74. The Académie Française in 1940. The only
time that the "Immortals" have allowed
themselves to be photographed during a
dictionary session

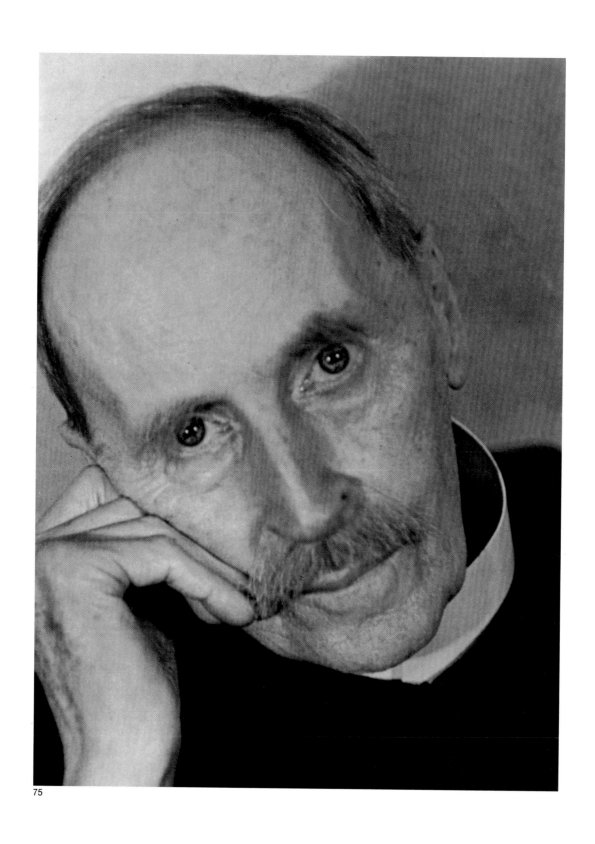

75

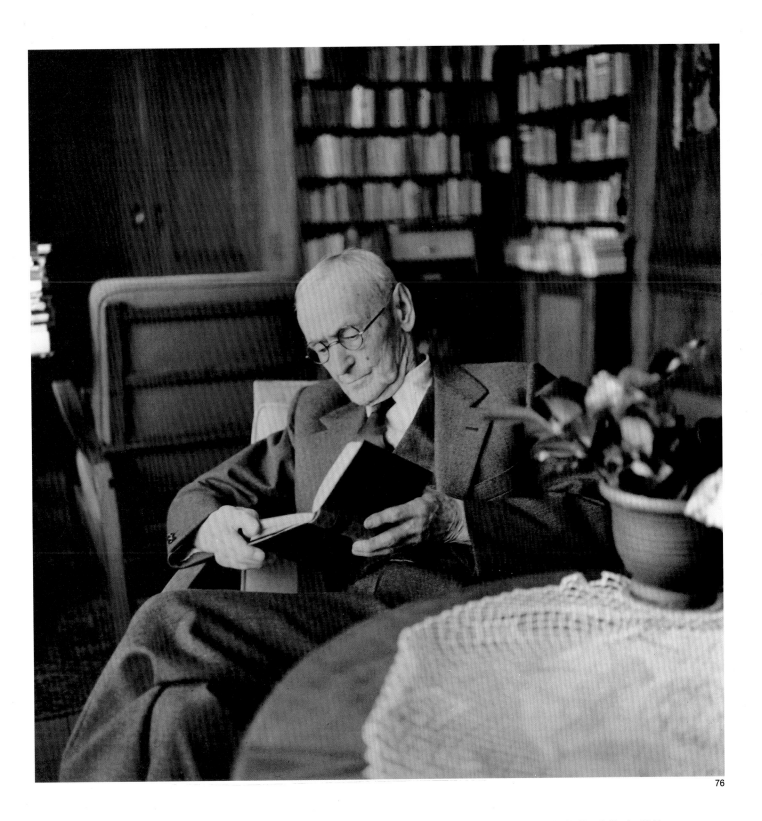

76

75. Romain Rolland, Paris, 1940

76. Hermann Hesse in Montagnola, early
1950s

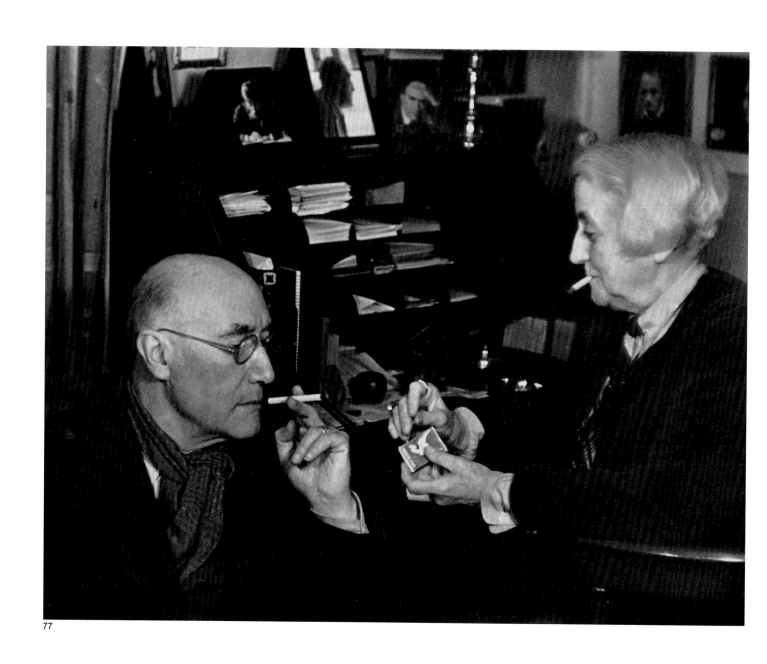

77

77. André Gide with "la petite Dame"
 (Mme. Théo van Rysselberghe)

78. André Gide under the mask of Leopardi,
 in his home, Rue Vanneau, Paris, 1939

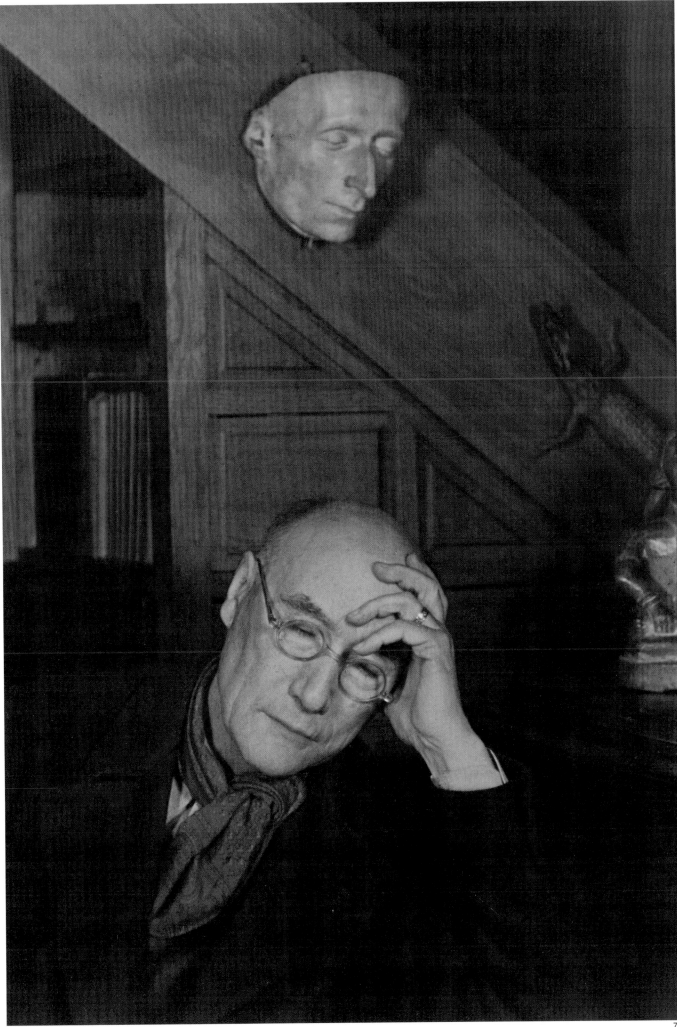

79. Garden party at Gallimard's, Paris, 1967

80. Jean Paulhan, editor of the *Nouvelle Revue Française*, Paris, 1947

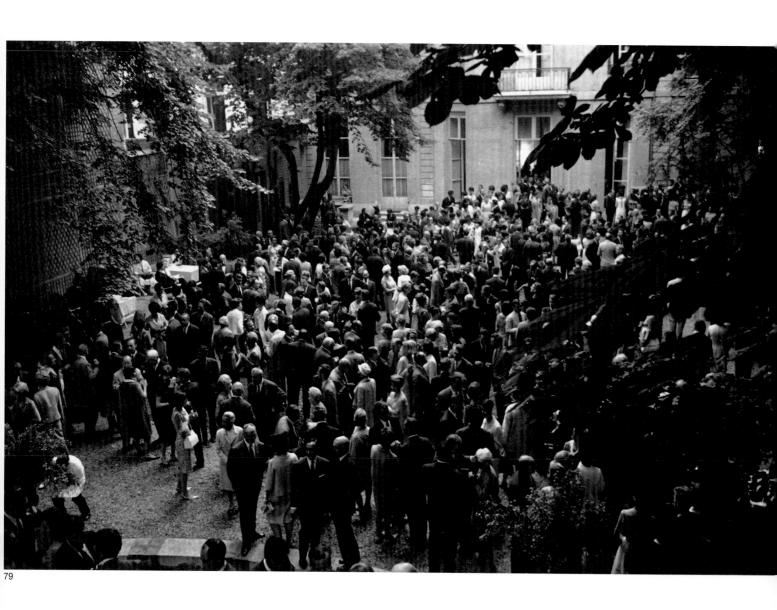

79

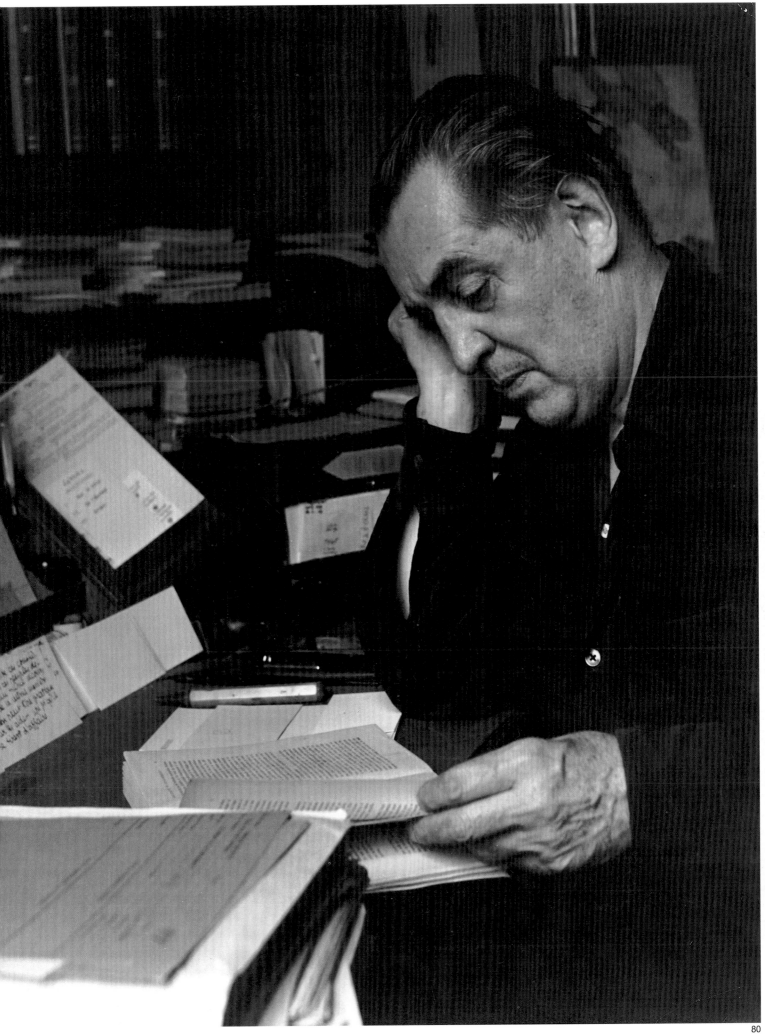

# COLETTE

Colette did not care about looking beautiful in her photographs. I think that above all she wanted to fascinate. With her sharp gaze and contrived gestures, she was a born actress who loved the camera and understood its demands.

She preferred to work lying down because, already in 1939, she suffered a good deal from arthritis in her feet. She knew all the secrets of makeup, having been an actress and having also owned a cosmetics shop. You can't tell her age from my photograph, but she was already over sixty.

I had to promise her that no one would see these pictures before she did, and that she would decide whether they could be published.

When she came to my place to see a projection of these color photographs, she was accompanied by a young man.

"Stay outside," she told him.

We studied the pictures by ourselves, and I was a little nervous waiting for her verdict. Finally her face lightened in a smile. She opened the door with an imperious gesture.

"Come in, Maurice, you can look."

Maurice was her new husband.

81. Colette, Paris, 1939

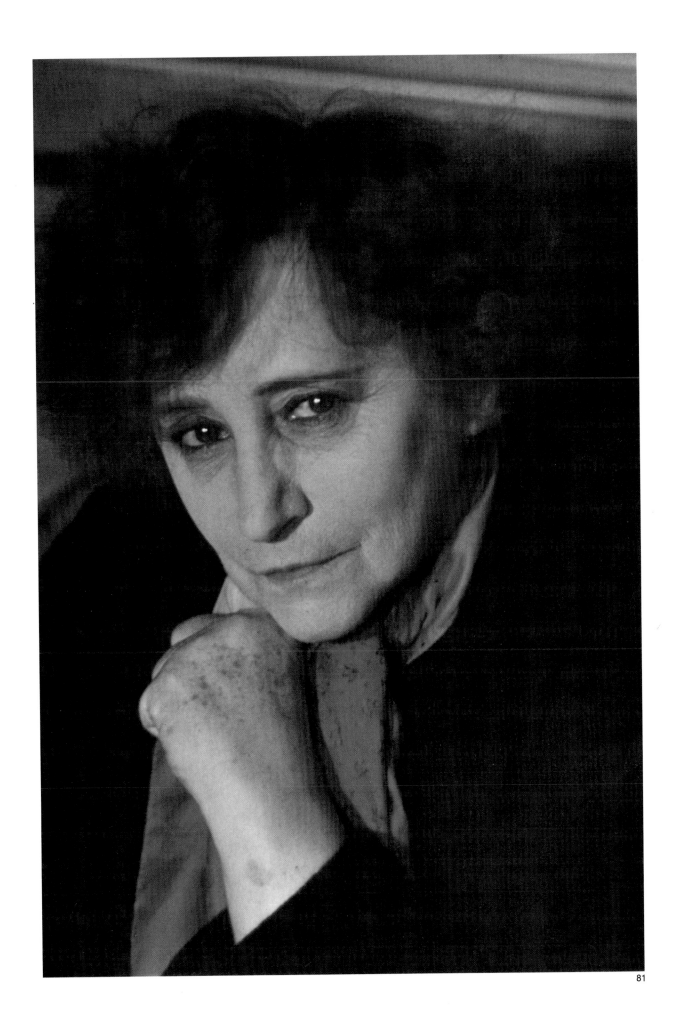

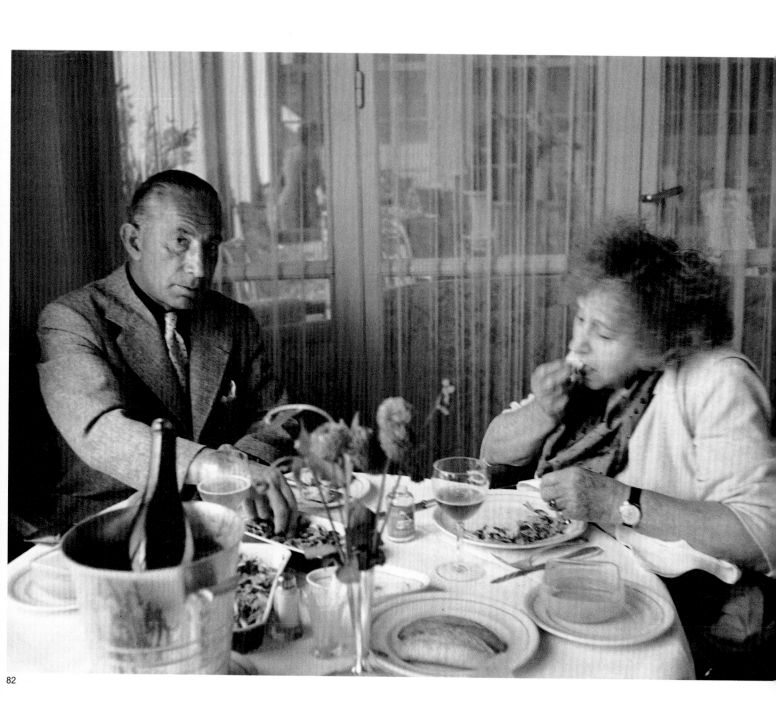

82

82. Colette with her husband, Maurice
Goudeket, in Deauville, 1954

83. Colette working in bed, Paris, 1939

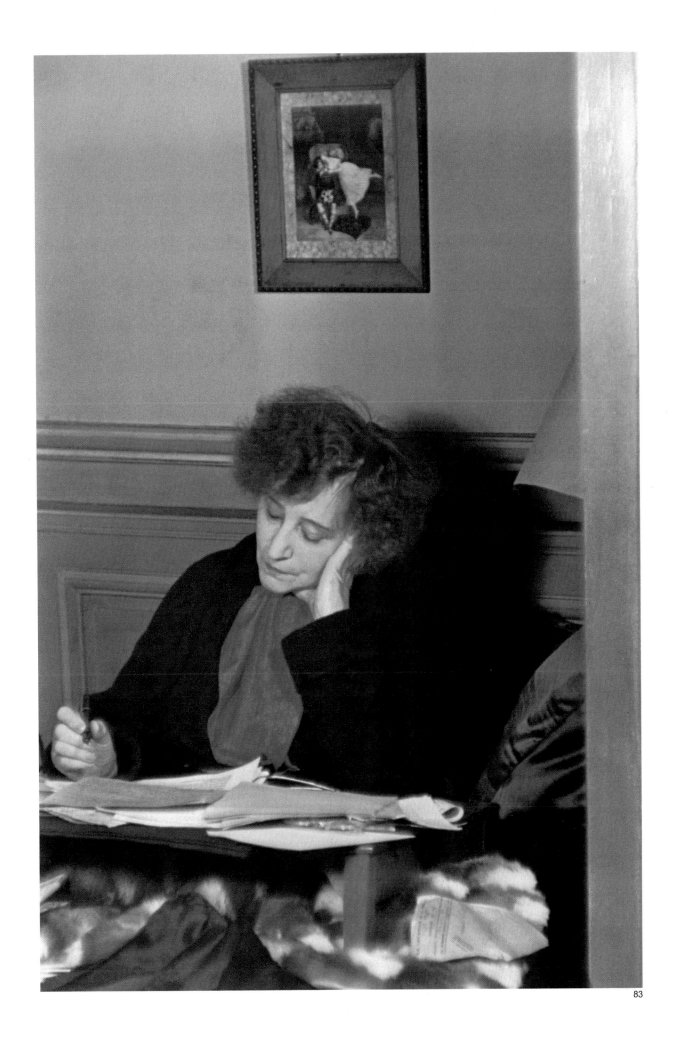

83

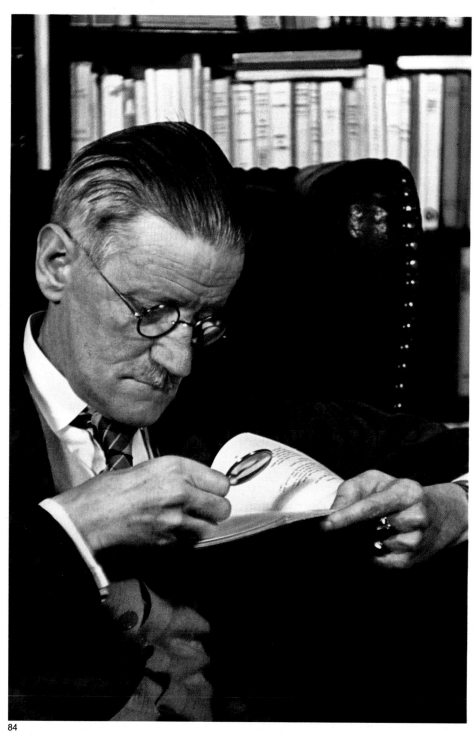

84

# JAMES JOYCE

Joyce was a very superstitious man. It was owing to this that I was able to photograph him in color. In 1938, I had been commissioned by *Life* to do a photoreportage on him in black and white. It has appeared for his centenary in a little book under the title *Trois jours avec Joyce*, published by Denoël in France, then in Germany by Suhrkamp Verlag, and finally in 1985 in America by Persea in New York.

Joyce suffered all his life from poor eyesight, and the idea of having to expose himself to a strong light, as was still necessary in 1939 if you wanted to photograph someone in his home, seemed impossible.

"My eyes won't stand a strong light…"

Meanwhile *Time* magazine had commissioned me to take this picture of him in color for one of its covers. What was I to do?

Joyce was indeed very superstitious. Sylvia Beach knew it and advised me to write to him under my husband's name, which happened to be the same as one of the characters in *Ulysses*.

I followed her advice and immediately received a reply from Joyce, who agreed to pose for me once more, even in color.

When I arrived, with all my lighting equipment, at the Rue Edmond Valentin, where Joyce was living at that time, he was not happy about it. His nervousness transmitted itself to me, but finally everything was ready. Joyce got up in order to sit on a chair that I had placed for him. In groping his way across the room—I should add that Joyce was very tall—he bumped his head into a lamp that hung from the ceiling and he let out a cry:

"I'm wounded, you're trying to kill me!"

And he dropped into the chair I had set for him. His wife, Nora, was in the next room.

"Lend me a pair of scissors," I asked her, remembering my childhood and how they had comforted me in similar circumstances. I pressed the cold metal to the writer's forehead at the almost imperceptible spot where he had touched the lamp.

Joyce, having calmed down, posed while reading a book with his special eyeglasses and also with the help of a magnifying glass.

Then I left in a hurry because they were already waiting for me at the laboratory; the photos had to be sent off to America as quickly as possible. But my taxi, trying to go too fast, collided with another car. The windows were broken, the camera fell out of my hands, and I arrived home in tears.

I immediately telephoned Joyce and said to him, "Mister Joyce, you're the one who's trying to kill *me*! I'm almost dead, my taxi had an accident, and the pictures are ruined. Are you satisfied? You've put a hex on me!"

Joyce sighed. Then he said, "Come back tomorrow."

So I'd been right.

Next day everything went fine. It took me very little time.

When the films were developed, I discovered to my great surprise that the ones from the first sitting had not been damaged after all. I thus had two series of color photographs of Joyce.

When Joyce saw the picture on the cover of *Time*, he was very pleased. He told his friends:

"Gisèle is stronger than the Irish. I didn't want to be photographed in color, but she took possession of me, not once but twice!"

84. James Joyce with magnifying glass, Paris, 1939

85/86. James Joyce with taxi in the Rue de l'Odéon, 1938

85

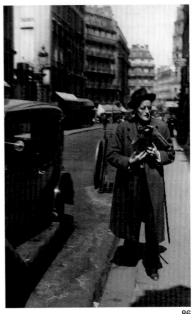

86

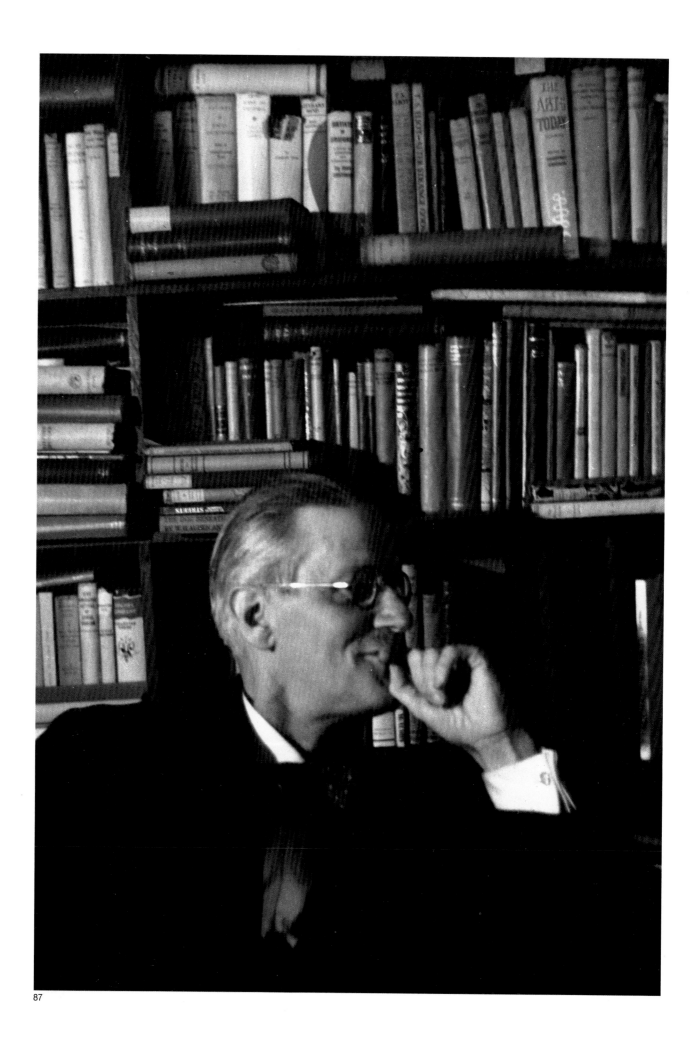

87

87. James Joyce in the bookstore Shakespeare and Company, Paris, 1938

88. Page proof of *Finnegans Wake*, Collection Maria Jolas

89. James Joyce with Adrienne Monnier and Sylvia Beach, the two publishers of *Ulysses*, in Shakespeare and Company, Paris, 1938. Adrienne Monnier had published the French translation of *Ulysses* in 1929

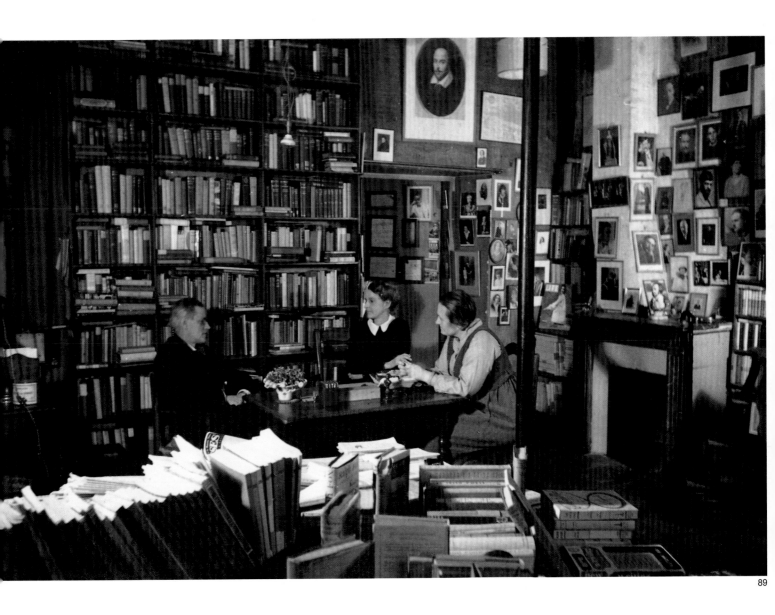

88

89

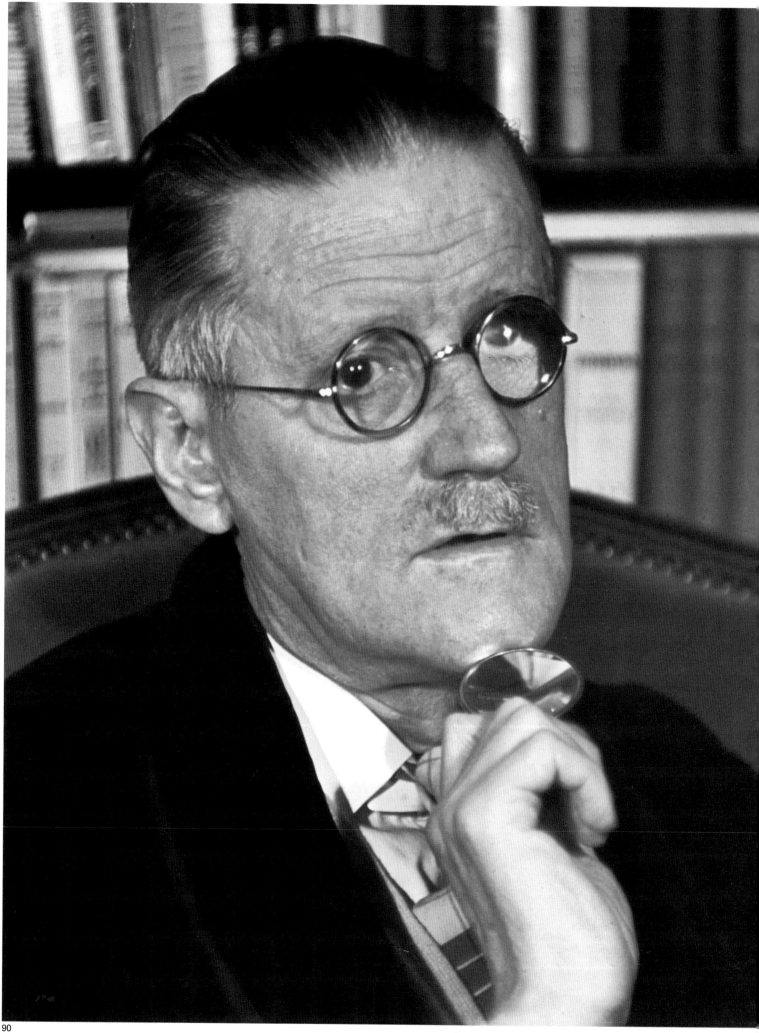

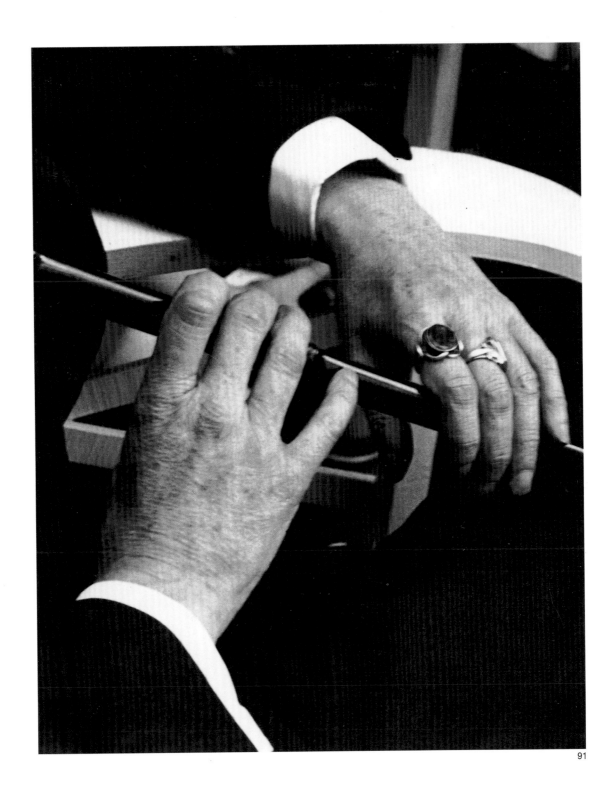

91

90. Portrait of Joyce, Paris, 1939

91. Joyce's hands, Paris, 1938

# GEORGE BERNARD SHAW

92. Sunday orator, England, 1939

93. G. B. Shaw by moonlight, London, 1939

The image of G. B. Shaw, with his long white prophet's beard, was inseparable from the intellectual landscape of the first decades of the twentieth century. His sarcastic mind, with which he judged his contemporaries, was legendary.

He had asked me to photograph him at his home one evening. While I was setting up my reflectors, Shaw kept giving me advice: "Above all, don't cut off my beard!"

When I was ready, I asked him to be seated. Then came a disaster. The lights suddenly went out.

I opened the heavy curtains. The full moon illuminated his study.

"I could photograph you by moonlight, but you'd have to sit still for three minutes and you're not capable of it!"

"Nothing is impossible for me, young woman. Take your picture." And Shaw sat down in the armchair near the window.

It took less than ten seconds for the photo, but since he had bothered me so much with his advice, I waited. Shaw didn't budge. Finally I told him that the pose was over.

"I hope you haven't cut off my beard," was his final remark.

When the picture was developed, I noticed that I had indeed cut off part of his beard, and I never dared to send him a print.

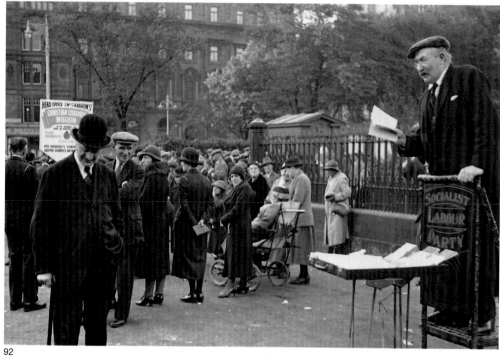

92

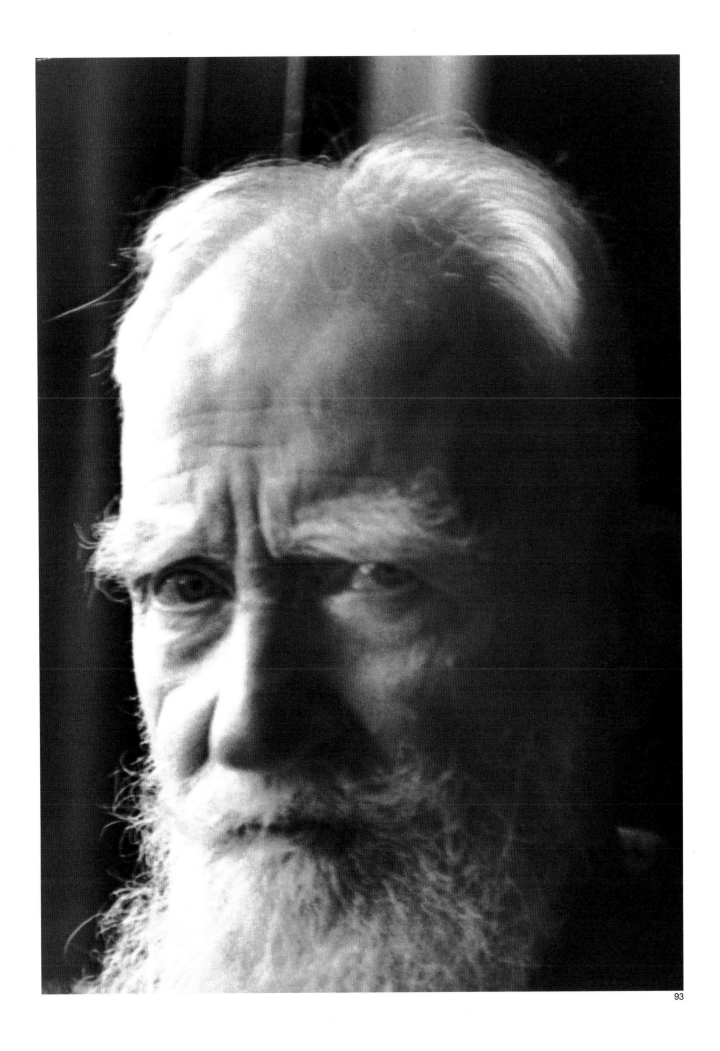

# VIRGINIA WOOLF

Frail, luminous, she was the very incarnation of her prose. She was fifty-eight years old when I photographed her, and her hair was turning gray. She was tall and slender, and the features of her face, simultaneously sensual and ascetic, were surprisingly beautiful. Her large, grave eyes in their deep sockets were surmounted by prominent eyebrows. Her mouth, with its full, soft lips, had an expression of touching sadness. The fine, straight nose seemed devoid of flesh. This face, as though bathed in an inner light, reflected both the sensitivity of a visionary and a great sincerity. A captivating atmosphere emanated from the entire person of this extremely reticent woman.

Decades after having met her, I read her diary and letters. I was very much surprised to read her reactions to the memorable sitting that took place on June 24, 1939, in her house on Tavistock Square, and the comments of the editors of her works.

Virginia Woolf must have been undergoing an acute anxiety attack when she wrote her letters to Victoria Ocampo and Vita Sackville-West, berating the first for having brought me and telling the second that I was a "devil woman." In the notes of her diary, the two days that we met, June 23 and 24, 1939, are merged into a single day.

Her exegetes accuse me of having "violated" Virginia Woolf by making her pose for me. The editor of the *Diary* has added a footnote in which Victoria Ocampo is called "a Trojan horse for her protégée's benefit. (Nevertheless, posterity can be grateful for the results of this *ruse de guerre*—or treachery.)" *Sic*!

The truth is quite another story!

After seeing the projection of my color portraits of writers on June 23, 1939, Virginia invited me to come back next day and photograph her.

In those days, color film was still so weak that you could not take indoor shots, and I had to count on the cooperation of my subjects. In looking at the photos of Virginia that I publish here, you will also notice that she is wearing different dresses. Indeed, she had suggested changing dresses because "one or the other will be more photogenic for the color film." Do you seriously believe that a person who goes to such lengths for the success of her pictures feels herself "violated"?

Unfortunately, the war prevented me from showing her the results of my work. The film, of German manufacture (Agfacolor), could no longer be developed in France. I had to send the reels to America and have black-and-white prints made from these color negatives. Then I had to rush out of Paris to keep from falling into the hands of the Gestapo, which had arrived with the German troops. I suppose that Virginia Woolf, not having seen any photos come and not realizing what difficulties there were, must have thought that I didn't want to show her these pictures. Otherwise her reaction toward me is incomprehensible.

"We also have a photographer in our family," she had told me, and in making me a present of the album of portraits taken by her relative Mrs. Cameron, which she and Leonard Woolf had printed at the Hogarth Press, she inscribed the book for me. But the war, the destruction of her home, the death that prowled all around her must have precipitated her decision to commit suicide. In 1941 she drowned herself in the Ouse River, which flows calmly and silently right next to the country house where she spent the last days of her life.

94. Portrait of Virginia Woolf, London, 1939

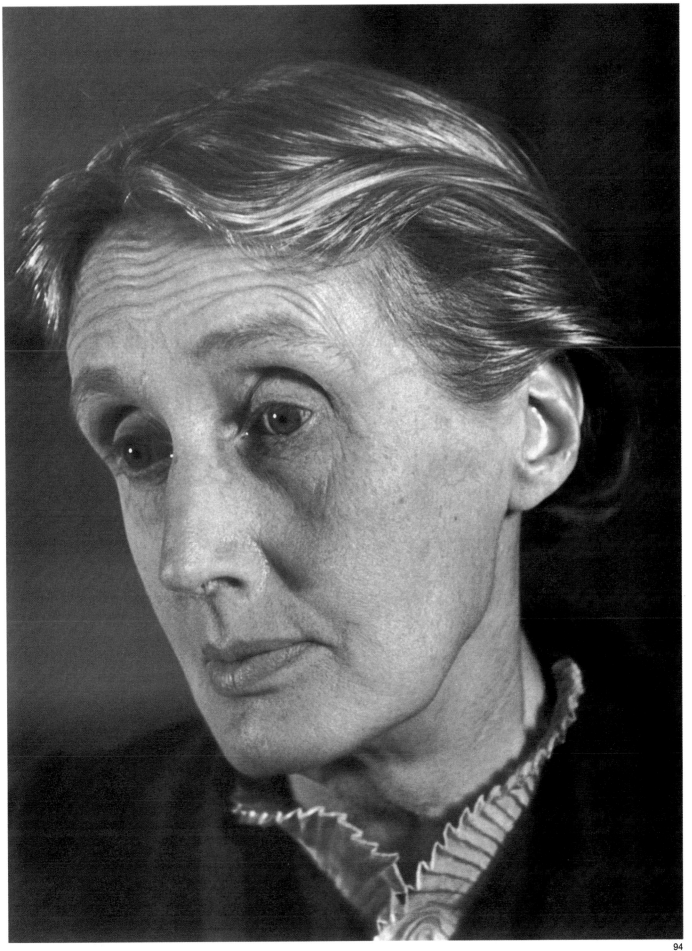

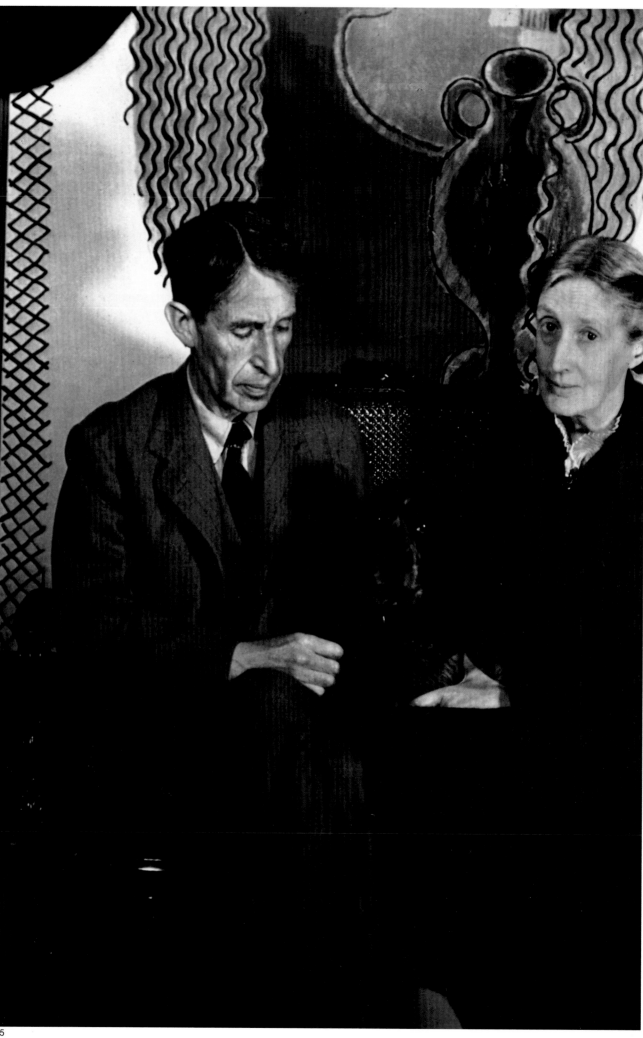

95. Virginia and Leonard Woolf, London,
1939. In background, mural by her sister,
Vanessa Bell, and Duncan Grant

96/97/98. Virginia Woolf, London, 1939

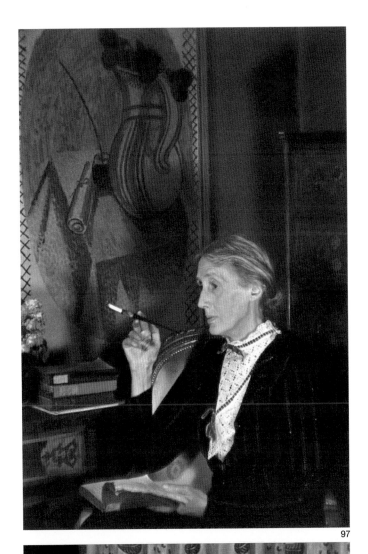

97

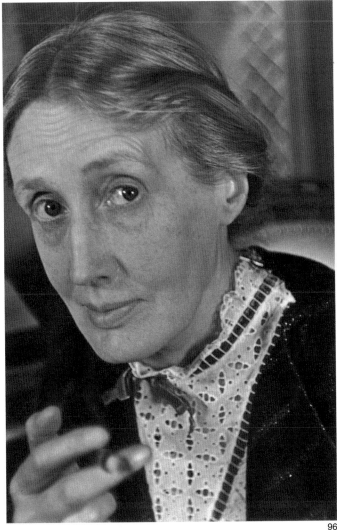

96

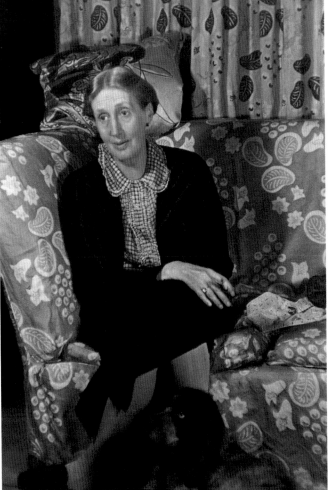

98

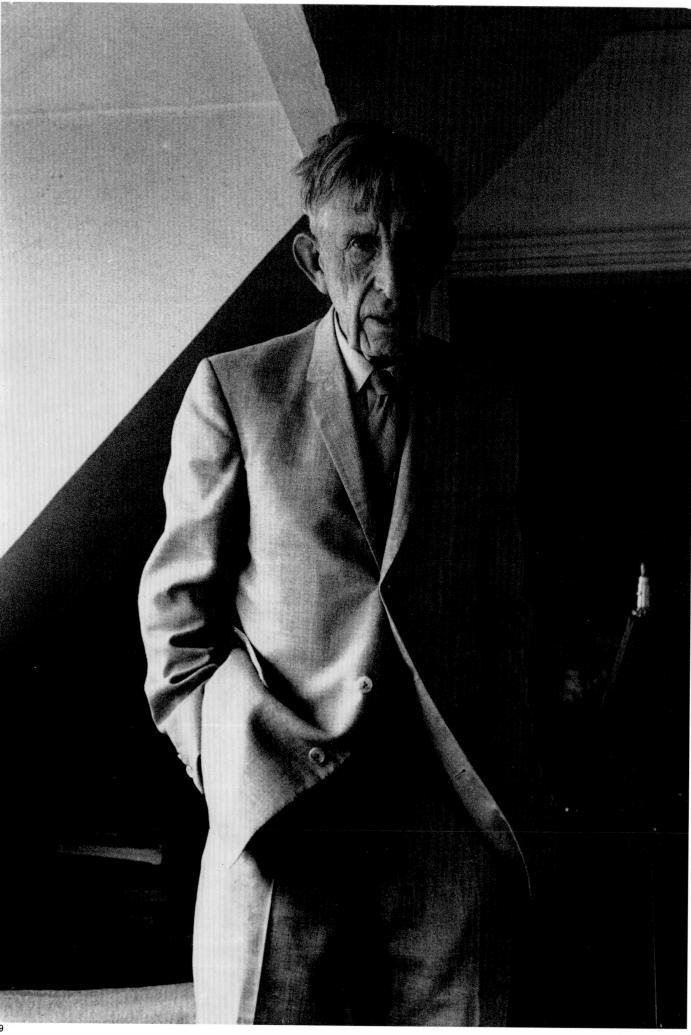

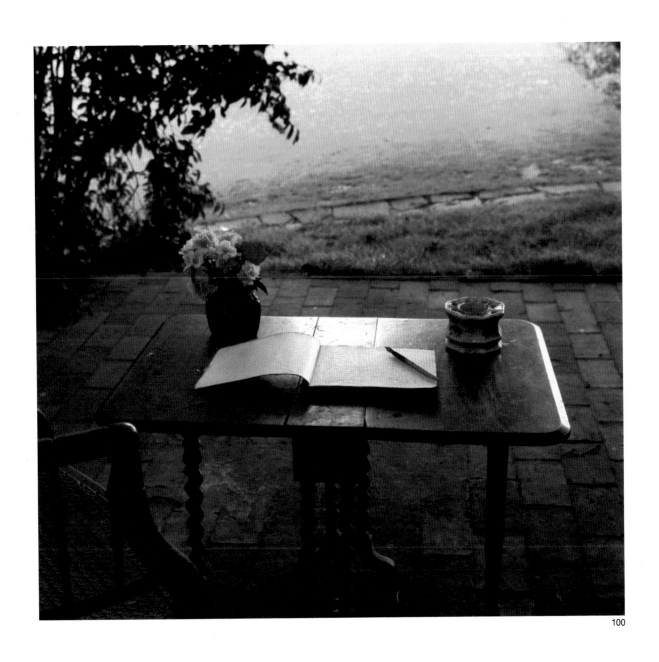

100

99. Leonard Woolf at Monk's House, his country house in Sussex, England, c. 1967

100. Virginia Woolf's work table at Monk's House, Sussex, England, c. 1967

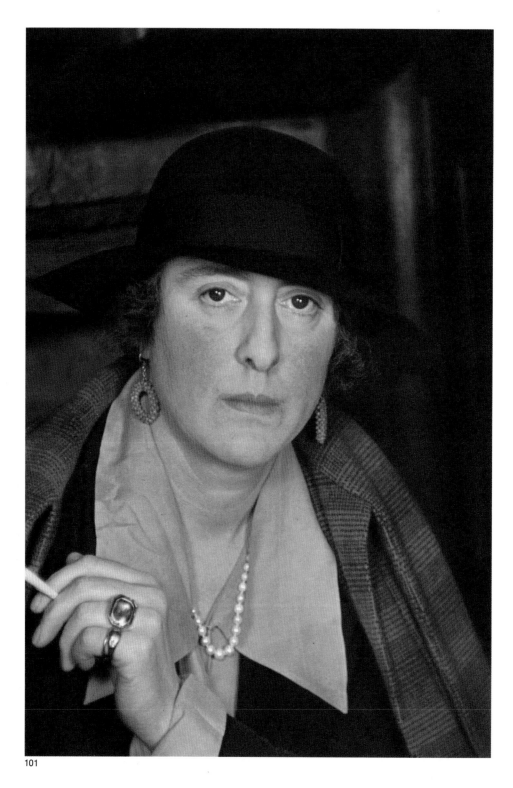
101

101. Vita Sackville-West, Sissinghurst Castle,
     England, 1939

102. Vita Sackville-West in her tower, Sis-
     singhurst Castle, 1946

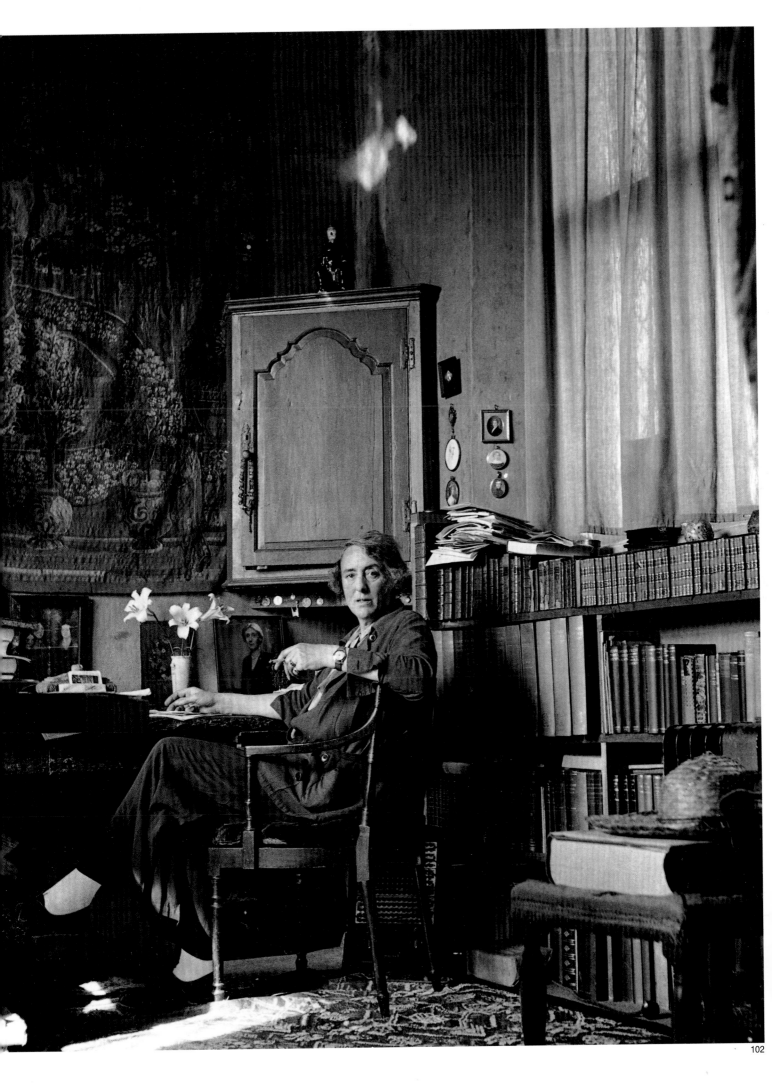

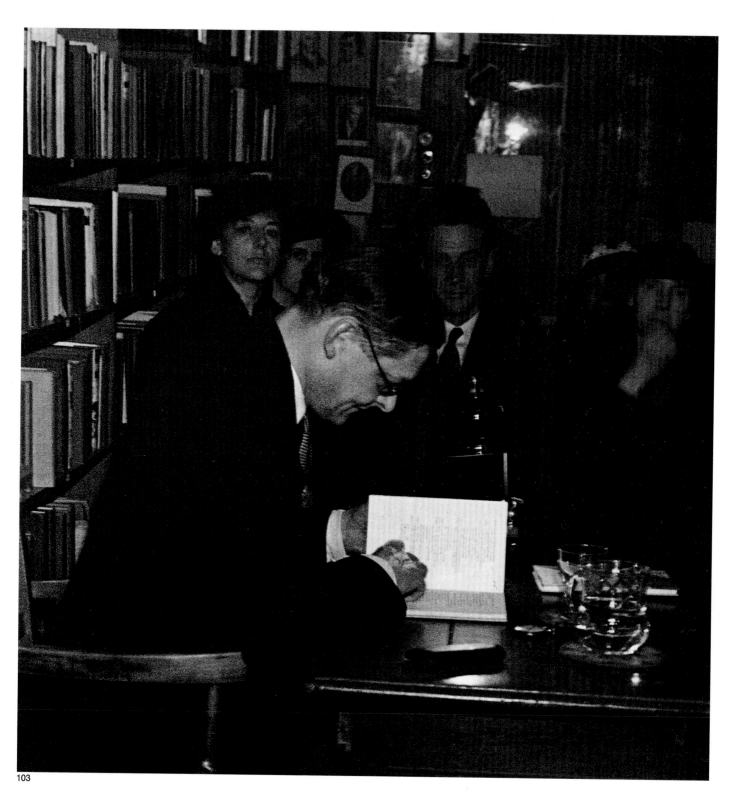

103

103. T. S. Eliot reading an unpublished text at
     Shakespeare and Company, Paris, 1937

104. T. S. Eliot, London, 1939

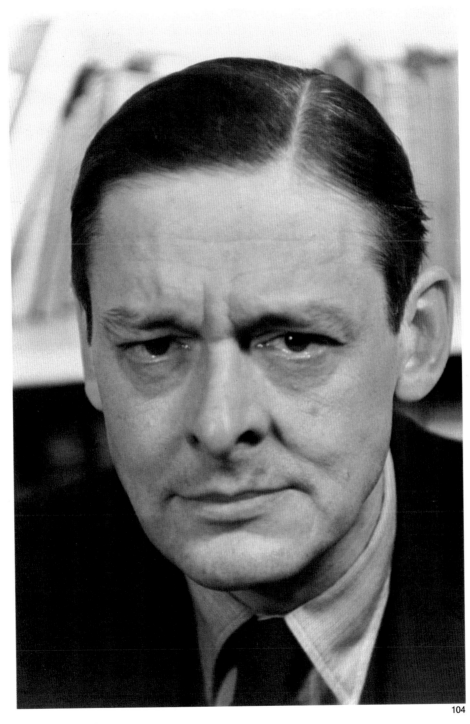

104

105. Stephen Spender, London, 1939

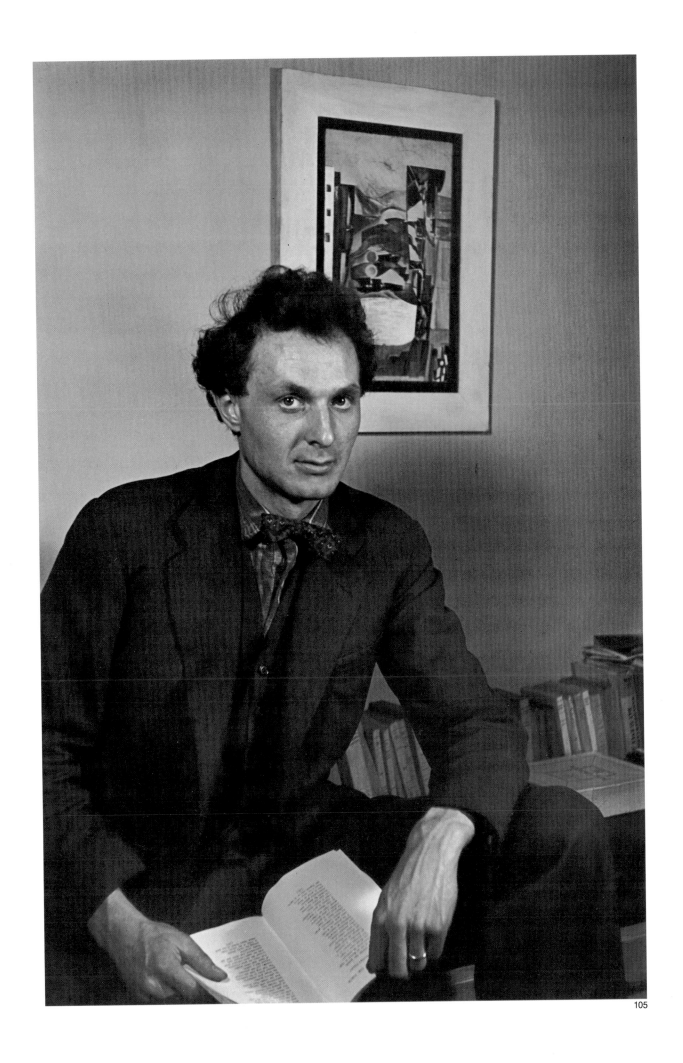

106

106. Stephen Spender (left) with Christopher
     Isherwood, London, 1959

107. W. H. Auden, London, 1963

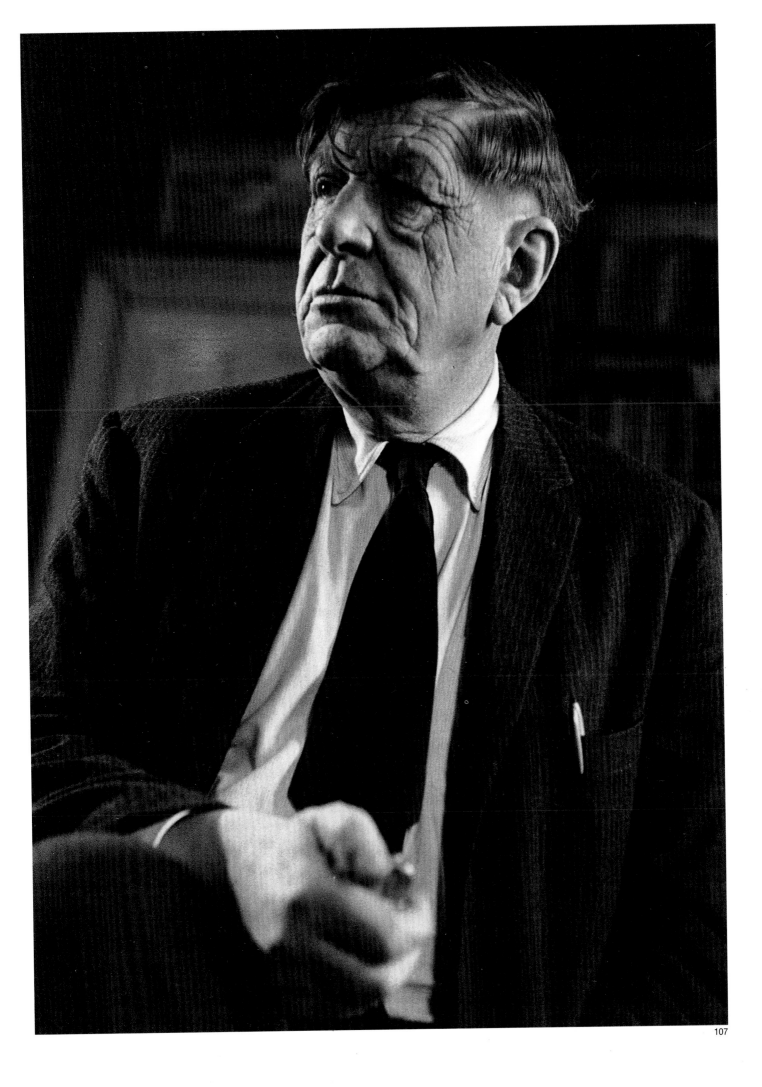

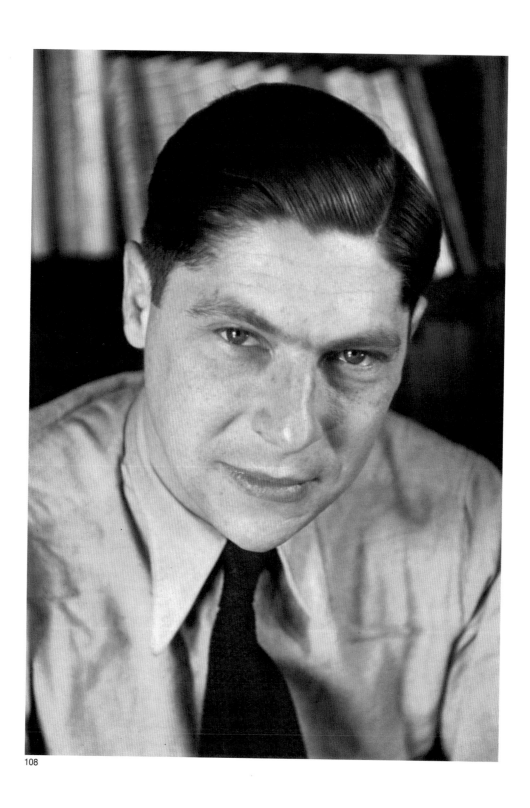

108

108. Arthur Koestler, Paris, 1940

109. Arthur Koestler, London, 1967

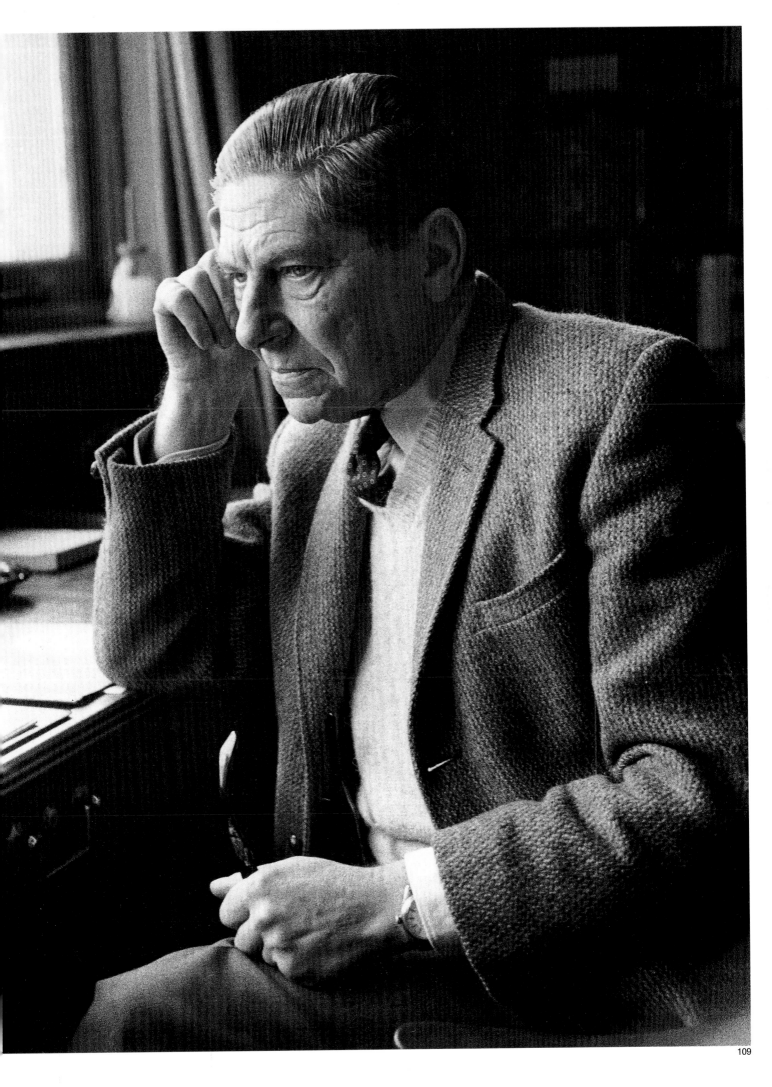

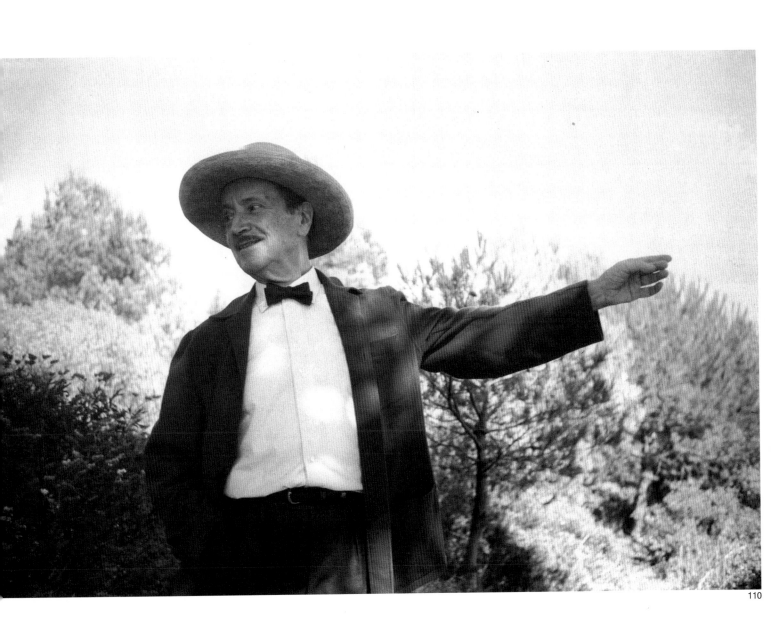

110

110. Saint-John Perse, Giens, 1966

# MARIE BONAPARTE

Princess of Greece and psychoanalyst, she was, from her own account, the last Bonaparte, Napoleon being her great-great-uncle. She was very rich. This fortune had come to her from her maternal grandfather, François Blanc, who in 1863 had become the owner of the Casino of Monte Carlo. He died a multimillionaire and his only daughter, Marie-Félix, inherited his fortune. There was much talk about it in the newspapers at the time, and Princess Pierre Bonaparte, mother of Prince Roland, saw in François Blanc's heiress the ideal bride for her son. Urged on by his mother, Roland became engaged to Marie-Félix, and they were married in November, 1880. On July 2, 1882, she gave birth to a baby daughter named Marie; a month later she died, at the age of twenty-two.

Marie Bonaparte was raised by a strict and stingy grandmother. She never knew a mother's love, and this fact was to have a great influence on her life. When she was old enough, her father arranged for her to marry Prince George of Greece and Denmark, son of the king of the Hellenes. Marie's large fortune must have played a central role in this arrangement.

Prince George of Greece was a giant with blue eyes and a blond mustache, but already bald. He was fifteen years older than she. The couple had two children, and there their sexual relations came to an end. You will find all the details of Marie Bonaparte's life in the exciting biography by Célia Bertin, published in 1982.

Marie Bonaparte enjoyed great personal success as a psychoanalyst, having been first a pupil of Sigmund Freud, then his close friend. She introduced psychoanalysis into France. The Surrealists were profoundly influenced by Freudian theory.

Marie Bonaparte lived a double life. She did not neglect the role forced on her by her marriage to a king's son. She attended society gatherings of royalty and the aristocracy while at the same time pursuing her professional life and her writings and seeing her patients. She owed all this to her strong personality and her humanity. It was thanks to her that Freud was able to leave Vienna in 1938 after the arrival of the Nazis and settle in London, bringing not only his large family but his library and manuscripts as well. She also helped many Jews, both famous and obscure, to leave Nazi Germany.

It was in May, 1939, that Marie Bonaparte, always keen for new things, asked me to photograph her, as well as her son Pierre, in color. Most likely it was the veil she was wearing that day that stimulated me to photograph her this way. Her gaze was extraordinarily lucid and intelligent.

She traveled a good deal. That is probably the reason why I never had a chance to give her the photos. In May, 1940, I wrote to her. It was the time when hundreds of thousands of Parisians were fleeing the capital before the advance of the German troops and when I myself had to escape to the south of France.

It was only after I had found refuge in a village in the department of Lot that I received a forwarded letter from Marie Bonaparte, dated May 24 and written by hand. She asked me to send the photos to her at an address in Bénodet, Finistère. Her letter shows every sign of being written in haste. She mentions being unable to remember whether these were "portraits of my daughter, my son, my granddaughter, or probably myself... I'm not sure any more.... " She signed herself: "Marie, Princesse de Grèce, née Bonaparte."

111. Marie Bonaparte, Paris, 1939

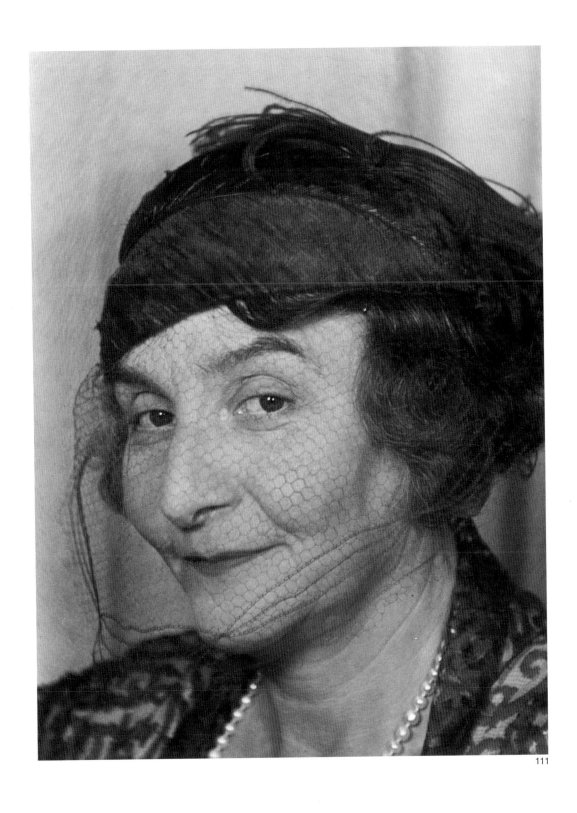

111

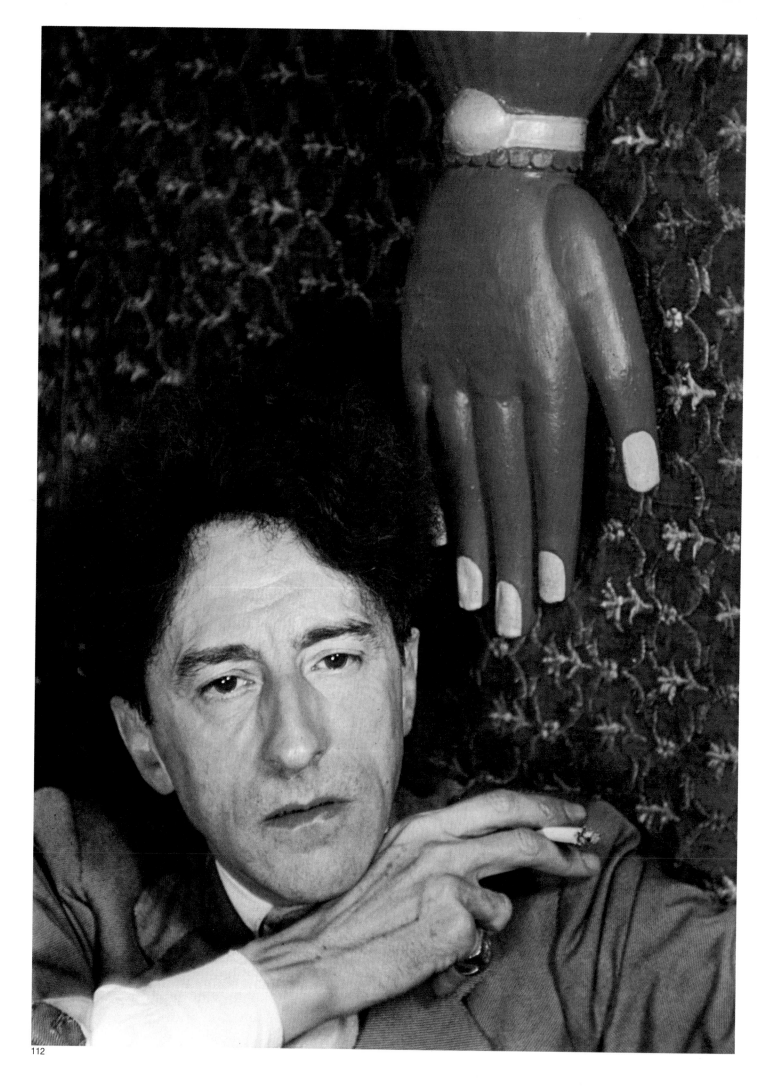

# THE SURREALISTS

"André Breton looks like an archangel!" exclaimed Adrienne Monnier when she saw his image appear on the screen during that memorable showing in her bookstore. The subject himself kept silent, his arms crossed on his chest, his head tilted slightly back. He was the leader of the Surrealist movement. I photographed most of the members of this literary and artistic group. Since the beginning of their movement in 1925, they had believed in the need to connect art with political action. The First World War had left them with a profound disgust for nationalism.

" 'Transform the world!' said Marx. 'Change life!' said Rimbaud. These two watchwords are one and the same," Breton declared. But this declaration was not enough to maintain the unity of the group. Influenced by the social changes occurring in Russia, which seemed to point to a more just world, Louis Aragon, Paul Eluard, and others left the Surrealists. But how effective would they find those changes today?

Surrealism was expressed much more in painting than in the other arts, but it had an undeniable influence on photography as well.

I met André Breton and Louis Aragon a number of times in my life and thus had the opportunity to photograph them again. My last pictures of Breton date from a few months before his death. He was still living on the Rue Fontaine in Montmartre. His apartment was a real museum. He had an extraordinary collection of Pre-Columbian statuettes, most of which he must have brought back from Mexico. At the same time, his divan was covered with countless holy-water stoups, and African masks hung on the walls with a large painting by Dali. Another time I ran into him by chance at the flea market, which he visited regularly. It was there that he had discovered a painting by the Douanier Rousseau.

By the end of his life, Breton had quarreled with almost all his old friends, but in literary history he will remain the chief theoretician of Surrealism and a great poet and writer.

113

112. Jean Cocteau under the sign of a glove seller, Paris, 1939

113. Detail of mural painted by Jean Cocteau in the church of Villefranche, 1957

114. Jean Cocteau, Paris, 1939

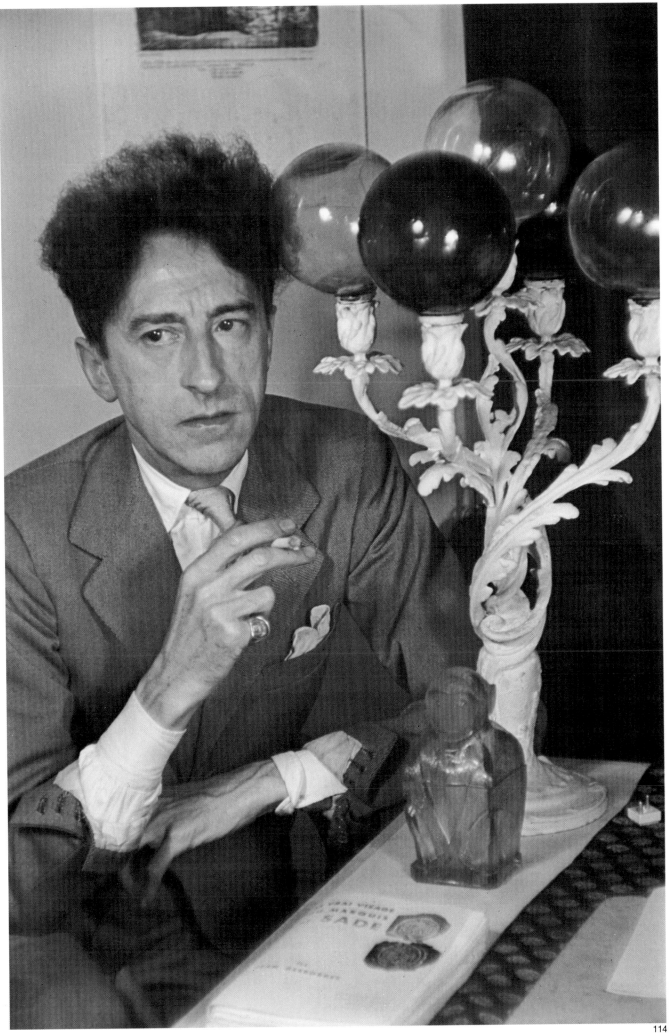

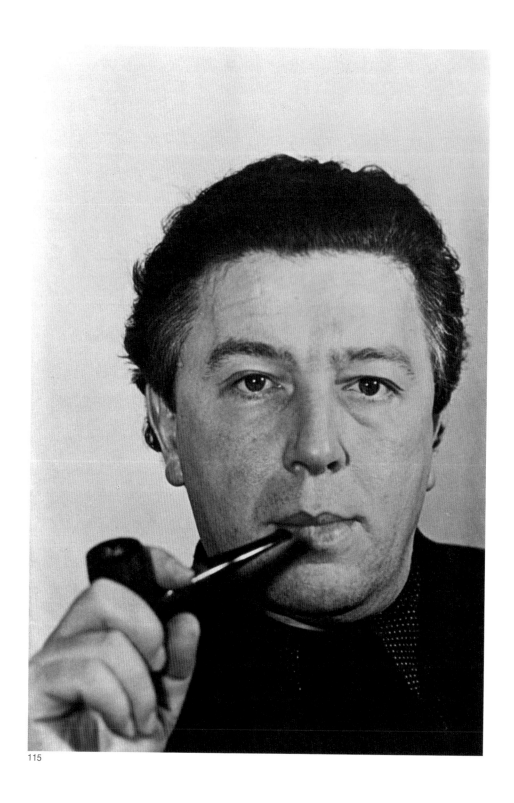

115

115. André Breton, Paris, 1939

116. André Breton at the flea market, Paris,
1957

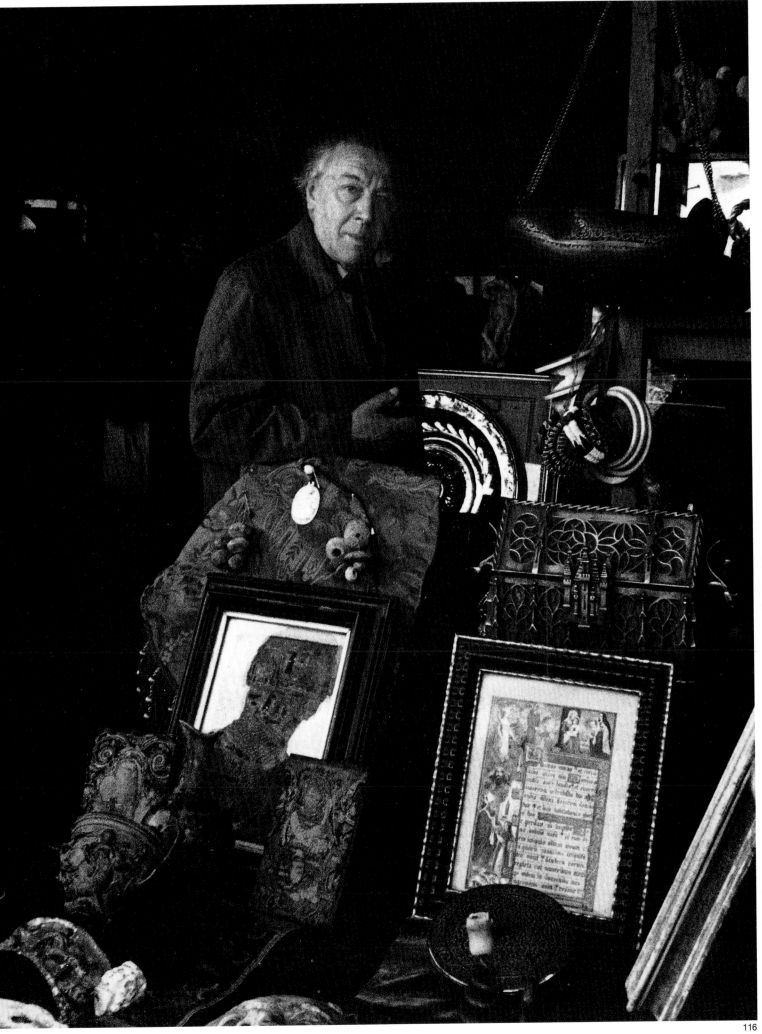

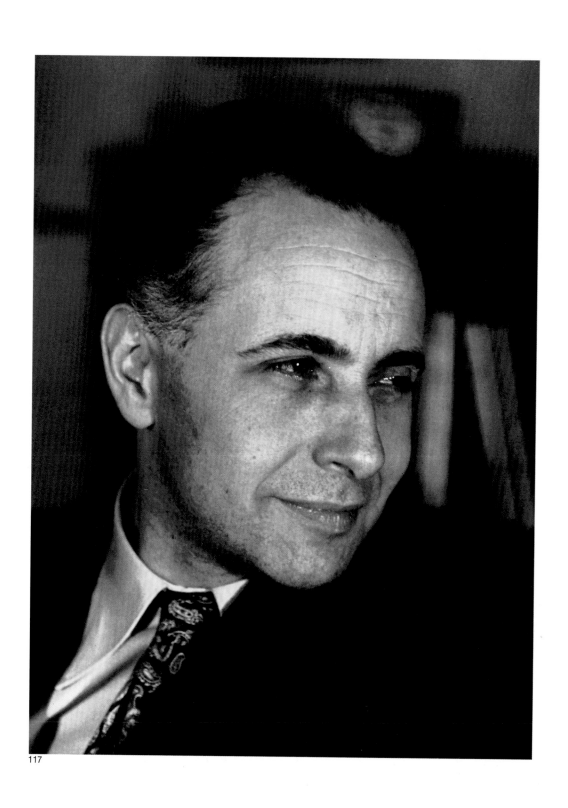

117

117. Louis Aragon, Paris, 1939

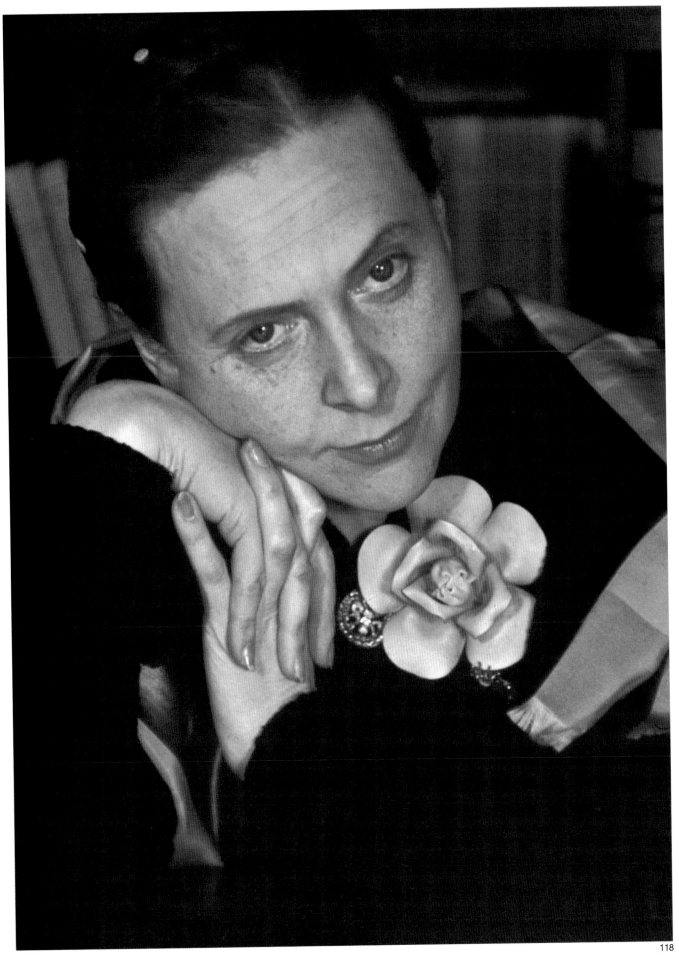

118. Elsa Triolet, Paris, 1939

119

119. Jacques Prévert in Vence, 1953

120. Paul Celan, Paris, 1970

122

121. Pierre Reverdy, Saint-Jean-Cap-Ferrat,
1953

122. René Char, Ile-sur-Sorge, 1971

# ANDRE MALRAUX

I first met André Malraux in 1933, in the office of Jean Paulhan, editor of the *Nouvelle Revue Française*, published by Gallimard. Once a week Paulhan received his contributing writers in his office on the Rue Sébastien-Bottin.

"You ought to meet André Malraux," I was told by the philosopher Bernard Groethuysen, who had taken me there. "Gide, who's now much involved in revolutionary ideas, considers him somewhat as his spiritual son."

Malraux was then in his early thirties. His restless gaze flitted from one person to another, from object to object, like a hunted bird seeking shelter. He gesticulated, indulging in a kind of vehement pantomime. There was drama in his simplest words. And, with his cigarette butt stuck to his lips, he spoke without letup. His sleek brown hair floated around his pale face.

He had just published *La Condition humaine* (Man's Fate), for which he received the Goncourt prize, the most coveted literary award in France.

We used to see each other quite regularly. He was interested in hearing about the Nazi regime, of which I had just had firsthand experience. He was interested too in my thesis on photography and the democratization of the portrait, which allowed people of all social classes to perpetuate their images cheaply; in 1936, he tried to place it with Gallimard.

In April, 1935, Malraux informed me that he urgently needed a portrait for the new edition of *La Condition humaine* and asked me to photograph him. At that time, I had only a limited experience of photography, but I already knew that it was essential to make the subject forget the existence of the camera if you wanted to take natural pictures.

What has always facilitated my task as a portrait photographer with writers has been my knowledge of their work. Every man is interested above all in himself, and that is human. So for the writer it is a matter of getting him to talk about his literary concerns.

Already at that time Malraux was interested in the "museum without walls," art and its representation through the centuries. He spoke with dizzying volubility and intensity, with each new idea jostling the one that preceded it. I watched him through my lens, ready to click the shutter. When I realized that he had forgotten the camera, I was able to take him the way I wanted.

Malraux liked one of the photos. Today it has become identified with his name, the one with "wind-blown hair," as he liked to recall when he inscribed one of his books for me.

I photographed Malraux from time to time for more than forty years. The six photos that represent him here seem to me symbolic of his life, which was overwhelmed by so many tragic events: the women he had loved the most, dead; his brother shot by the Germans during the war; his two sons cut down in the flower of youth by an accident. His last picture, taken at the end of his life, is the face of an aged man, ravaged by illness and already confronted by death, which had preoccupied him ceaselessly throughout his literary work.

123. André Malraux, Paris, 1935

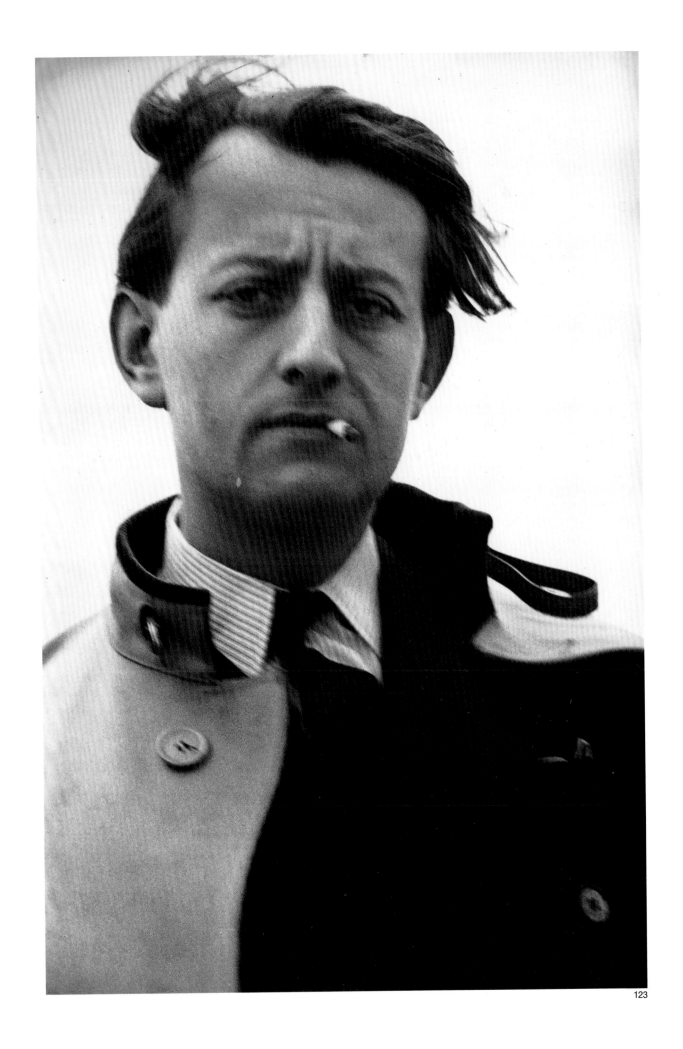

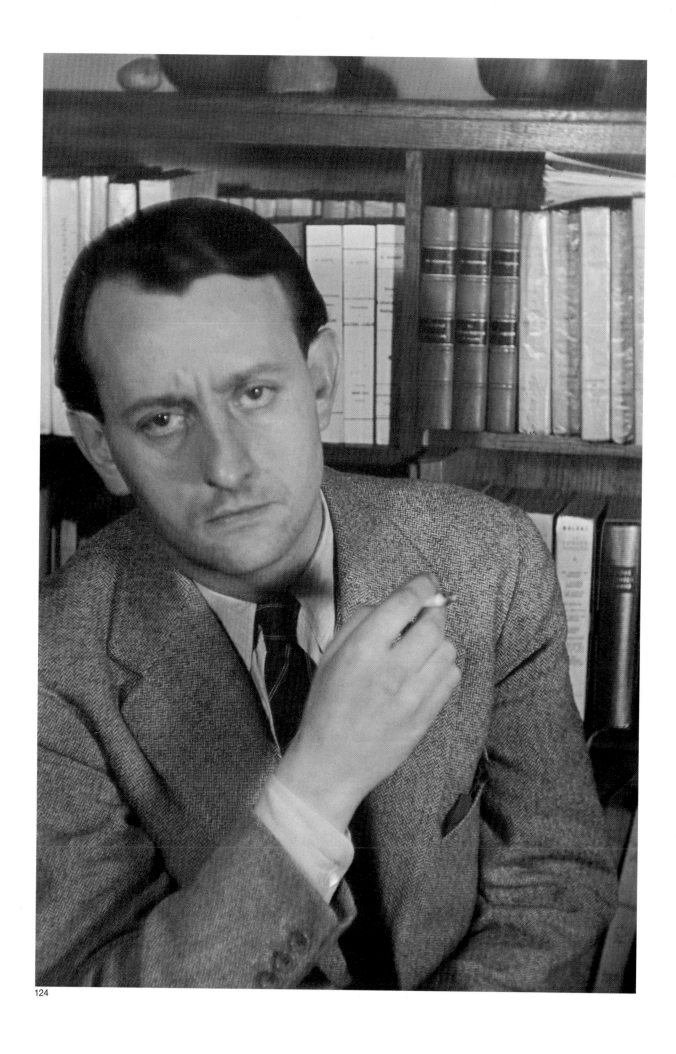

124

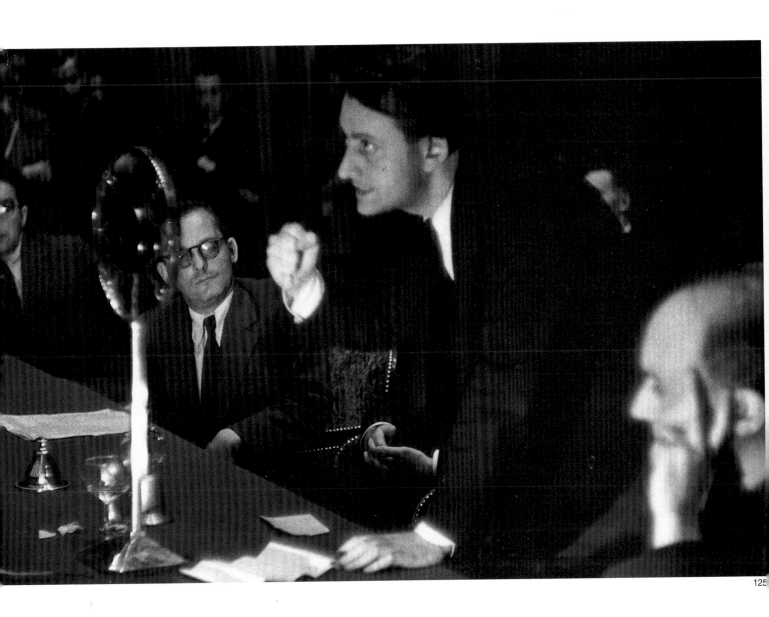

124. André Malraux, Paris, 1939

125. André Malraux at the Congress for the
Defense of Culture, Paris, 1935

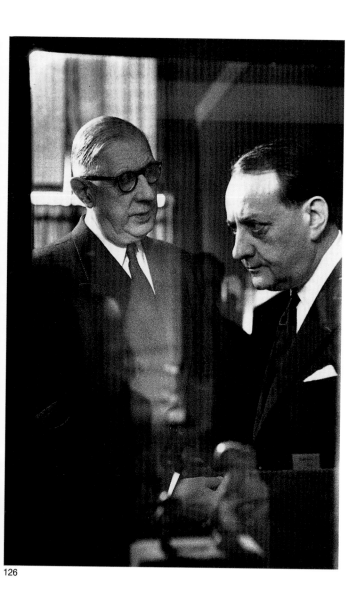

126

126. André Malraux with General de Gaulle,
at the Mexican exhibition, Paris, 1962

127. André Malraux as minister, living at La
Lanterne, a small château in Versailles,
1967

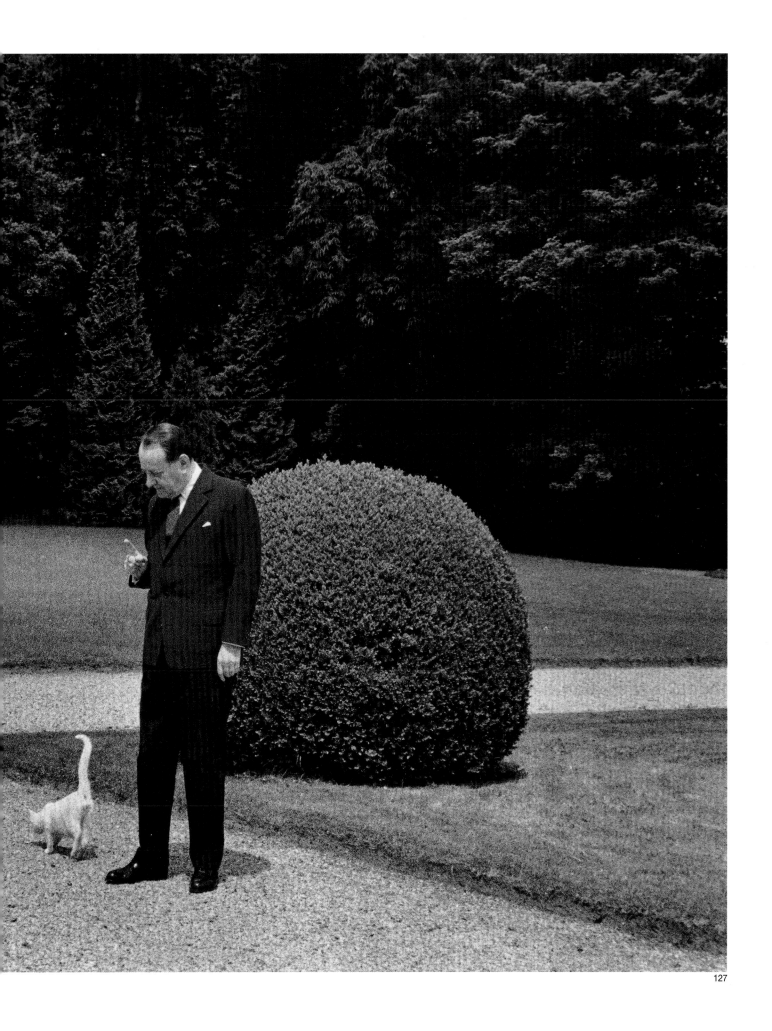

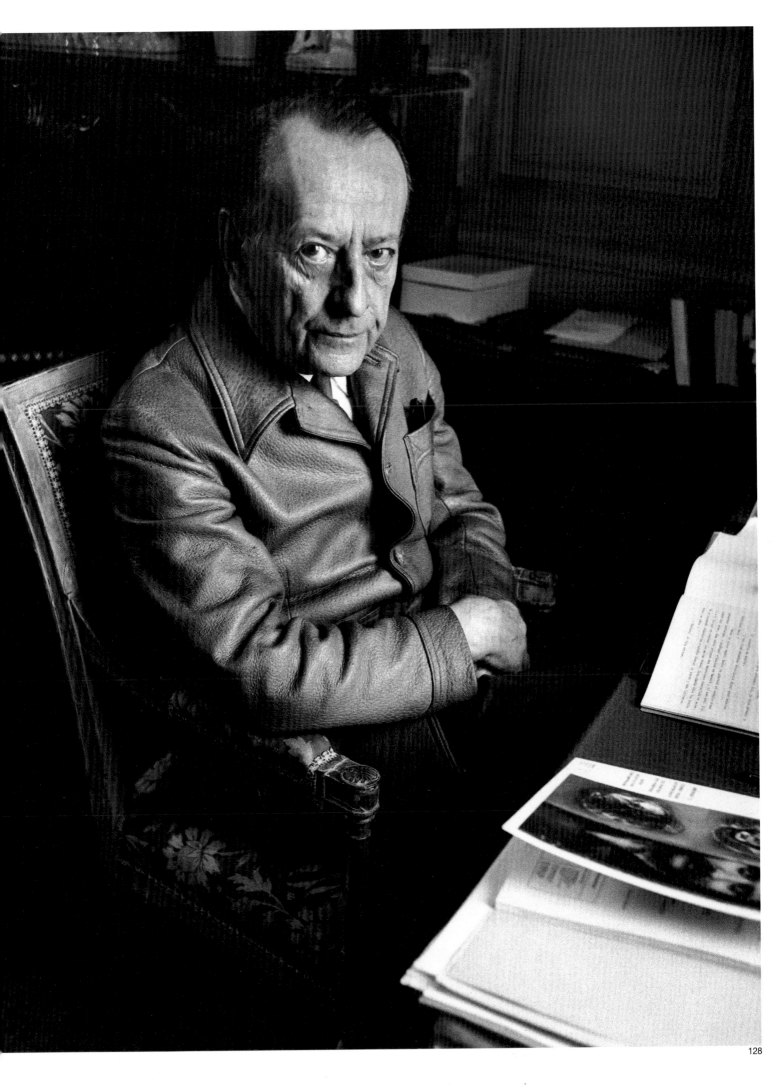

# JEAN-PAUL SARTRE AND SIMONE DE BEAUVOIR

I met Jean-Paul Sartre for the first time in 1939. He had just published *Le Mur* (The Wall), his second book. André Gide, impressed by its literary quality, had asked Adrienne Monnier to arrange a meeting between himself and this young writer. She invited them both to dinner in her apartment, which, like her bookstore, was on the Rue de l'Odéon. In addition to the two writers, Adrienne had invited a few friends.

Sartre was the last to arrive. He wore a shabby blue suit and seemed quite at ease, which was not true of Gide, who seemed very nervous and never stopped smoking. Sartre had very regular features, but his face was disfigured by a cast in his right eye. Several operations in his youth had failed to correct this defect. But when he opened his mouth to speak, you forgot all about it, for he had a warm and melodious baritone voice and an attitude toward his interlocutor that was immediately relaxing.

Simone de Beauvoir's attitude is quite different. She behaves very reticently toward anyone who doesn't belong to the small circle of her intimates. I have photographed her from time to time for over forty years. Only once have I seen her smile. I caught her, by chance, coming out of her bakery. When Sartre saw this photo, he exclaimed, "You've taken Simone smiling, that's unusual!" I knew it was.

Not smiling is probably her way of protecting herself from others, for celebrity can be a heavy burden.

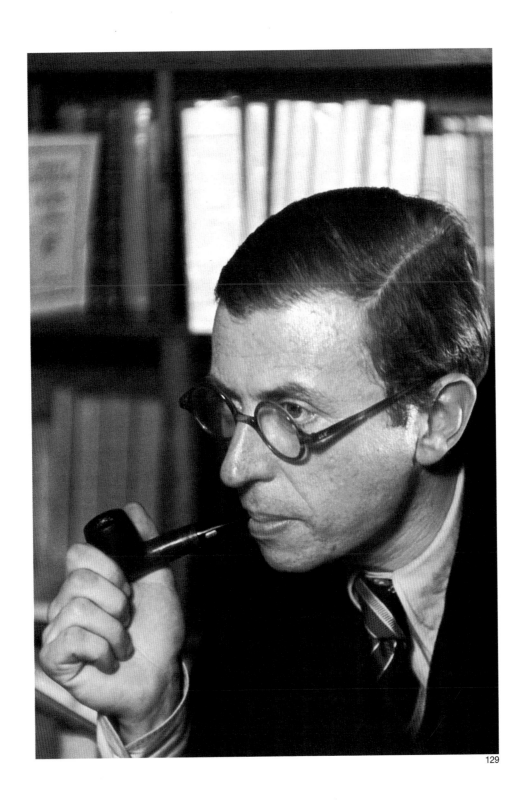

129

129. Jean-Paul Sartre, Paris, 1939

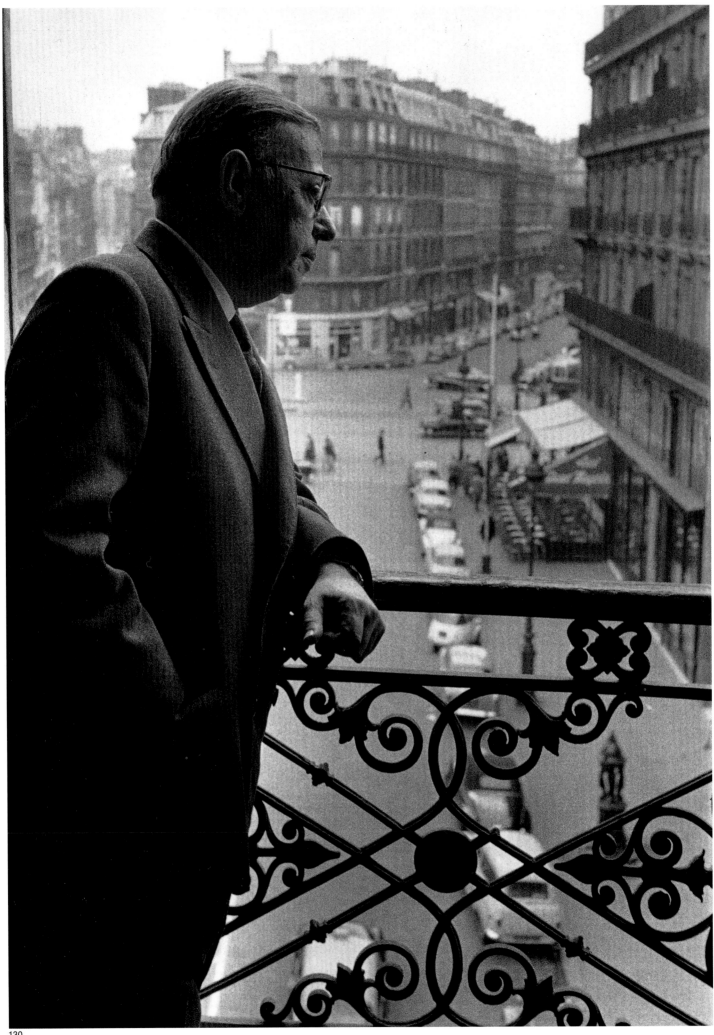

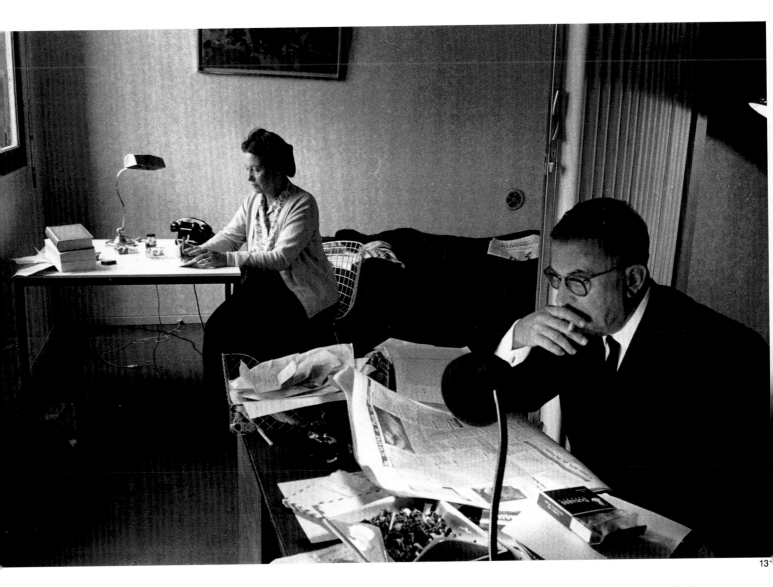

130. Sartre at his window, gazing at Saint-
Germain-des-Prés, Paris, 1959

131. Jean-Paul Sartre and Simone de Beauvoir
working together, Paris, 1964

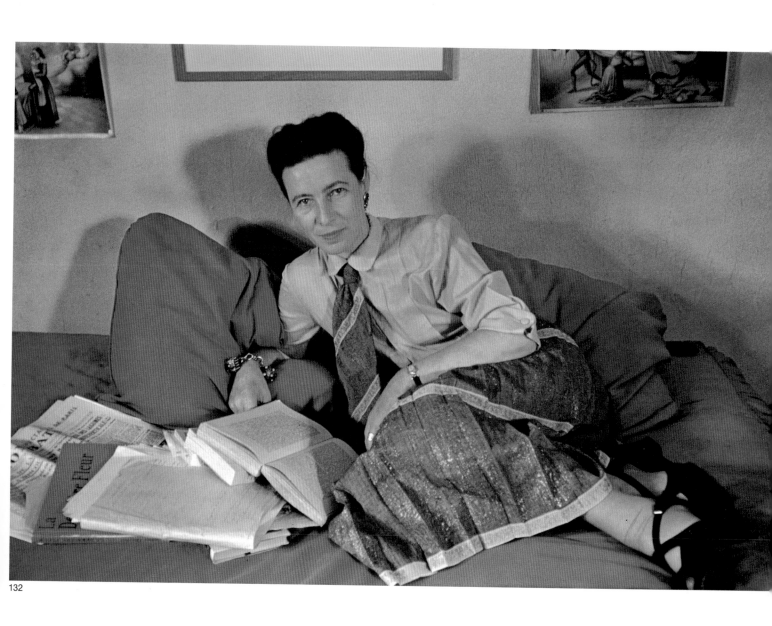

132

132/133. Simone de Beauvoir, the day of the
Prix Goncourt, Paris, 1952

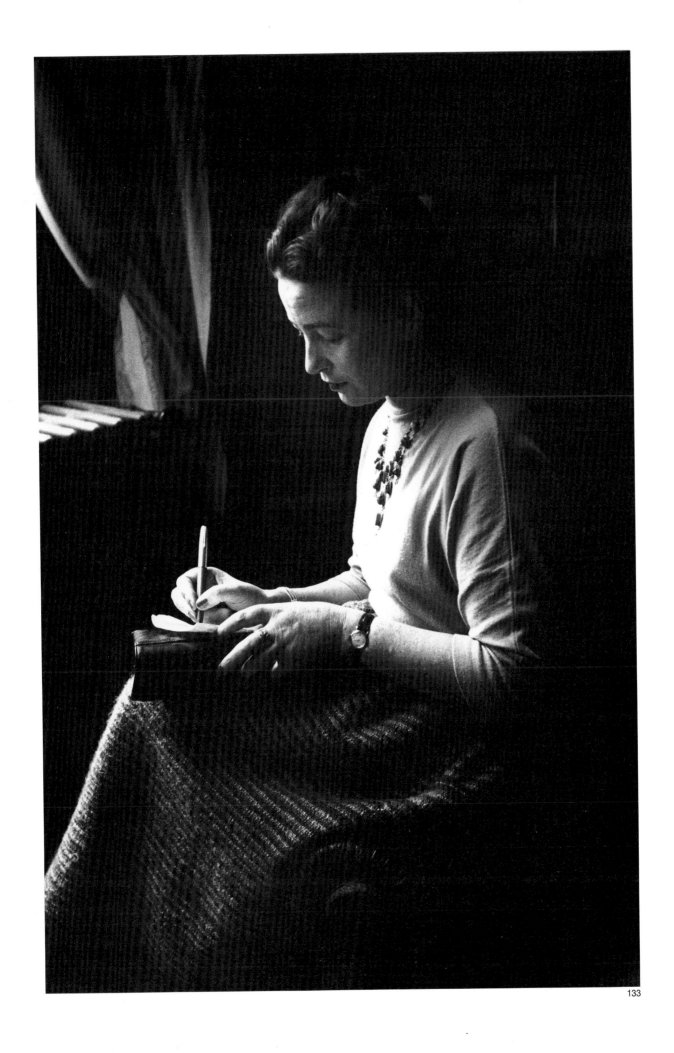

133

134

134. Wall of the Santé prison, Paris, 1964

135. Samuel Beckett, Paris, 1964

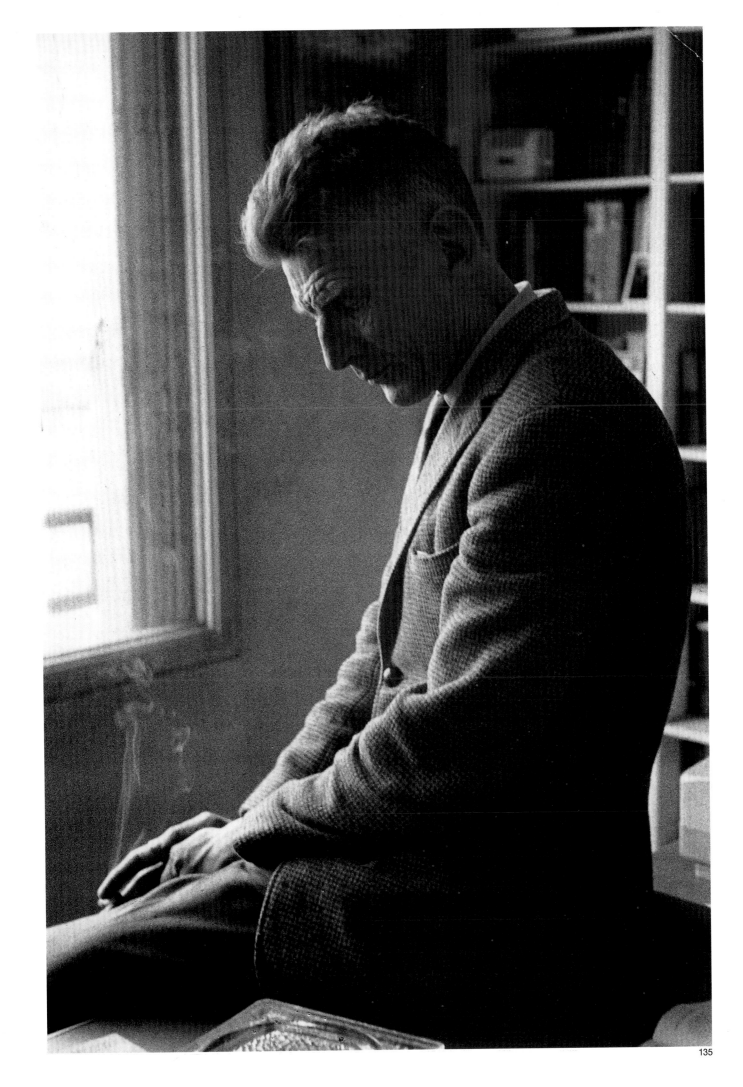

136

136. Eugène Ionesco, Paris, 1966

137

137. Scene from Ionesco's *Macbett*, Paris, 1966

138. Eugène Ionesco and his wife Rodika
during a performance of *Macbett*

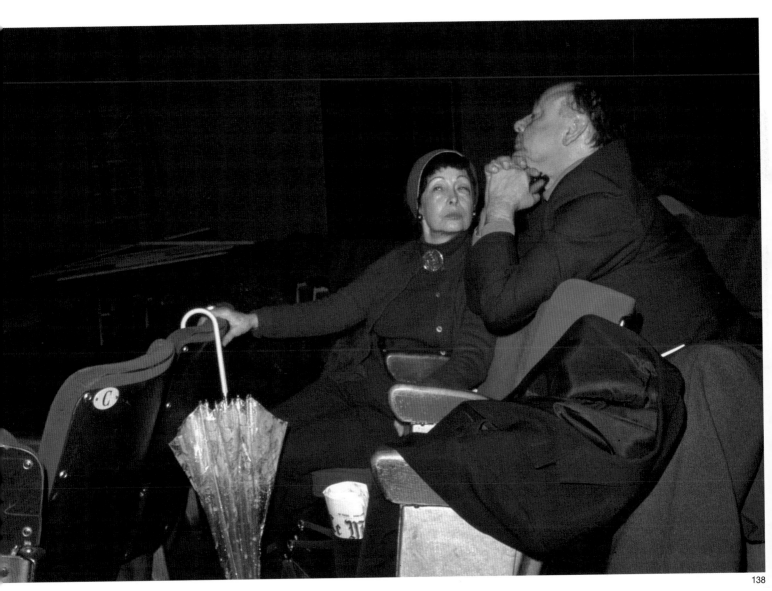

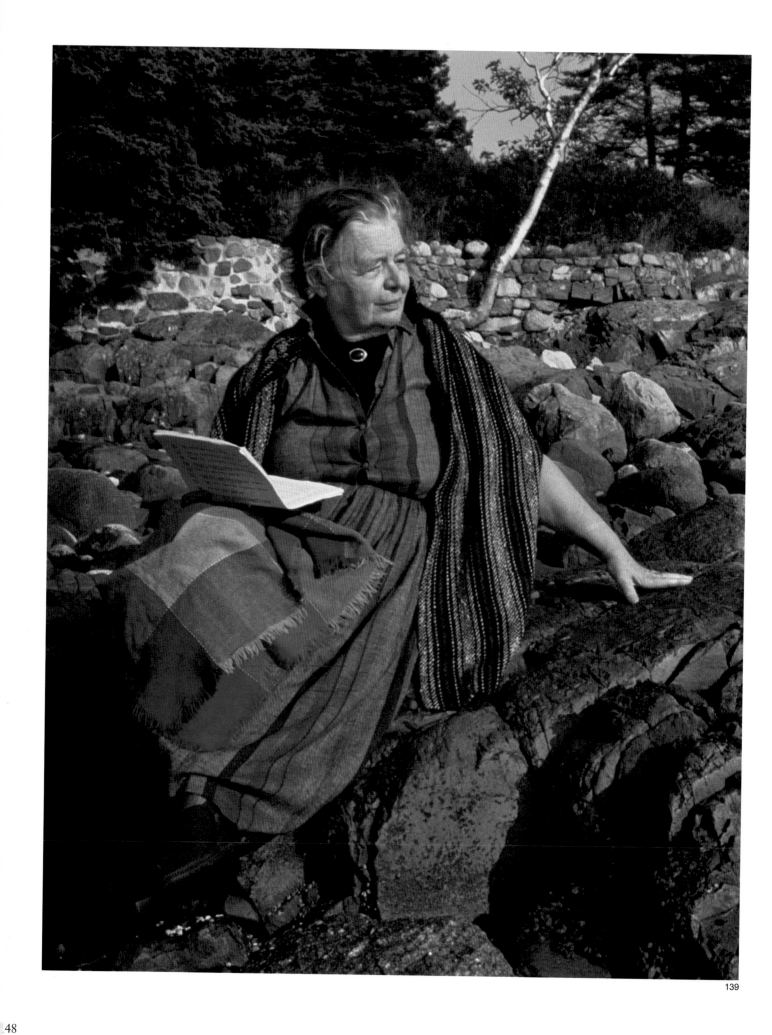

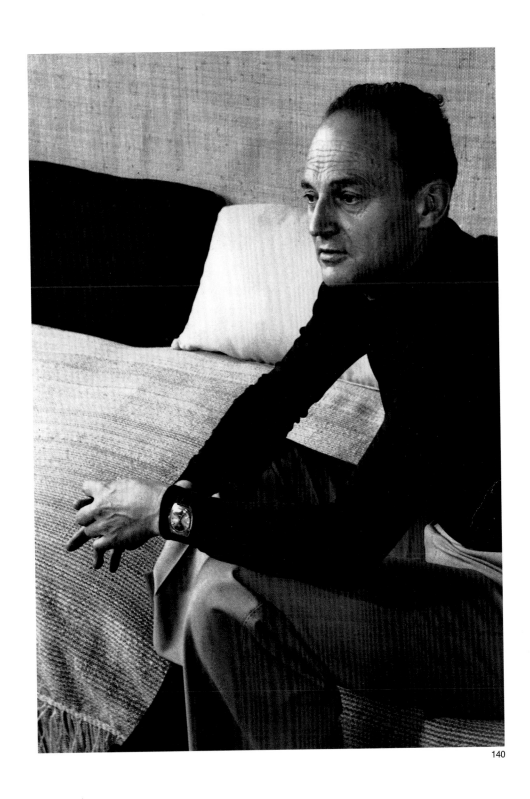

140

139. Marguerite Yourcenar, Mount Desert
      Island, 1966

140. Michel Tournier, Paris, 1975

# AMERICAN WRITERS

It was in Paris that I met most of the Americans I've photographed. They either lived there or had come as visitors.

One afternoon I recognized John Steinbeck at the American Express office. He was signing some travelers' checks. It was already getting dark and the photo suggests the chiaroscuro of Rembrandt. Steinbeck didn't realize that I had taken his picture. Shortly thereafter, this photo was exhibited in a gallery in San Francisco. A newspaper critic in that city praised the picture, which he pronounced beautiful despite the fact "that it was posed." The truth is that I've never posed a black-and-white photo.

My photo of Tennessee Williams was taken in a hotel room on the Champs-Elysées. He had come to Paris to see the production of his play *Orpheus Descending*. An actress friend who had a part in the play had told me of his arrival.

I photographed the poet Robert Lowell thanks to his friend Mary McCarthy. As for her, the picture was taken in her Paris apartment on the Rue de Rennes.

I met Thornton Wilder, the author of *Our Town*, at Adrienne Monnier's on the Rue de l'Odéon.

To photograph Katherine Anne Porter, I went to her. Her apartment was on a university campus near Washington, D.C. At that time, she was already more than eighty years old.

Richard Wright had settled in Paris with his family after the last war. It was a time when blacks were still mistreated in the United States. In France, however, they could enter any restaurant or café without fear of intimidation. We became friends. We also met in Buenos Aires, where with an Argentine crew he was shooting a film based on his most famous novel, *Native Son*, and playing the leading role himself. But despite the freedom that he had in France, Wright did not feel happy. He had become an exile, and being so far from his American homeland, he no longer succeeded in writing as he would have liked.

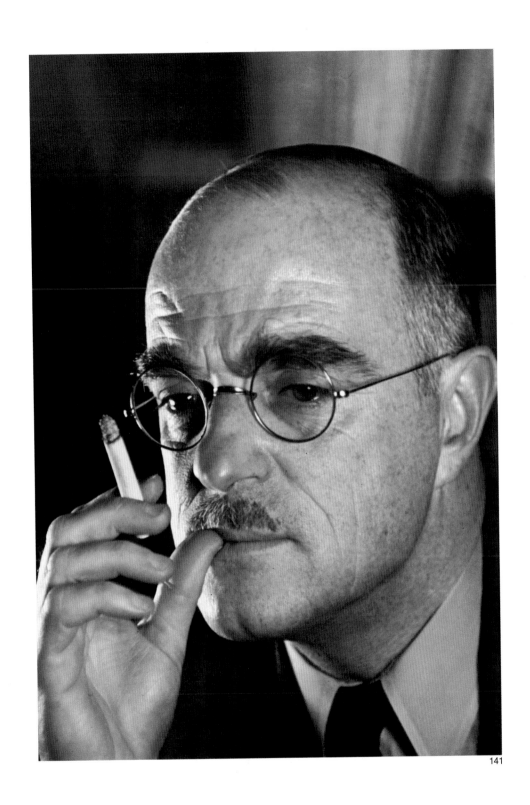

141

141. Thornton Wilder, Paris, 1939

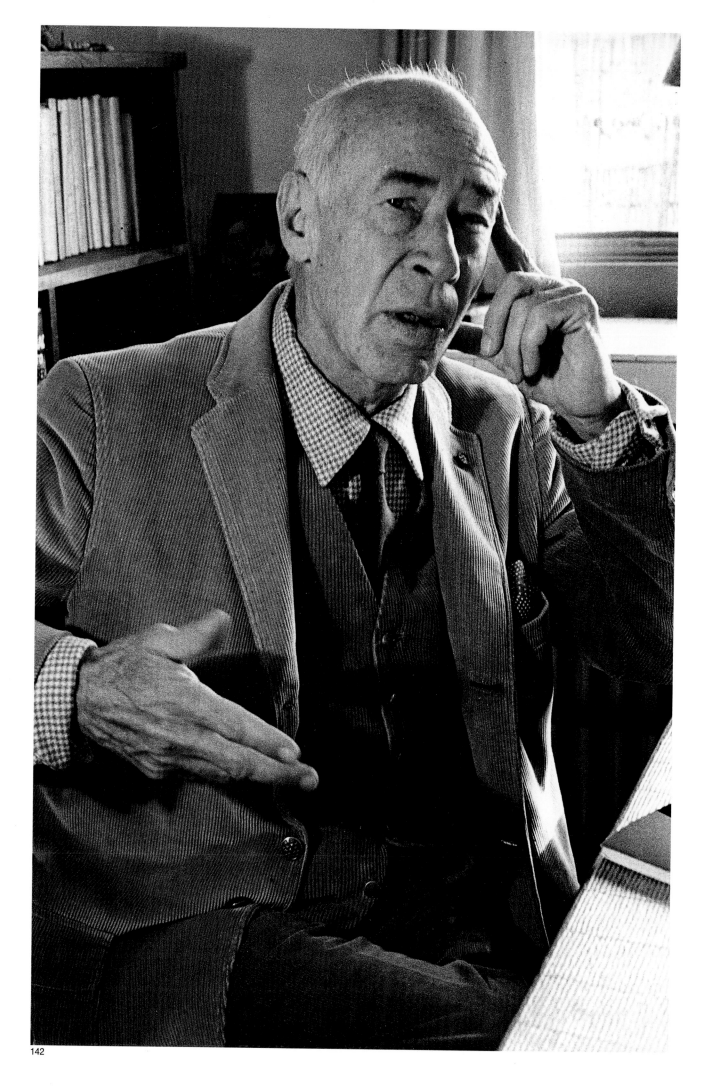

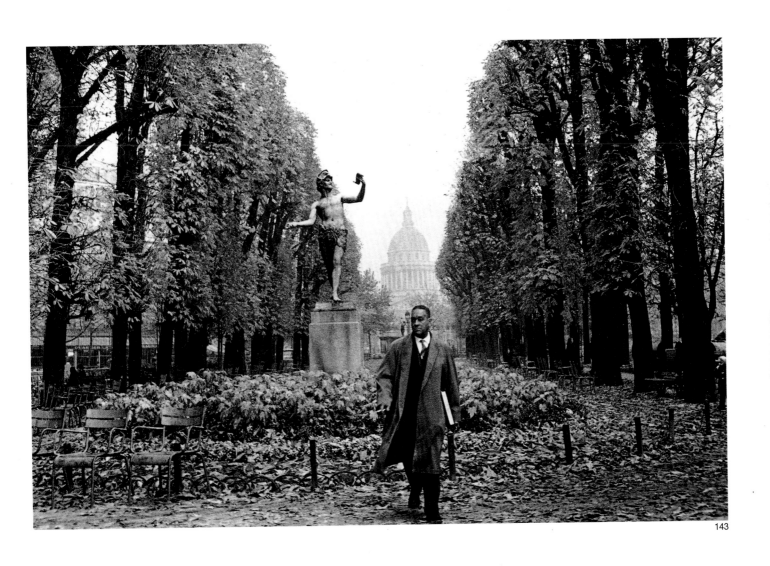

143

142. Henry Miller, Paris, 1961

143. Richard Wright in the Luxembourg
Gardens, Paris, 1959

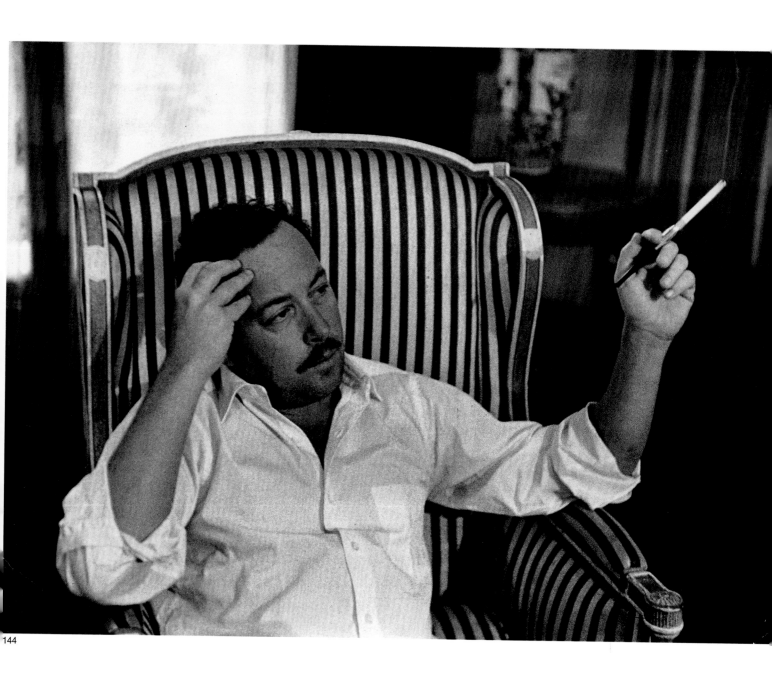

144

144. Tennessee Williams, Paris, 1959

145. Katherine Anne Porter, College Park,
    Maryland, 1970

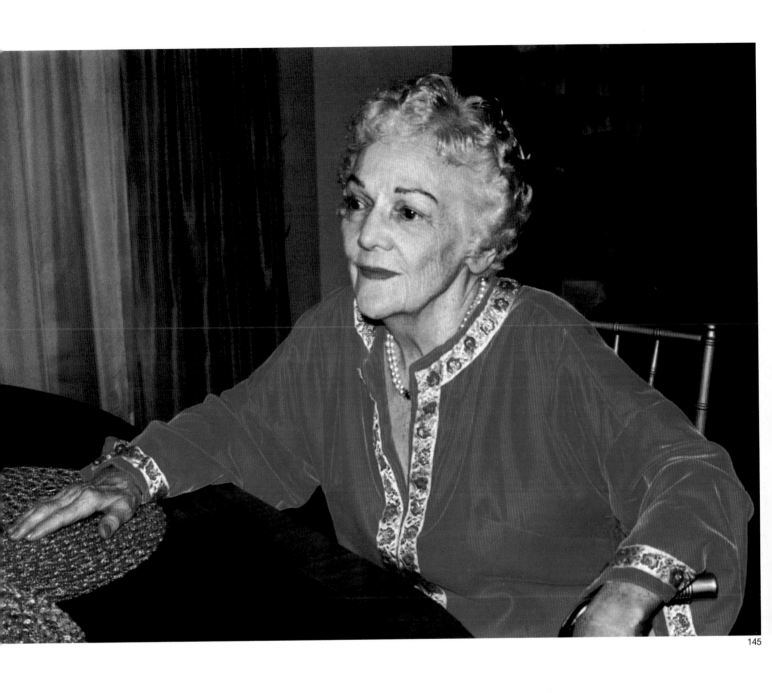

146. John Steinbeck, Paris, 1961

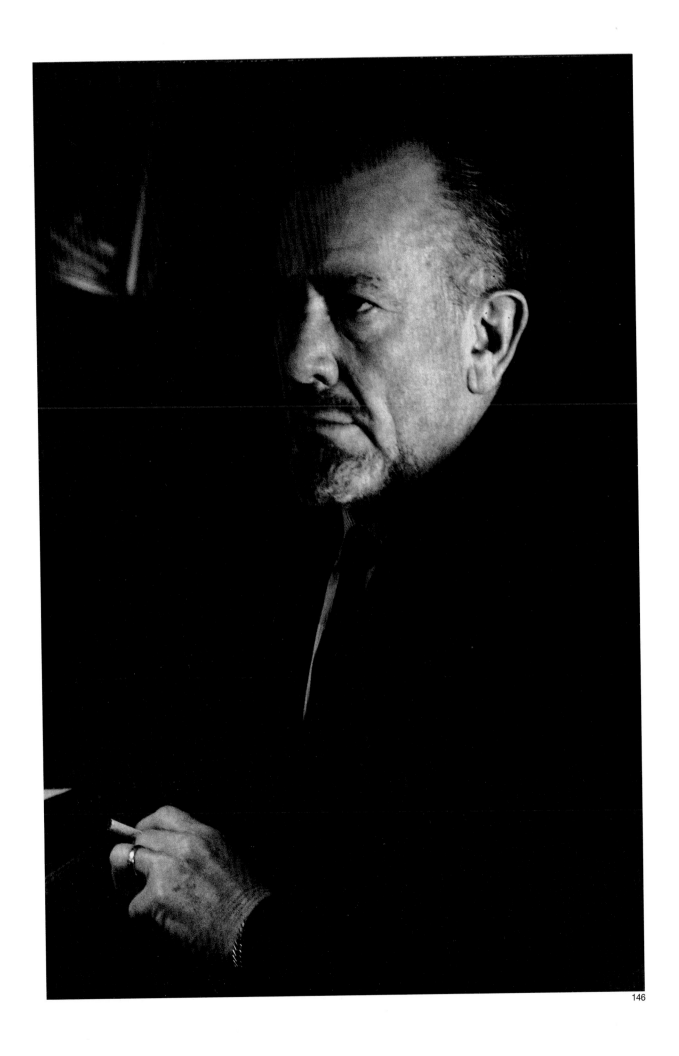

146

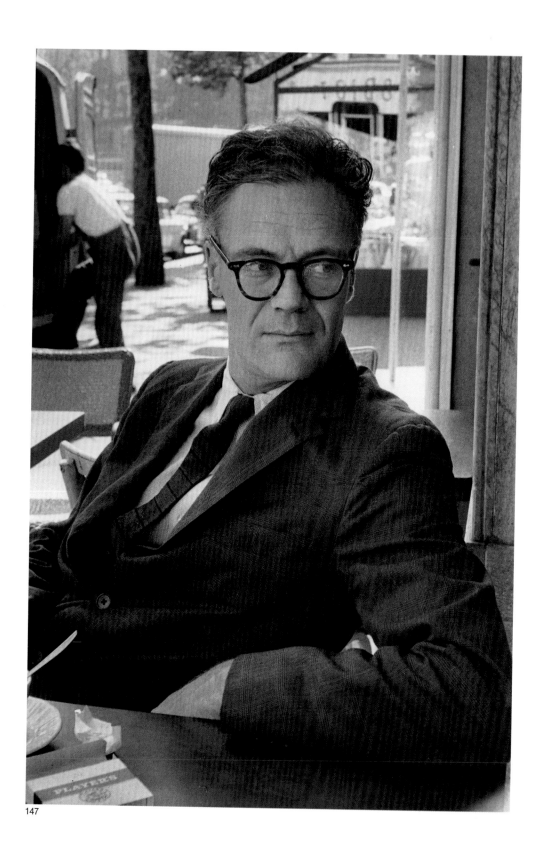

147

147. Robert Lowell, Paris, 1963

148. Mary McCarthy, Paris, 1964

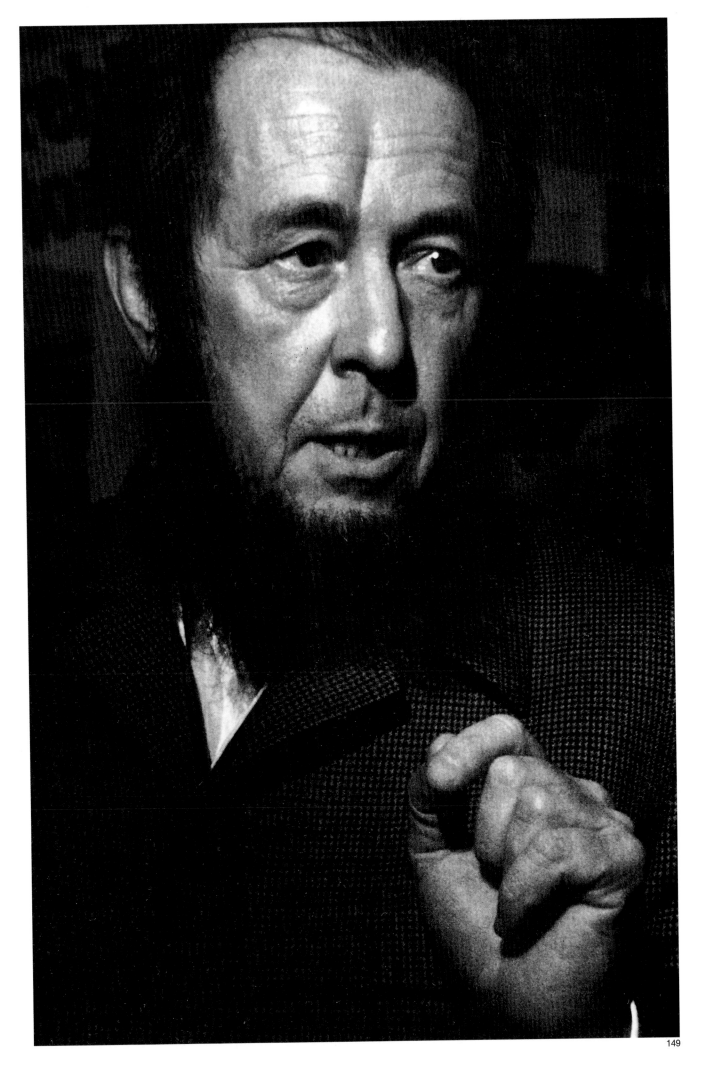

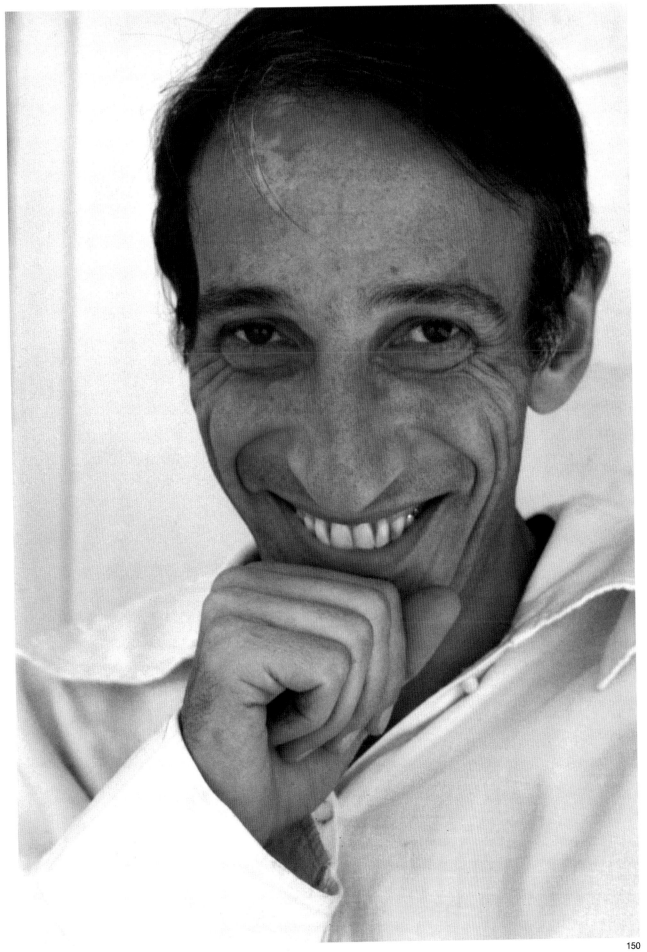

150

# PEGGY GUGGENHEIM

Marcel Duchamp said to me one evening when I was dining with him and his charming companion Mary Reynolds at his home in Neuilly, "You absolutely must photograph Peggy Guggenheim. I'm going to introduce you to her."

I knew that Peggy was an American multimillionaire who collected Surrealist paintings. She lived in a spacious apartment on the Ile Saint-Louis.

"I'm not photogenic, my legs are the only good thing about me. Photograph them with Herbert Read's head."

The famous British art critic was her adviser and was seated next to her.

"That's easy to do in painting, but a little difficult in photography," I remarked.

When Peggy closed her London gallery, she invited me to project my photos at the farewell party. I arrived at about nine o'clock in the evening, and she installed me on the steps of a staircase leading to the upper floor.

The gallery was soon packed by a crowd of people, and I didn't know a soul. The hours passed and I was feeling more and more lonely and unhappy. I could hardly make out the crowd below, separated as we were by a dense cloud of cigarette smoke. Peggy seemed to have forgotten me. Finally, around midnight, she noticed me; she had apparently had a lot to drink. She tried to introduce me, but her voice was lost in the uproar of that crowd, now completely drunk. I rolled up my screen, closed my projector, and fled with the box of slides under my arm.

I never saw Peggy Guggenheim again, but years later I was amused to read her memoirs. When I took pictures, I often wore slacks to be comfortable, something quite ordinary today, but to Peggy it was a sign of masculinity. I wonder if she thought the same thing about George Sand. Moreover, I realized that she had wanted to offer her guests a sensation: literary celebrities photographed in color. In her memory, that was what she had done, but my collection was never projected in her defunct gallery.

151. Peggy Guggenheim and Herbert Read,
Paris, 1939

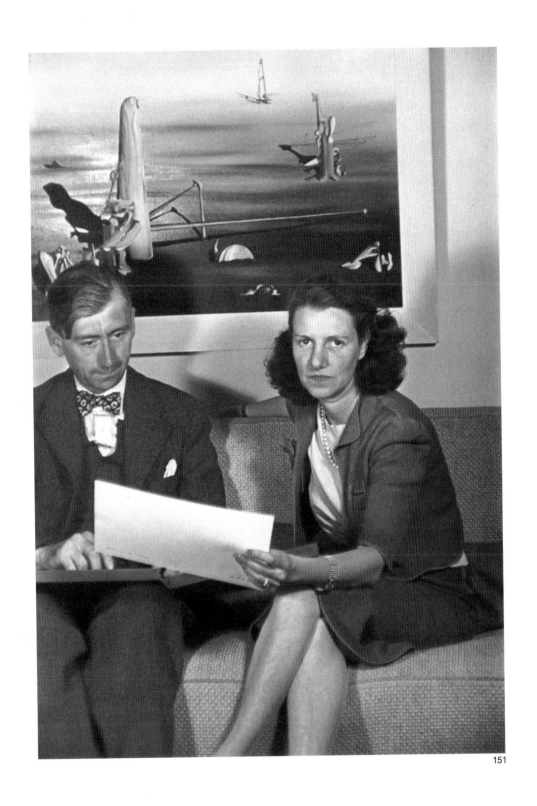

151

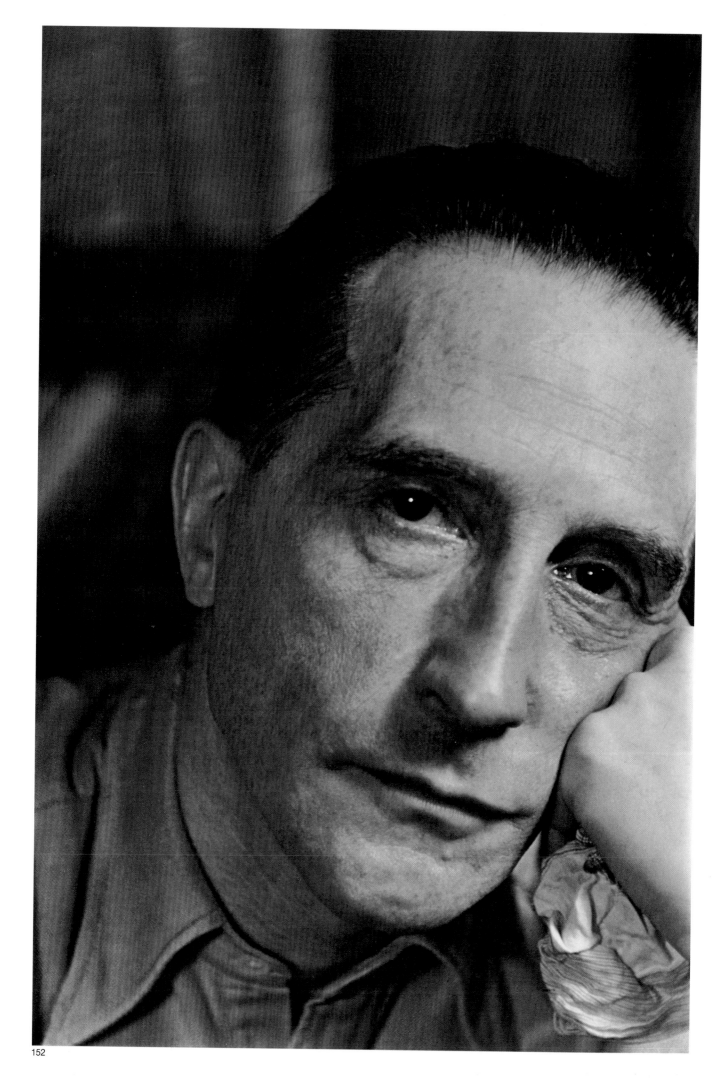

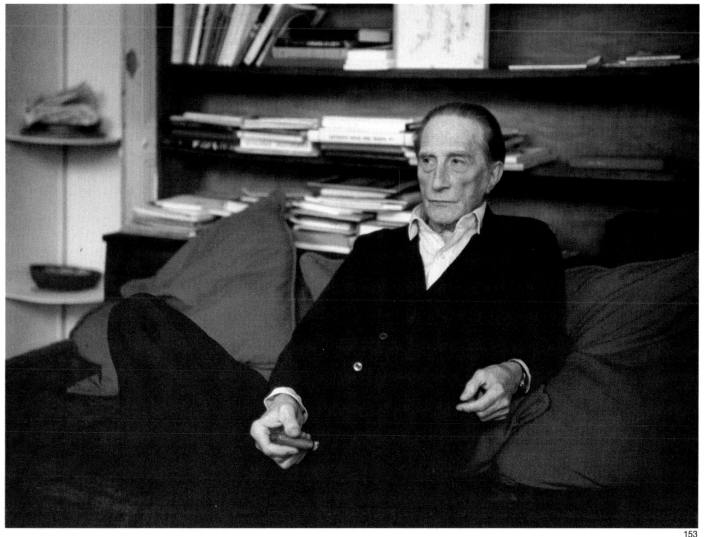

153

152. Marcel Duchamp, Paris, 1939

153. Marcel Duchamp, Paris, 1966

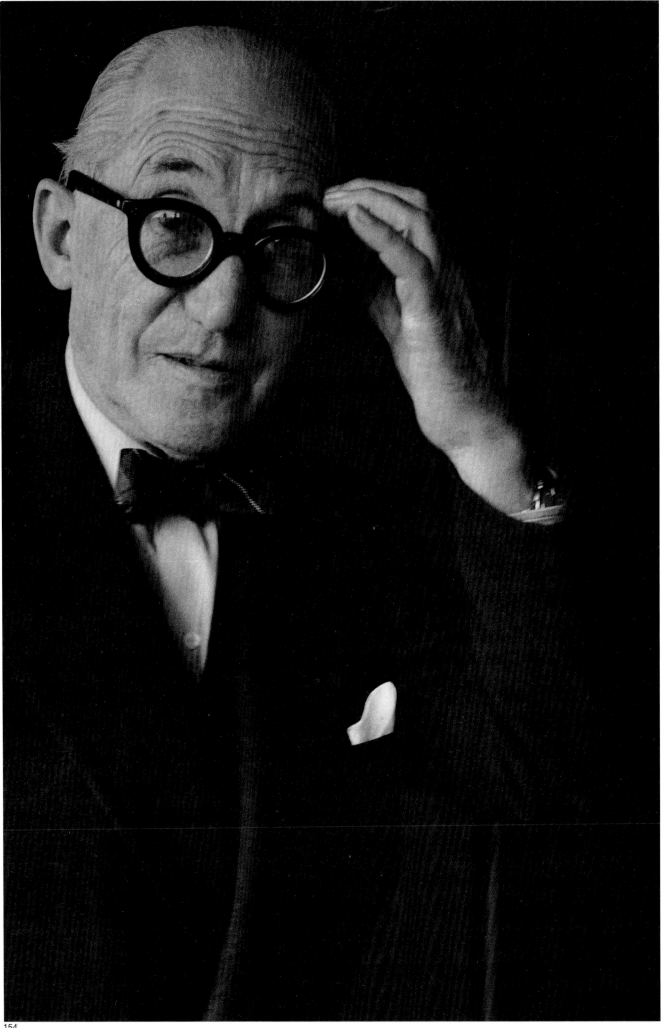

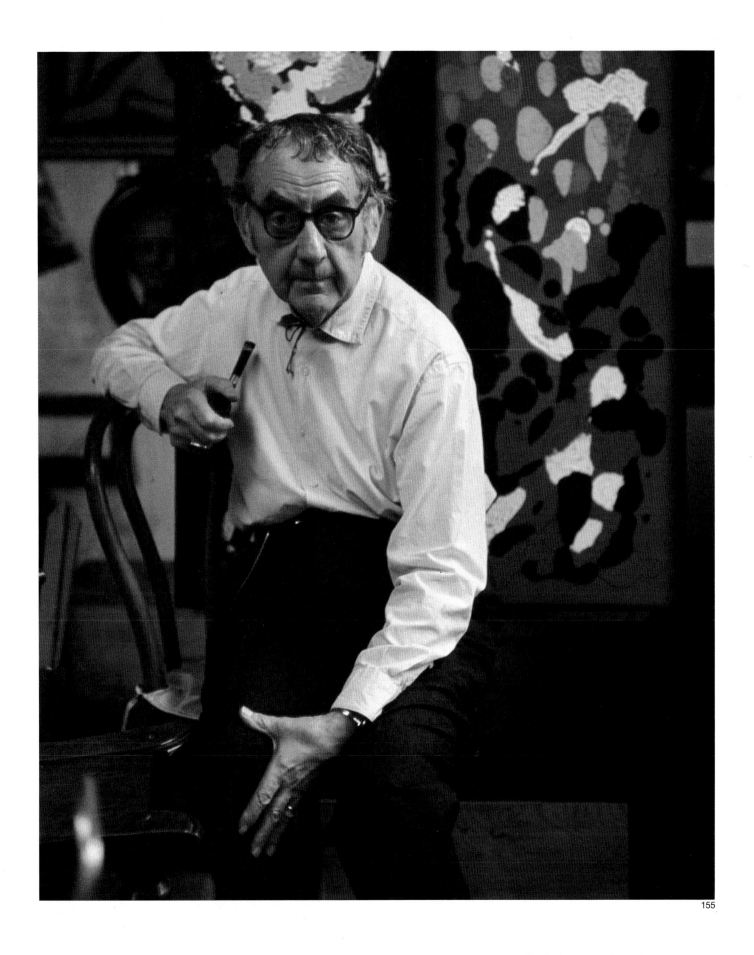

155

154. Le Corbusier, Paris, 1961

155. Man Ray, Paris, 1967

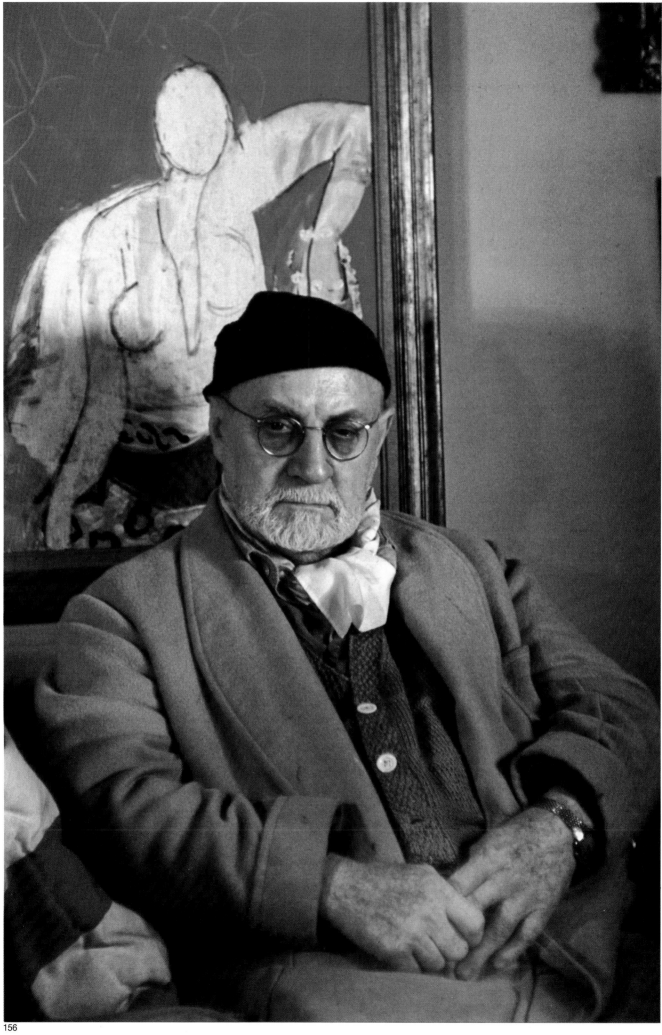

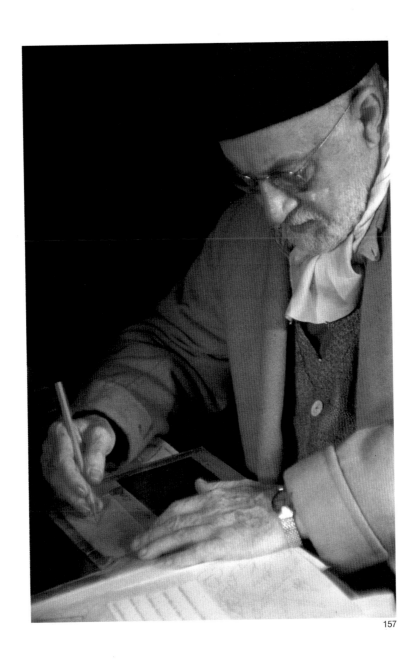

157

156. Henri Matisse, Paris, 1948

157. Henri Matisse, Paris, 1948

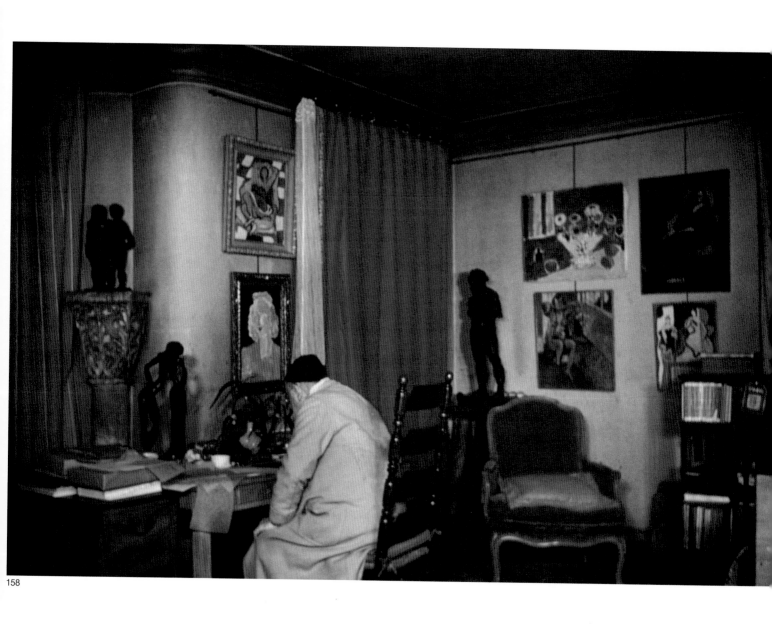

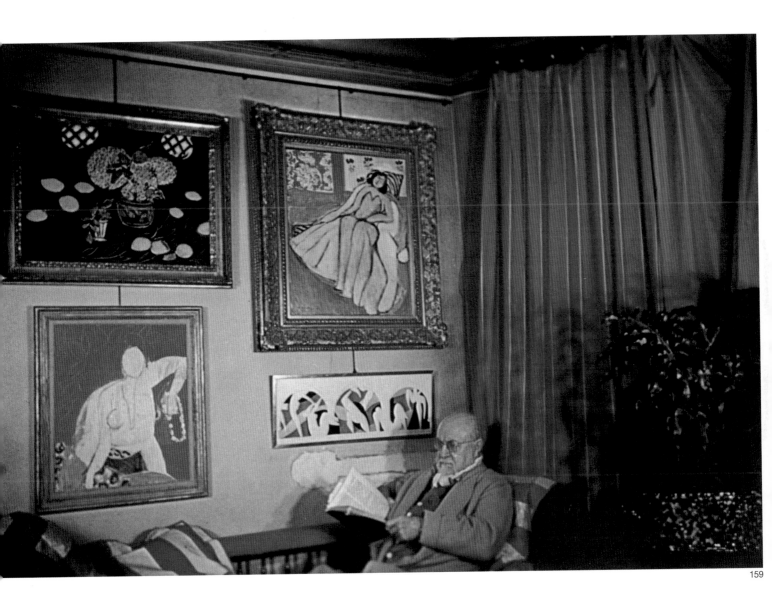

159

158. Henri Matisse, Paris, 1948

159. Henri Matisse, Paris, 1948

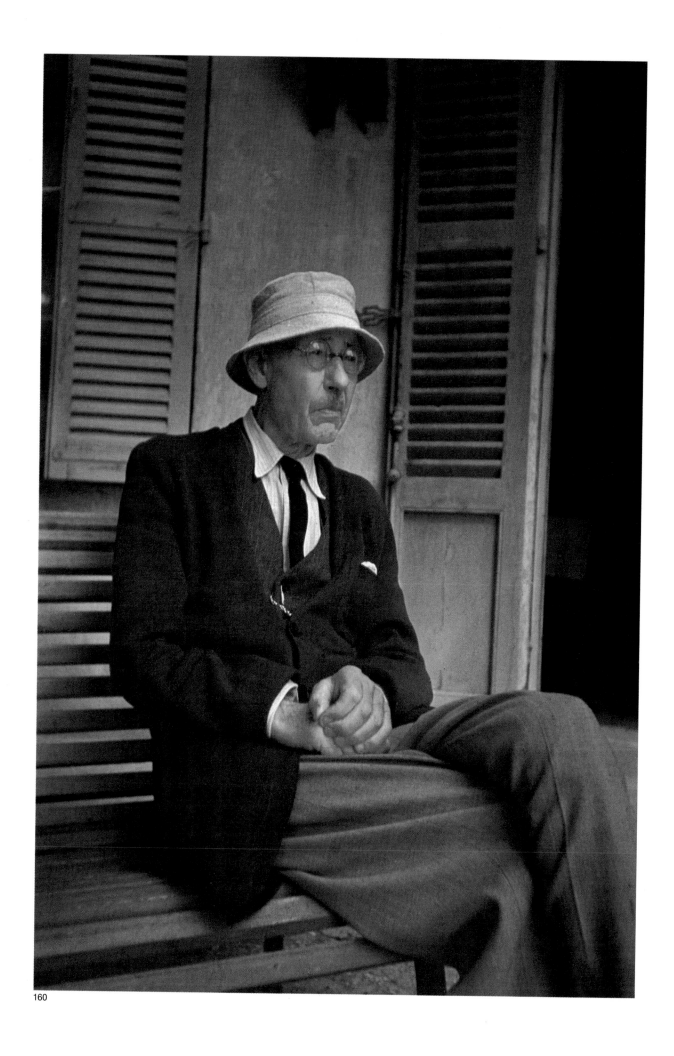

160

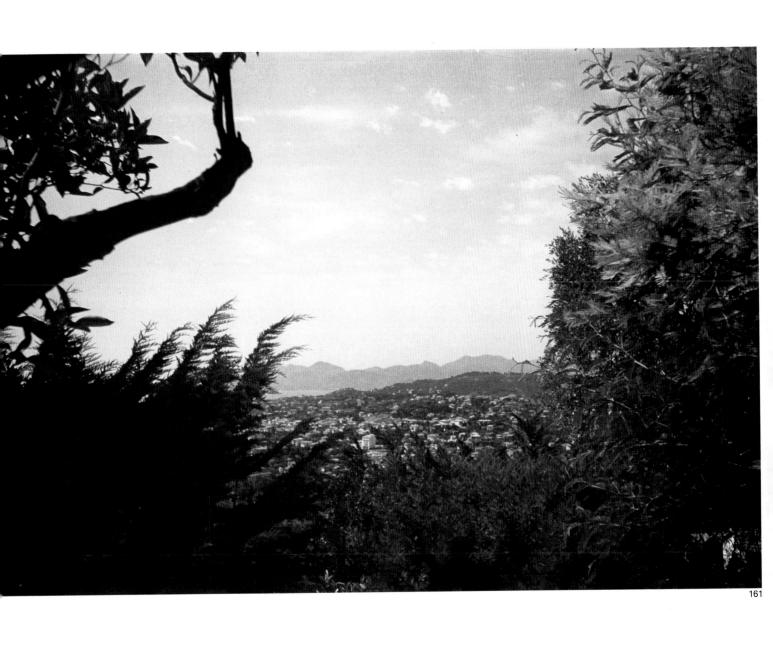

161

160. Pierre Bonnard, Le Cannet, France, 1945

161. Landscape, view from Pierre Bonnard's
window, Le Cannet, 1945

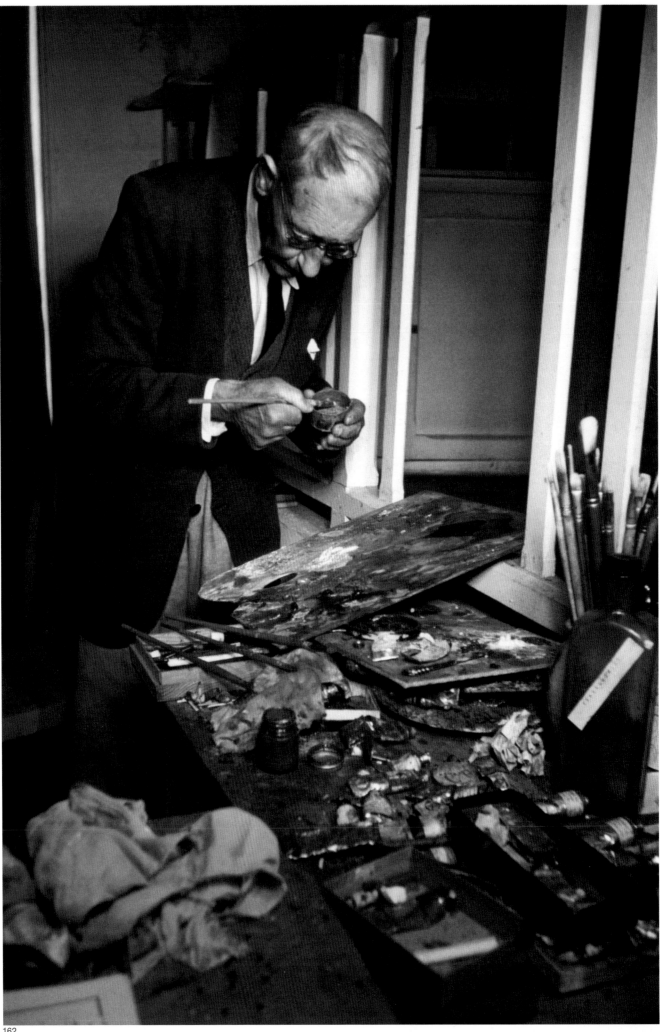

162

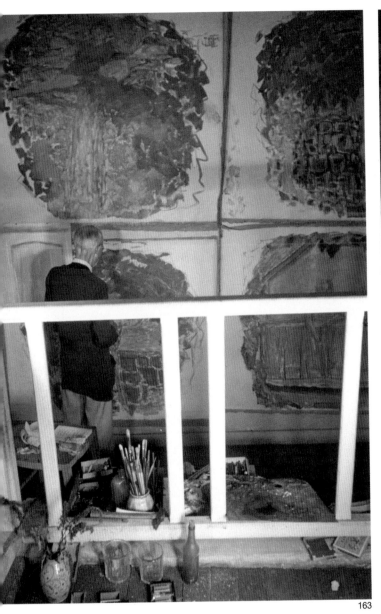

163

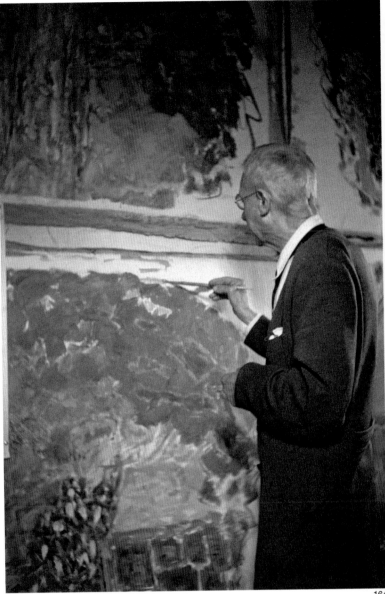

164

162. Pierre Bonnard with palette, Le Cannet,
1945

163/164. Pierre Bonnard painting, Le Cannet,
1945

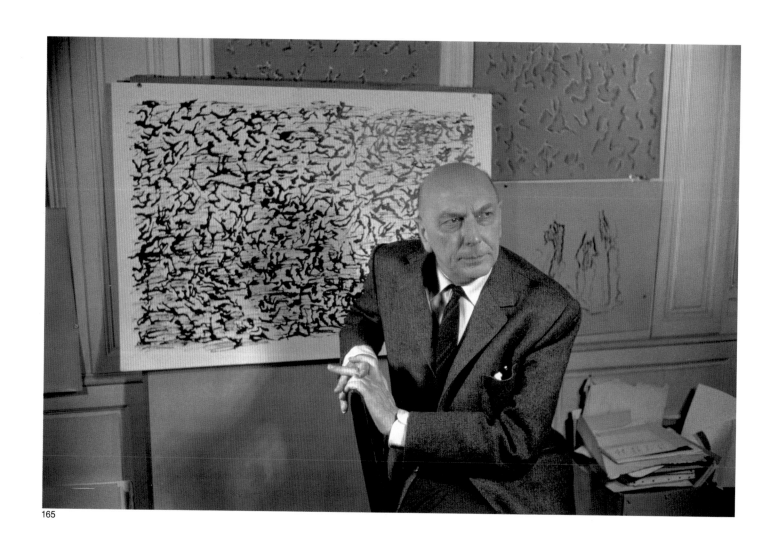

165

165. Henri Michaux with painting, Paris, 1973

166. Henri Michaux, Paris, 1972

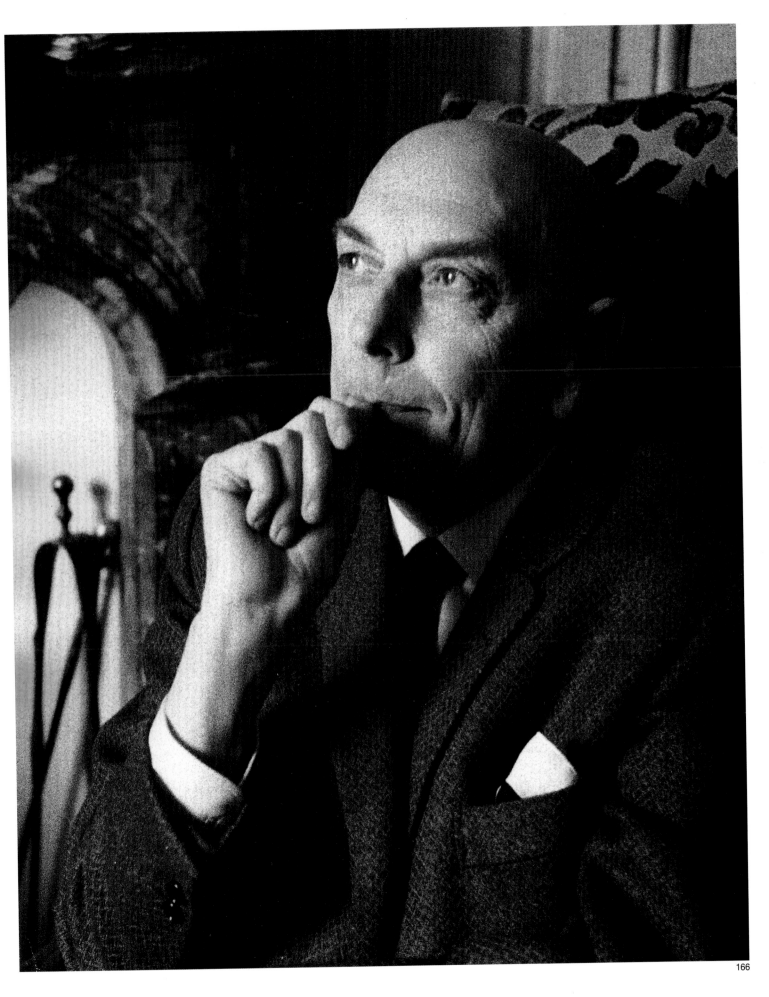

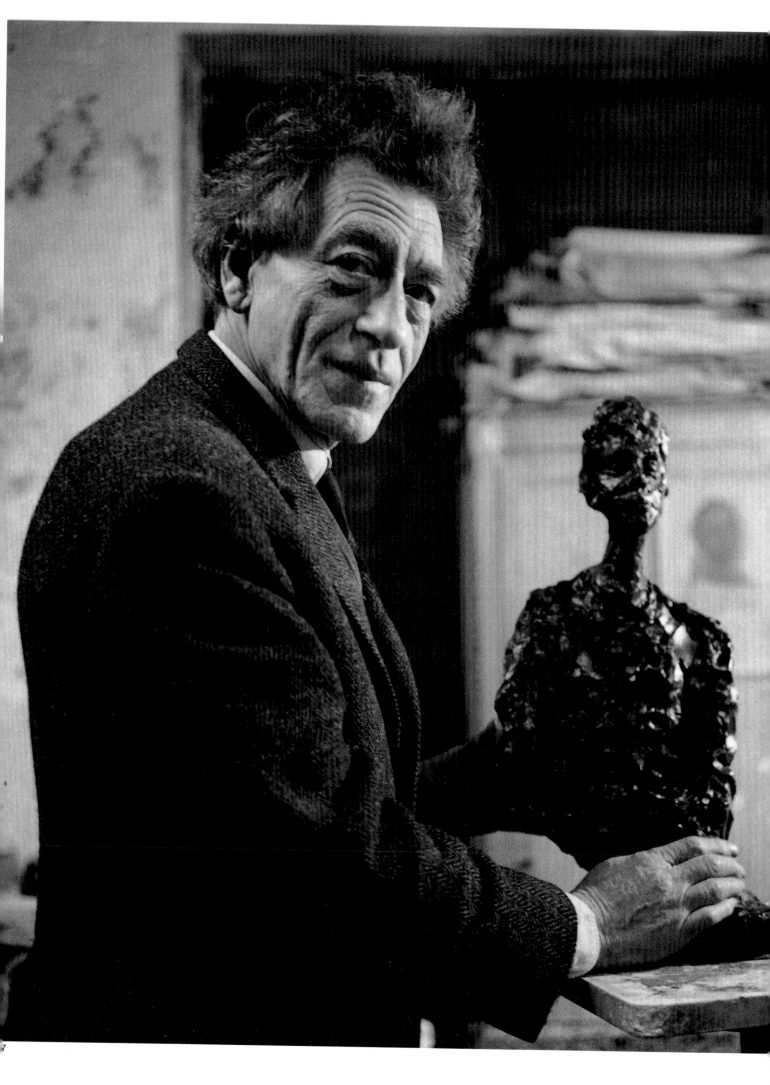

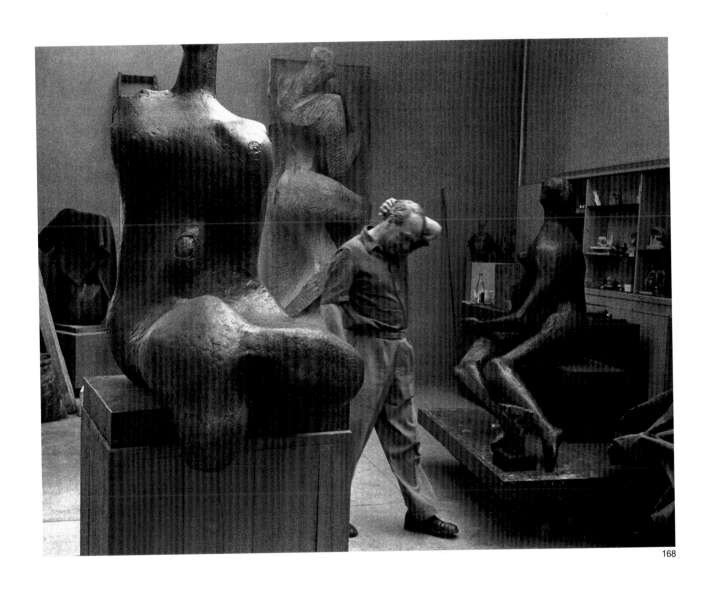

168

167. Alberto Giacometti, Paris, 1966

168. Henry Moore, England, 1959

# VICTORIA OCAMPO

For half a century, Victoria Ocampo was the ambassador of Argentine letters. In 1931 she founded the literary magazine *Sur*, in which she launched a whole generation of Argentine poets and writers. The magazine also published the best works of the American continent and introduced the great European writers into America. *Sur* had given Victoria an international prestige.

I met her in 1938 in Adrienne Monnier's bookstore.

She was very tall, strikingly beautiful, and extremely rich by reason of belonging to one of the wealthiest families in Argentina. Smiling and laughing, she had a good sense of humor. Her elegance—she bought her clothes at Balmain's and always wore flowers in her buttonhole—was disconcerting to French literary circles.

She adored France, where she had spent part of her youth, and wrote almost all her articles and essays in French—impeccable French. With the same facility, she had mastered Spanish, English, and Italian. She was a citizen of the world.

When we became friends, she told me that her parents, whenever they went to Europe, used to take not only their children and several servants but also a cow, in order to have fresh milk on the boat, an idea that I found delightful.

Her numerous friends included Paul Valéry, Aldous Huxley, Rabindranath Tagore, Count Keyserling, Igor Stravinsky, and Virginia Woolf.

During a dinner to which she had asked Roger Caillois, Denis de Rougemont, and myself, she invited us to Argentina. At that time I wasn't exactly sure where Buenos Aires was. People in those days didn't travel as they do now, and countries outside Europe seemed very remote indeed. But all three of us met again in Buenos Aires some years later.

Roger Caillois, who was much in love with Victoria—he was twenty-two and she was fifty—was the first to arrive. The Second World War caught him in Buenos Aires, where he founded *Les Lettres Françaises*, a high-quality literary magazine that enabled French writers in exile, such as Saint-John Perse who was in Washington, or Georges Bernanos in Brazil, to publish their works. Denis de Rougemont came from New York. I was the last to reach the banks of the Río de la Plata.

I could have made a lot of money photographing Argentine high society. Thanks to Victoria, all doors were open. But to satisfy that clientele, as everywhere else, I would have had to bow to its taste and do retouching, which was the reason I had always refused to earn my living as a portrait photographer. I preferred to travel and be a photojournalist, at the risk of a more uncertain existence. For years I traveled up and down through the countries of Latin America, doing photoreportage and making contact with artists and writers. Some of them became great friends of mine and sat for their portraits before my camera. Probably I would never have known and loved the people of this region of the world if Victoria Ocampo, a great patriot who loved her country, had not invited me one day in the spring of 1939.

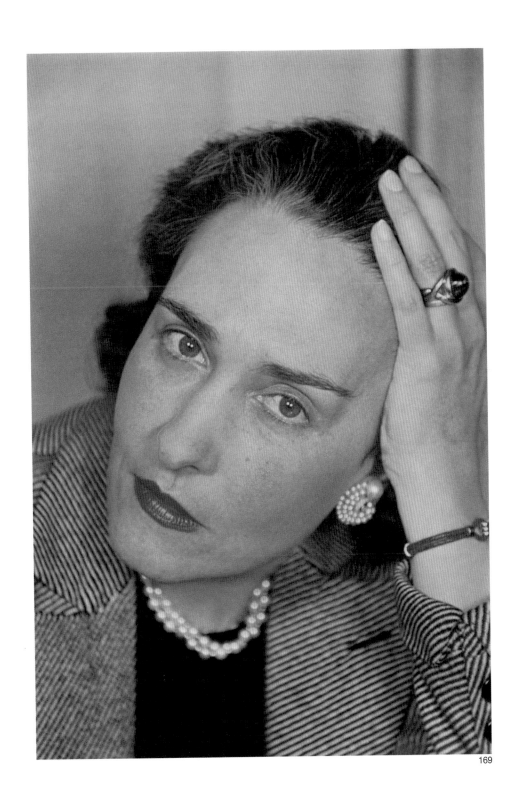

169

169. Victoria Ocampo, Paris, 1939

170

170. Jorge Luis Borges, San Isidro, Argentina,
    1943

171. Jorge Luis Borges, London, 1971

173

172. Julio Cortázar, Paris, 1966

173. Pablo Neruda, Santiago de Chile, 1944

174. David Alfaro Siqueiros, Cuernavaca, 1974

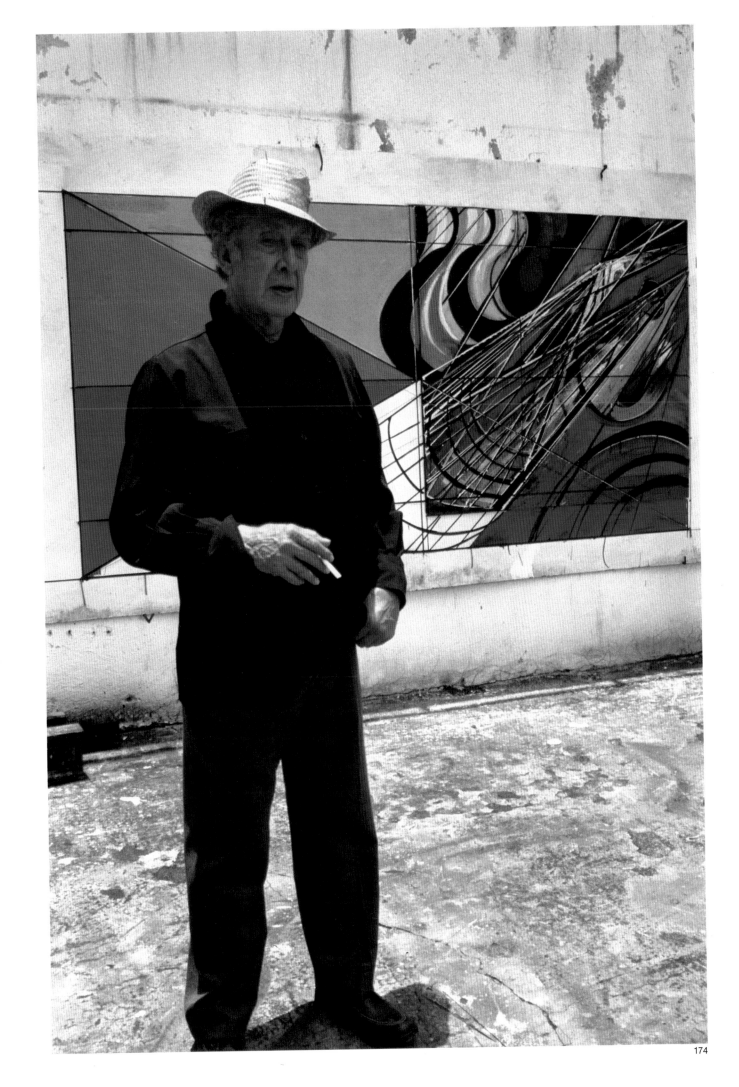

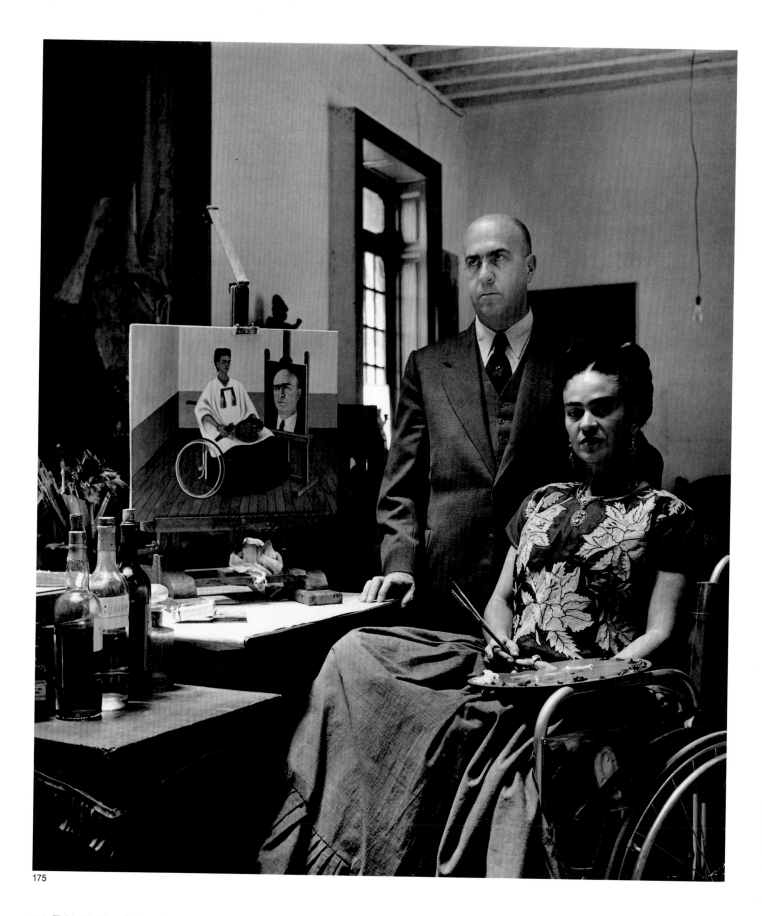

175

175. Frida Kahlo with her doctor and her portrait of the two of them, Mexico City, 1951

176. Frida Kahlo, 1951

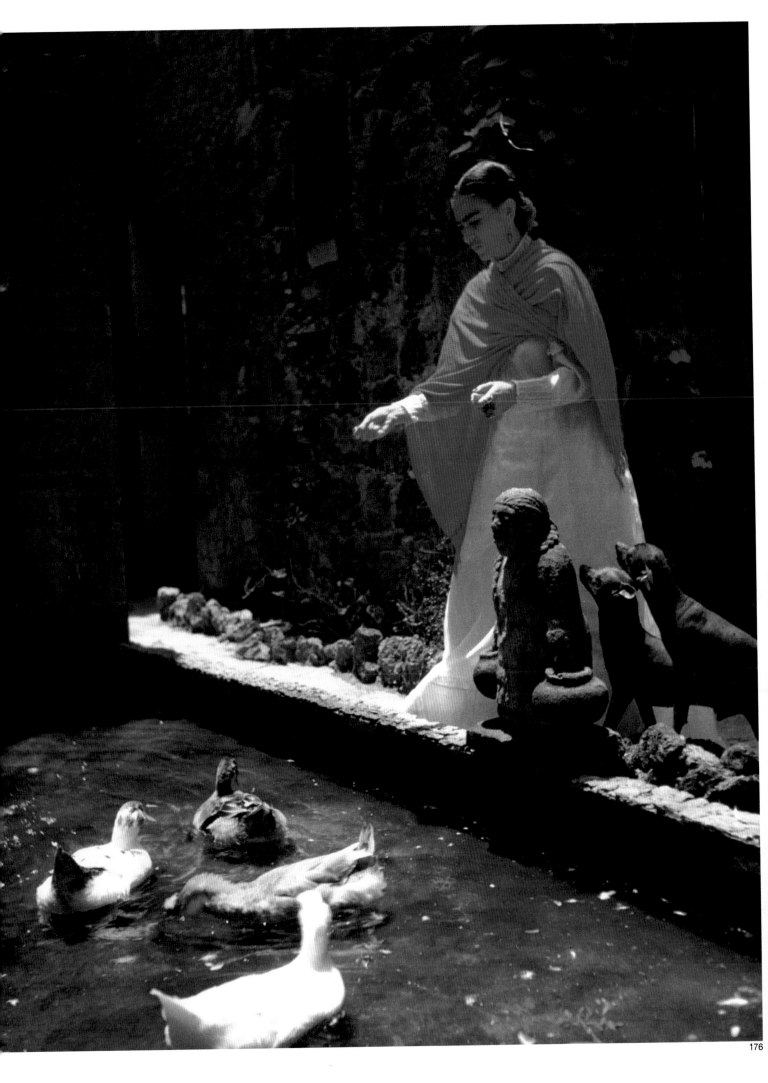

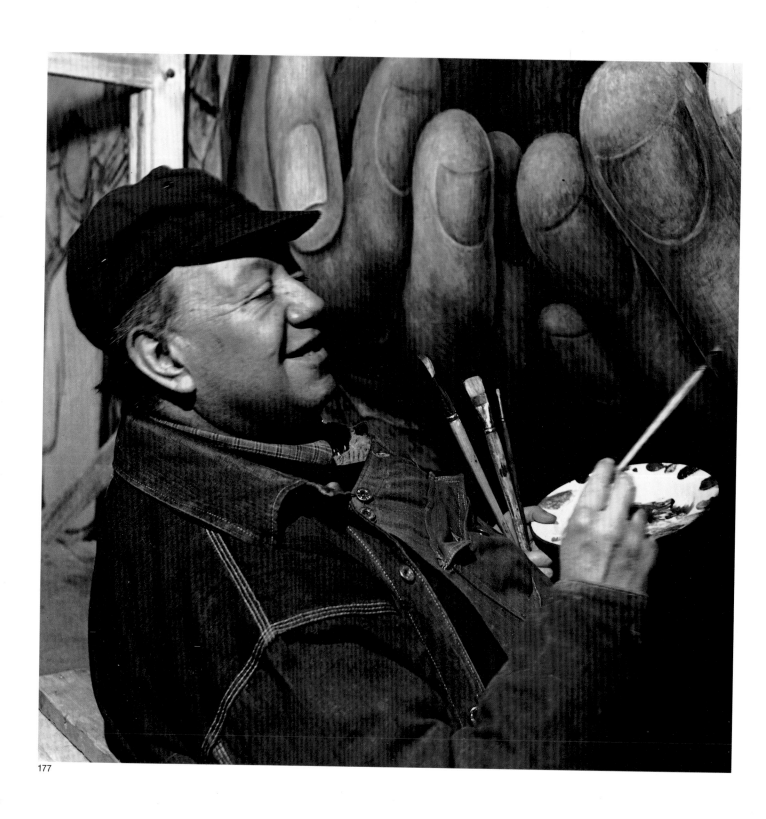

177

177. Diego Rivera, Mexico City, 1951

178. José Clemente Orozco, Mexico City, 1949

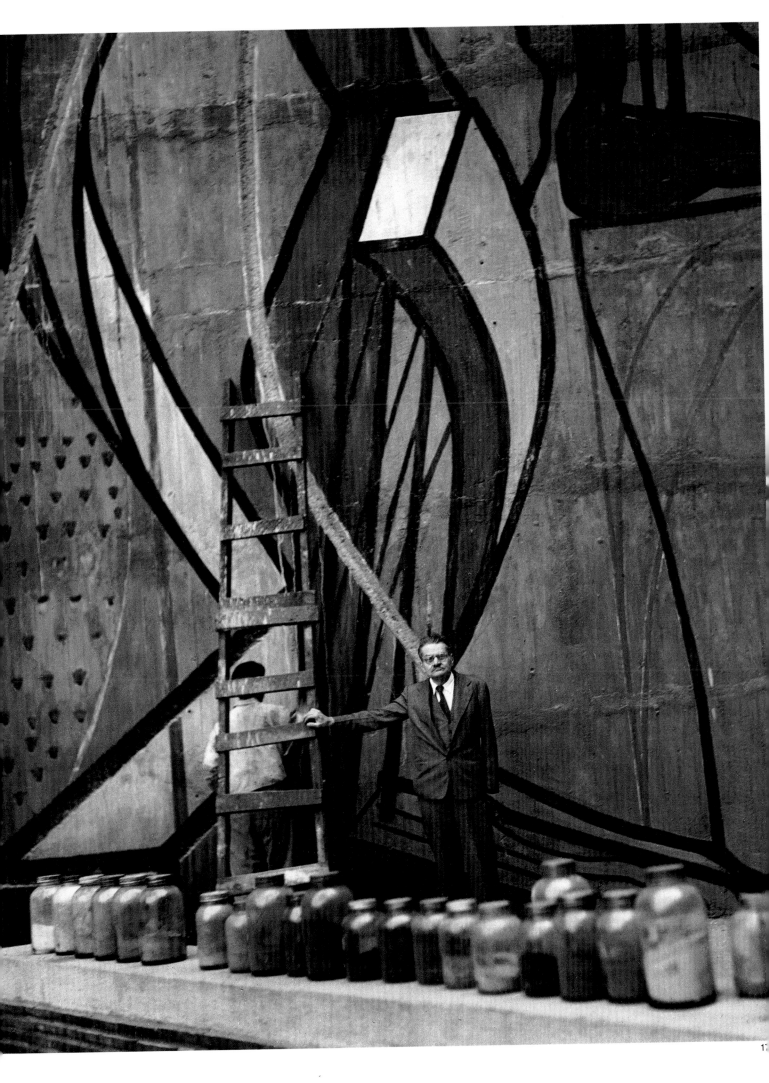

179

179. José Luis Cuevas, Mexico City, 1975

180. Maria Elena Vieira da Silva, Paris, 1972

181. Earth goddess, Mexico, 1978

# Latin America

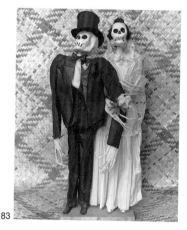

182

184

It was in the 1950s that the poet and writer Alfonso Reyes invited me to Mexico to give a lecture on French literature, accompanied by a projection of my portraits of writers. The two weeks I was supposed to spend in that country turned out to be two years, for I was fascinated by its art and people.

A few days after my arrival, a friend tried to explain to me the Mexican mentality.

"Here are three true anecdotes," he said. "In a market in Mexico City, a fruit vendor spreads two dozen oranges out in front of her on a newspaper. A customer approaches and asks the price. Then he says to her, 'I'll buy all your oranges.' 'That's impossible,' replies the vendor. The customer is astonished and asks her why. 'If I sell you all my oranges, what will I do for the rest of the day?' she exclaims.

183

182. Mexican peasant, Valley of Mexico, 1952

183. *Muertitos*, Easter, Mexico City, 1975

184. Pyramid of Teotihuacan, Mexico, 1952

185. Palo borracho, Buenos Aires, 1950

186. Grand Prize of the Livestock Exposition, Buenos Aires, 1950

"The Mexicans are excellent craftsmen. A tourist sees a beautiful chair in a carpenter shop. 'I'll buy it,' he says enthusiastically, 'and I'll give you an order for five more chairs just like it.' 'That's not possible,' the carpenter replies. The tourist doesn't understand and asks him why it's impossible. 'It's too boring to keep doing the same thing,' says the carpenter.

"Now here's the third anecdote," said my friend. "Two generals meet in a hotel that has a swinging door. One wants to go in, the other wants to go out. Then the sound of pistol shots is heard. The two generals fall down stone dead. They've killed each other."

What excited me most about Mexico was its art. At that time the great painters were Diego Rivera, José Clemente Orozco, and David Alfaro Siqueiros. Their murals adorned public buildings. They were thus following not only the art of their ancestors, the Aztecs and Mayas, but also the slogans of the Mexican revolution that say it is necessary to educate the people, for all these paintings show some event in Mexican history. These were realistic painters. It was only Tamayo who turned away from this tradition. There were also many young painters of talent, such as Frida Kahlo, Rivera's wife, who mostly painted herself, doing self-portraits that expressed her own problems. Frida had a broken spine due to an accident in her youth, and she suffered very much. It is only now, more than thirty years after her death, that her paintings, which were influenced by the Surrealist movement, have become famous.

It took me a while to understand the different cultures of Pre-Columbian art. The temples and countless sculptures are entirely dedicated to the religion of these peoples and their many gods. André Malraux considered the Anthropological Museum in Mexico City to be the most beautiful in the world.

Then there is Mexico's colonial art and finally its colorful popular art. But after staying two years, I felt the need to return to Europe, where nature is the measure of man.

Everything in Mexico is contrast and excess. In summer, the transparent sky radiates warmth and joy. But the Mexican peasant stoops anxiously over his land, fearing drought and famine. In winter, torrential rains threaten to destroy in a few hours the toil of long months.

Of all the other countries of Latin America, Argentina is the one I came to know best. I traveled from its far northern border with Bolivia to its southern extremity of Cape Horn. Its capital, Buenos Aires, is a huge city, built in all the European styles. The ancestors of the *porteños*, as the people of Buenos Aires are called, were almost all of European origin. Their port, with its slaughterhouses, is one of the largest in the world. Argentina's chief product is beef, and its most important social event is the livestock exposition that opens every year and is attended by the president of the Republic and the diplomatic corps. What strikes one most in the street is the elegance of the men. You cannot tell a clerk from his employer, a hotel proprietor from a great landowner, a worker from a factory executive. It is no accident that the hair pomade known as "Gomina" was invented in Argentina.

Elegance consists in a harmonious combination of forms and colors, and if this need is not the result of a traditional upbringing, it corresponds to the wish to keep up a good countenance. It can also result from a certain optimism that puts its trust in appearances. The secret of Gomina is Argentine optimism.

18

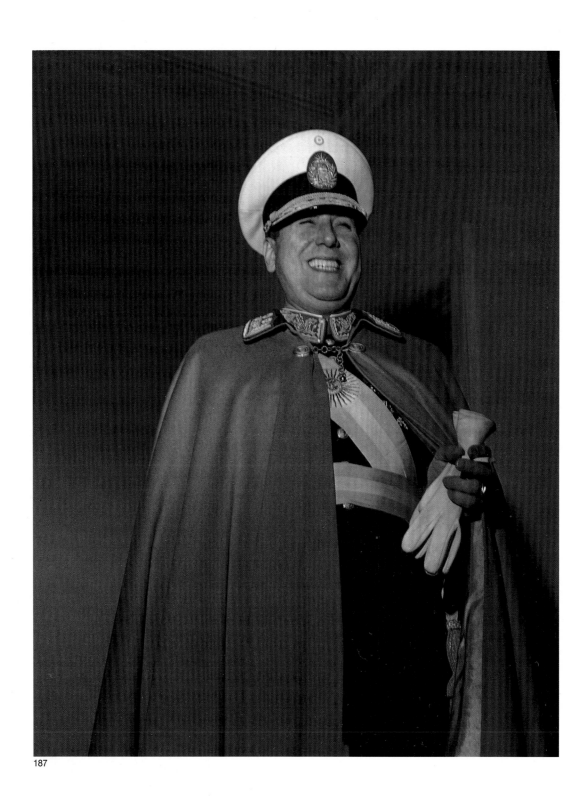

187

187. General Juan Perón, Buenos Aires, 1950

188. Evita Perón preparing for the national
　　 holiday, Buenos Aires, 1950

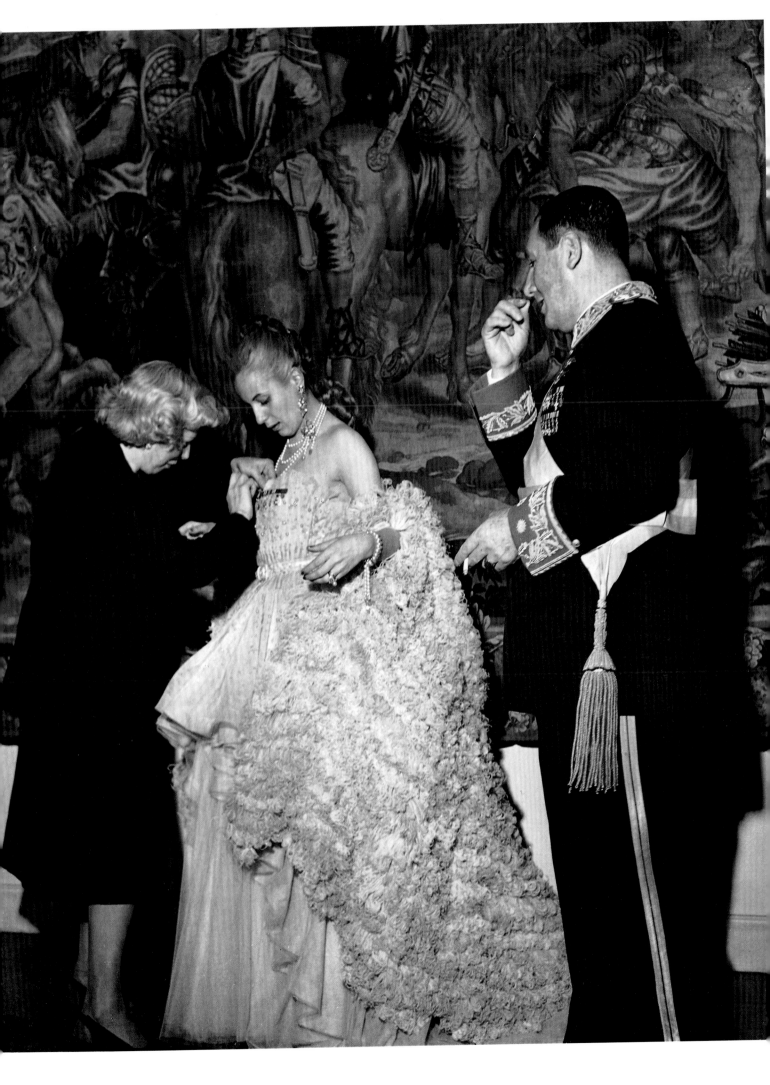

189. Tierra del Fuego, Chile, 1944

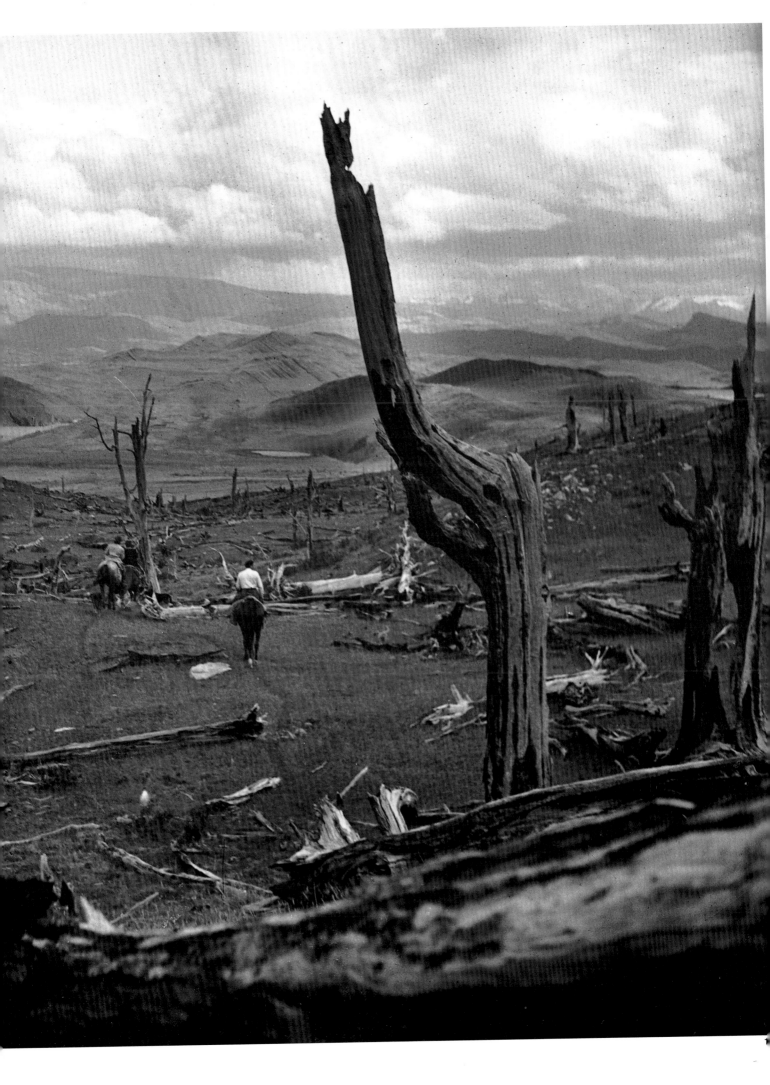

# Paris

On my arrival in Paris in 1933, I moved into a small hotel on the Rue Saint-Julien-le-Pauvre, because from my window I could contemplate the towers of Notre-Dame. One of my first photos was taken from the top of that cathedral. Parisians at that time were still heating their houses with coal. Today it has been replaced with oil. The smoke that once rose from thousands of chimneys has vanished, but the chimneys are still there, now decorated with countless television antennas.

In 1933, only one automobile used to park in my street, but today it has been transformed, like most Paris streets, into a garage.

Everybody still wore a hat, something that struck Simone de Beauvoir when she saw my 1933 picture of the Ile Saint-Louis. Today the fashion is to go bareheaded, and there are almost no hatters any more.

In Paris it seldom snows. That is probably the reason why I photographed, one winter day in the fifties, the trees covered with a thousand little white stars at the Sèvres-Babylone station of the Métro.

In 1933, an automobile accident was still an event. What strikes us today is less the accident than the fact that the street was still paved with large paving-stones. I photographed the streets of Paris being tarred. This must have seemed a novelty to me in 1933. But John Szarkowski, curator of photography at the Museum of Modern Art in New York, has shown me a photograph taken by Atget in 1912. He had photographed the same machine twenty-one years before me.

The streets of Paris are still decorated with strings of electric lights for July 14, Bastille Day, but dances are seldom held in the street now. My photo dates from 1952.

In the thirties, I spent most of my time at the Bibliothèque Nationale in order to finish my doctoral thesis. I could often hear the shouts that came from the Stock Exchange, not far from the Rue de Richelieu where the Bibliothèque Nationale stands. I went to take a look.

At that time, buying and selling still went on outside under the arcades. I noticed in particular one stockbroker who—now smiling, now with a look of anguish on his face—was exhorting the buyers with broad gestures. I took him as a focal point and submitted to a number of newspapers this little photo-reportage, under the innocuous title "Shots of the Paris Stock Exchange." Some time later, I received clippings from a Belgian paper and was quite surprised to find my photos under a headline that read: "Gains on the Paris Stock Exchange. Stocks Reach Fabulous Level." Thanks to tricky captions, my innocent little photoreportage had taken on the meaning of a financial event. My astonishment came close to the bursting point when a few days later I found the same photos in a German paper, this time under the headline: "Panic on the Paris Stock Exchange. Fortunes Collapse, Thousands of People Ruined." The two publications had given my photos diametrically opposite meanings. My pictures had perfectly illustrated the despair of the seller and the confusion of the speculator in the process of being ruined. From this experience I learned that the objectivity of the image is nothing but an illusion. Its meaning can be changed completely by the accompanying text.

Overleaf:
190. Paris, seen from Notre-Dame, 1933

191

191. Rue Saint-Julien-le-Pauvre, Paris, 1933

192. Paris under the snow, 1956

193. Ile Saint-Louis, 1985

194. Ile Saint-Louis, 1933

)

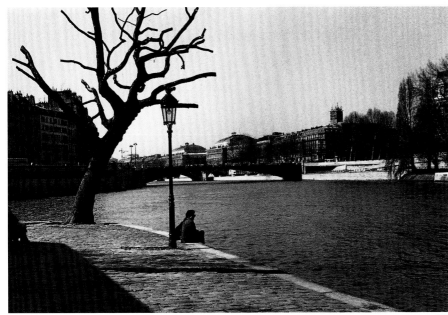

193

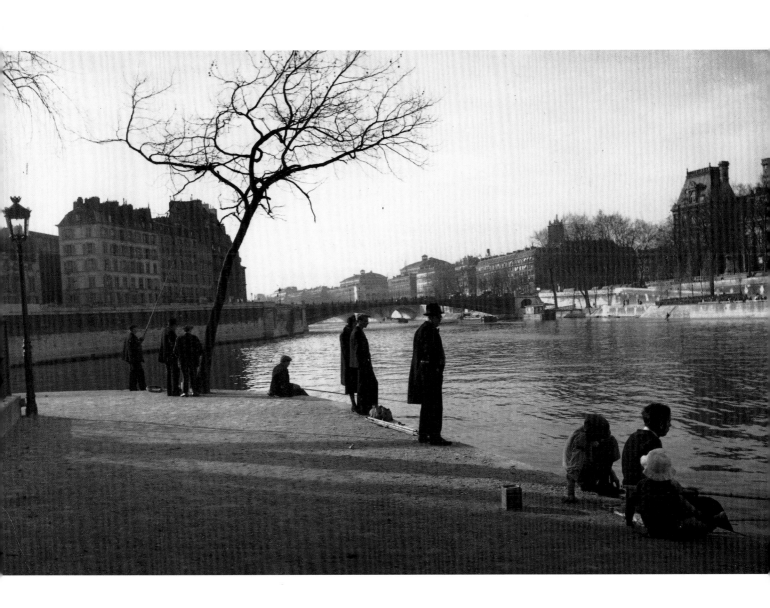

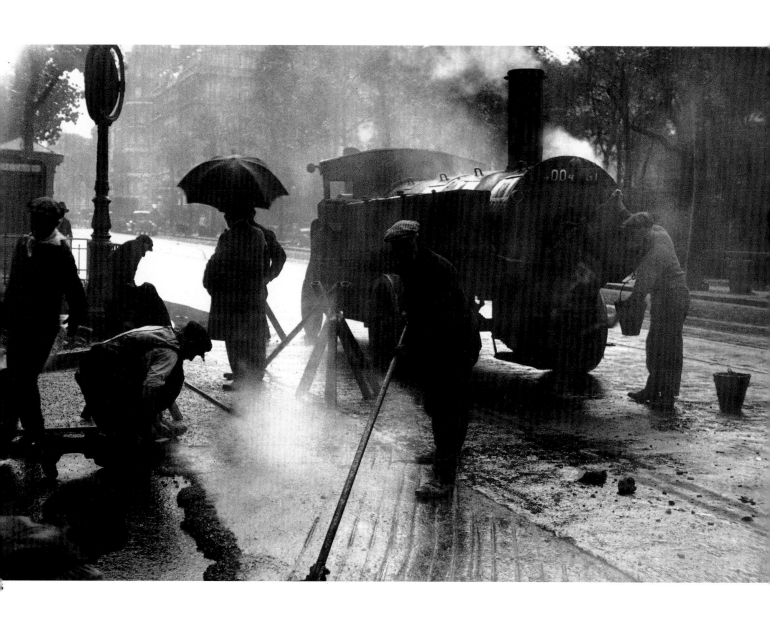

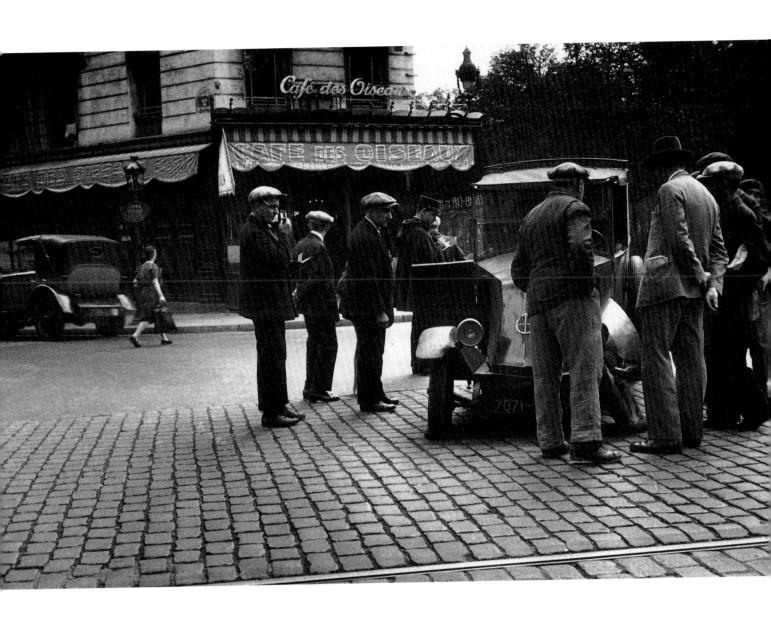

195. Street being tarred, Paris, 1933

196. Accident, Paris, 1933

197–201. Shots of the Paris Stock Exchange,
        1935

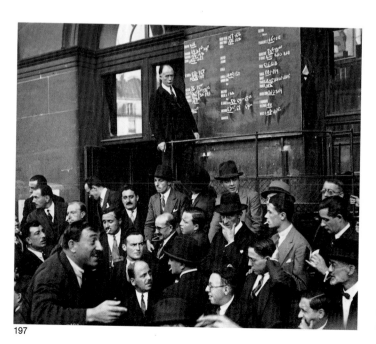

197

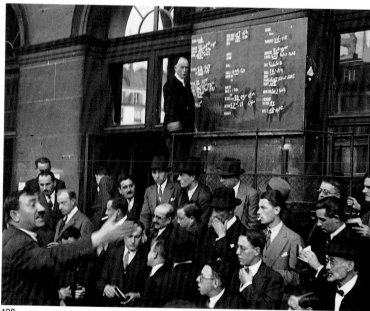

198

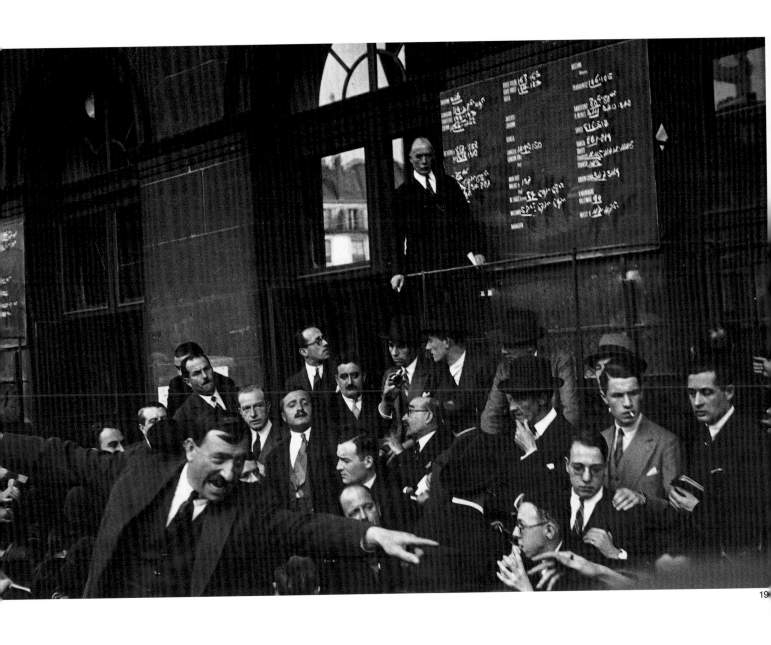

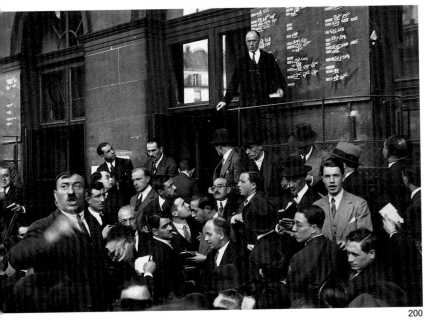

202. Onlookers, Bastille Day, Paris, 1952

203. Rue Boulard, Bastille Day, 1952

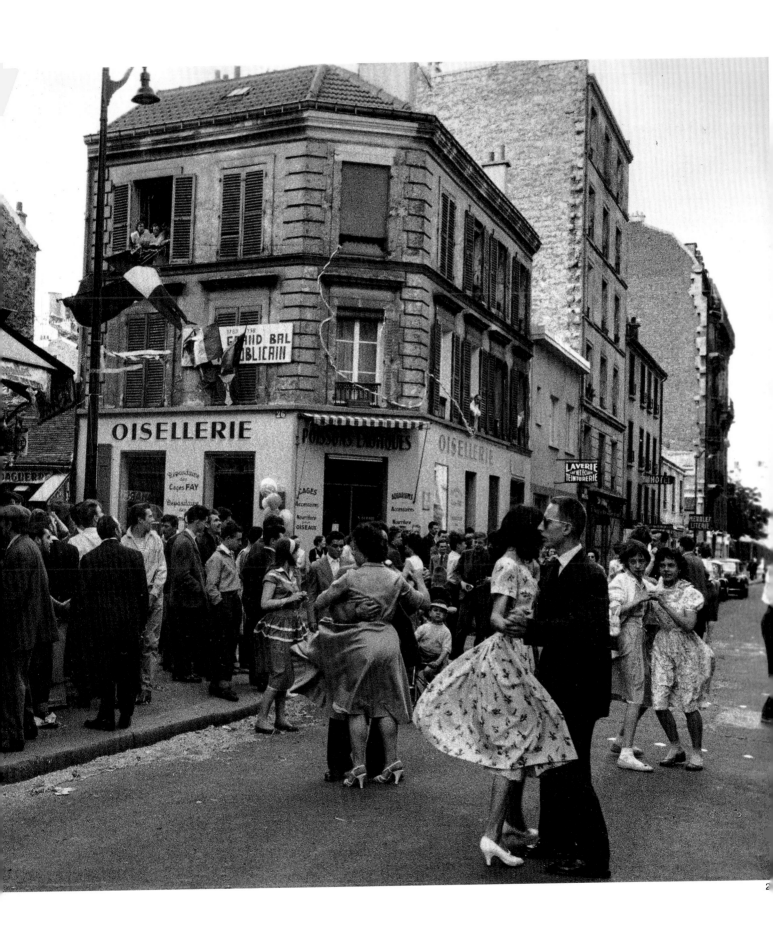

204. Cleaning the street, Paris, 1933

# Selected Bibliography

## BOOKS BY GISELE FREUND

*La Photographie en France au dix-neuvième siècle.* Paris: La Maison des Amis des Livres, 1936.

*La Fotografía y las classes medias.* Buenos Aires: Losada, 1941; Munich: Rogner & Bernhard, 1968.

*Mexique précolombien.* Neuchâtel: Ides & Calends, 1954; Munich: Hanns Reich Verlag, 1956.

*James Joyce in Paris: His Final Years.* New York: Harcourt, Brace, 1965; London: Cassel, 1966.

*Au pays des visages* (catalogue). Paris: Musée d'Art moderne de la ville de Paris, 1968.

*Le monde et ma caméra.* Paris: Denoël, 1970. English ed., *The World in My Camera.* New York: Dial Press, 1975.

*Photographie et société.* Paris: Editions du Seuil, 1977. English ed., *Photography and Society.* Boston: David R. Godine, 1980.

*Mémoires d'oeil.* Paris: Editions du Seuil, 1977.

*Trois jours avec Joyce.* Paris: Denoël, 1983. English ed., *Three Days With Joyce.* New York: Persea, 1985.

## ARTICLES AND CATALOGUES ON FREUND'S WORK

*Camera*, Switzerland, Nov., 1968.

*Fotografien, 1932–1977* (catalogue). Bonn: Rheinisches Landesmuseum, 1977.

*ICP Encyclopedia of Photography*, International Center of Photography, New York, Autumn 1984.

Kramer, Hilton, "The World in Gisèle Freund's Lens," *The New York Times,* Dec. 28, 1979.

Lehmann-Haupt, Christopher, "Books of the Times," *The New York Times,* July 2, 1980.

Monnier, Adrienne, "In the Land of Faces," *Verve*, Paris, no. 5–6, 1939.

Witkin, Lee, and London, Barbara. *The Photography Collector's Guide,* Boston: New York Graphic Society, 1979.

# Index

Illustrations are listed by plate number